er's Guide to Creating

nga Art

Learn to Draw, Color and Design Characters

3dtotal
PUBLISHING

Beginner's Guide to Creating
Manga Art

Learn to Draw, Color
and Design Characters

Contents //

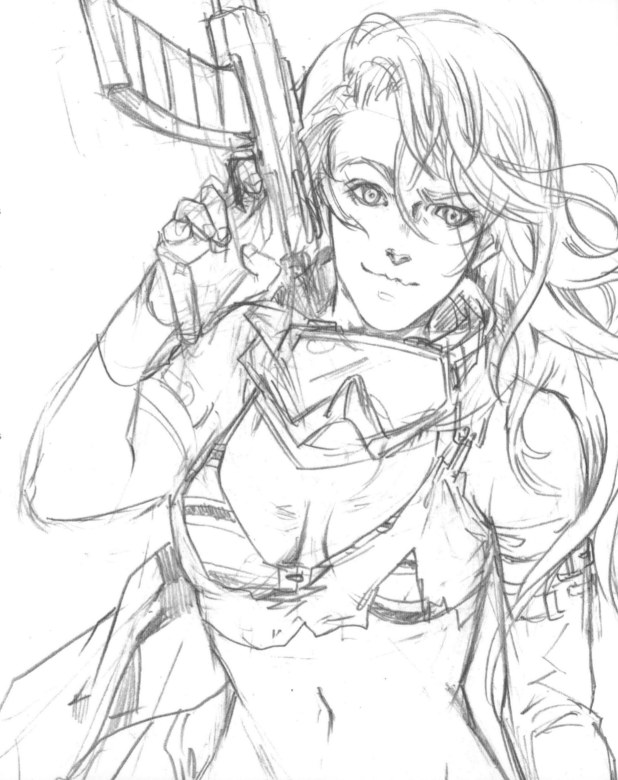

3DTotal Publishing

Correspondence: publishing@3dtotal.com
Website: www.3dtotalpublishing.com

Reprinted and published in 2013, by 3DTotal Publishing

Paperback ISBN: 978-0-9568171-6-7

Printing & Binding
Everbest Printing (China)
www.everbest.com

Featured Artists
Gonzalo Ordoñez
Steven Cummings
Israel Junior
Valentina Remenar
Georgina Chacón
Giovana Leandro da Silva Basílio (Eudetenis)
Supittha Bunyapen
Sandra Chlewińska
Christopher Peters
Mateja Pogacnik and Marco Paal
Phong Anh

Editor: Simon Morse
Sub-editor: Jo Hargreaves
Design and Creation: Christopher Perrins
Image Processing and Layout: Matthew Lewis

Visit www.3dtotalpublishing.com for a complete list of available book titles.

The Birth of Manga

Since the time they were created, manga and anime have spread quickly around the globe, becoming one of Japan's most significant and recognized contributions to modern pop-culture. Manga's importance and contribution to the entertainment industry is clear. Whole generations of us have grown up watching TV, playing video games and reading comics, meaning that we are familiar with the aesthetics, themes and codes of the genre. Manga and anime are a common part of our everyday lives and it is easy for us to assume that they have always been there in some way, even if styles and trends have evolved over time.

So where does the story of manga begin? Well, not with *Naruto*, *Bleach*, *One Piece*, *Rurouni Kenshin* or *Sailor Moon* in the 1990s. Not even with *Dragon Ball*, *Bubblegum Crisis* or *Macross* in the 80s. To understand manga, we must look at its source.

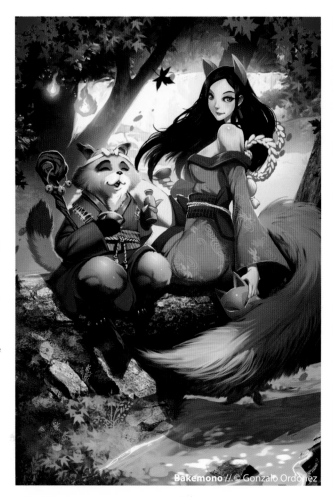

Bakemono // © Gonzalo Ordoñez

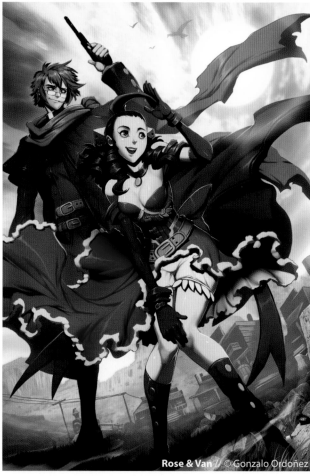

Rose & Van // © Gonzalo Ordoñez

Manga actually originated a long time ago, back in the twelfth century, and one of the first examples of it can be found in the Chōjū-giga scrolls. Created to record historic events, these scrolls were illustrated by an artist-monk called Toba Sōjō – also known as Kakuyū – somewhere between 1053-1140AD. They depict contemporary and dynamic images of characters and animals, several centuries before Disney gave us Mickey Mouse.

Toba took great pleasure in satirizing the religions of his time and their customs. His images were light-hearted and in many images he depicted religious figures as toads having fun, usually at solemn Buddhist ceremonies (such as funerals). The Chōjū-giga scrolls are part of a sub-genre of manga known as emakimono, which was very popular from the 11th to the 16th century. They were usually a mix of text and images that told stories, very similar to a picture

book of that time. What makes Toba's work unique is the total absence of text, his expressive use of fast lines and, of course, the fact that the protagonists were animals used in a humorous way.

During the Edo period, ukiyo-e became the popular form of illustration due to the ease in which it could be produced (as it was created with woodblock prints). The artists exploring the genre

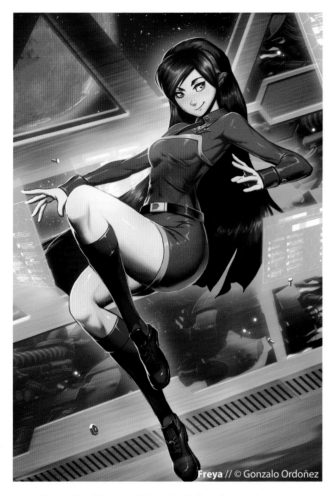

Freya // © Gonzalo Ordoñez

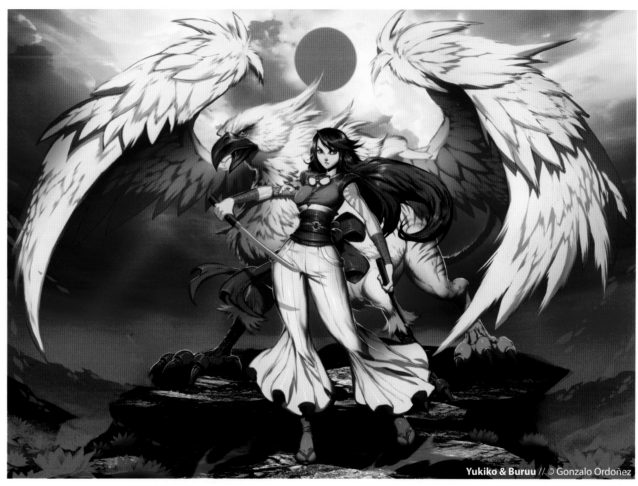

Yukiko & Buruu // © Gonzalo Ordoñez

started to tackle different subjects, including diverse Japanese landscapes, Kabuki (theatre) actors, supernatural characters from folklore and women from brothels (which gave birth to a sub-genre called shunga, that was specifically for adults).

As time went by and it became easier to travel around Japan, it became easier for artists to trade with more and more different

types of people. This meant that the popularity of the art form grew. Among the new wave of artists that became exposed to ukiyo-e was Katsushika Hokusai (1760 -1849). A painter and traveler, Hokusai is perhaps best known today for his illustrations depicting popular life in Japan in the 19th century and as the painter of one of the most iconic images in Eastern art: *The Great Wave off Kanagawa*.

Hokusai indirectly provided one of the most important milestones in the development of manga as an art form: the coining of the actual phrase "manga". This word was first used by the media when they published a selection of woodblock prints and sketches under the name *Hokusai Manga* (*Hokusai's Sketches*). These works were based on different landscapes and characters from Japan's Edo period, and Hokusai created 15 volumes of sketches that were

published from 1814 onwards. The success of his work gave birth to a growing audience fascinated by the cartoony style.

As Japan moved from the Edo to the Meiji period, the country's involvement with other cultures around the world began to expand and influence artistic styles. In 1862, *Japan Punch* was born and the first magazine based on this cartoony style of art was published. This magazine was based on the humor and satire of British cartoonist Charles Wirgman, who arrived in Japan in 1861 as a correspondent for *Illustrated London News*. Wirgman influenced many artists, not only in terms of technique and theme, but also in terms of editorial initiatives that would shape the market.

A few years later in 1874, the first Japanese magazines were published. These consisted of titles such as *Eshinbun Nipponchi*, *Kisho Shimbun* and *Garakuta Chinpō*. In 1895, Iwaya Sazanami created the first magazine specifically for children called *Shōnen Sekai*. Although *Shōnen Sekai* was targeted at young people, it wasn't specifically a comic. In 1906, however, *Shōjo Sekai* saw the light. It was a sister magazine aimed at girls, containing segments called Shōnen and Shōjo, and the first steps towards creating a manga comic were taken.

During the following years, manga comic strips continued to appear in a variety of different publications. These comics were specifically targeted at younger audiences, with the style even being adopted in pre-war animated productions such as *Urashima Tarō* (1918) or propaganda such as *Momotarō no Umiwashi* (1942).

Perhaps the biggest development in manga, however, came at the hands of Osamu Tezuka. He was a true visionary and designed what became some of the most recognizable features of the manga style. He was a pioneer when it came to developing characters with dynamic expressions and defining features, such as big eyes, which later inspired Disney characters like Bambi.

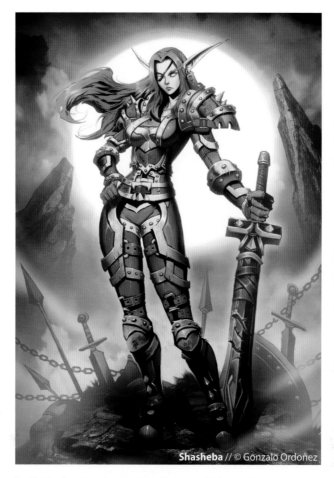

Shasheba // © Gonzalo Ordoñez

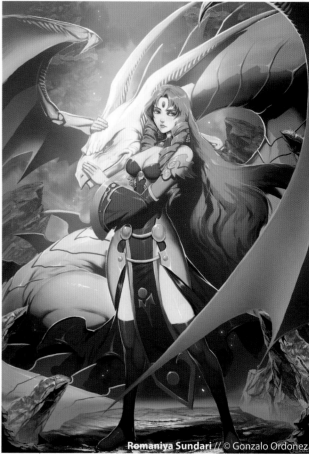

Romaniya Sundari // © Gonzalo Ordoñez

In 1947, when Tezuka was just 18 years old, he provided the illustrations for a published comic strip called *Shin Takarajima*, which was written by Sakai Shichima. While it's not Tezuka's most famous work, it was a huge success and it was at this point that he set the foundations of the modern manga style.

Tezuka became not only the father of modern manga, but also of animation, and was a pioneer when it came to streamlining

processes and reducing production costs. He created illustrations that touched on many different areas, from popular characters to everyday life. Some of his most famous projects were *Tetsuwan Atomu* (*Astro Boy*), *Ribon no Kishi* (*Princess Knight*) and *Burakku Jakku* (*Black Jack*). In these famous titles you will see the visual conventions that are identifiable in modern manga, and it is from this point that the manga you are familiar with today has developed and evolved.

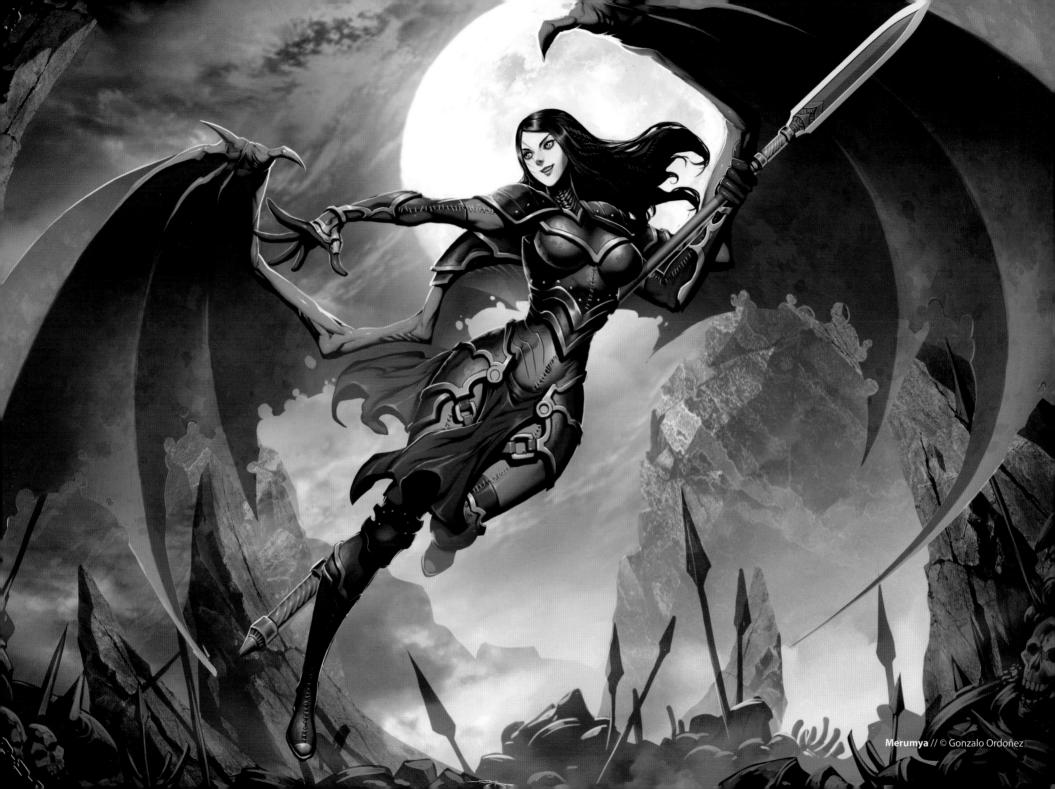

Merumya // © Gonzalo Ordoñez

Manga Styles

Defining Manga

So, we all know now that manga originated in Japan and there are certain visual conventions that appear within the style. But are there any definitive ways to identify art as being manga? Is it that manga comics often appear in black and white? No, it can't be that as many South American comics consist of black and white line art and there are loads of full color manga comics. Is it that the characters are dynamic and expressive? It can't be that either, because the same could be said about comics and many other art forms. Is it that the characters are human, but not drawn in a realistic way? But French and Italian artists have been doing that for years. So what is it that defines manga and identifies the sub-genres within this artistic style?

Technically there is no way to describe how to identify manga as a style. There are many different artists that create art that can be described as manga, however their art doesn't always look the same, or even similar. An example of this is the extremely popular Japanese manga artist Sazae-San, who has illustrated over 3000 comic strips, and is such a huge cultural icon that he has his own monument at Isono Park in Fukuoka. His work is considered manga, yet in many ways has more in common with cartoons such as *The Simpsons*. *Crayon Shin-chan* is another example of this.

The modern manga art form that you will be familiar with tends to be used on commercial projects and linked to shōnen or shōjo titles. Once a new series or comic is created they are quickly turned

into a successful TV series and toy range, etc. After this, the titles quickly migrate around the world and are enjoyed by other cultures.

Recognizable Features

But what is it that makes these recognizable as being manga in style? There is a mixture of different elements that are all recognizable in manga art and a lot of them have been mentioned already. Most manga characters have a strong sense of expression and a great deal of emphasis is put on the emotion portrayed by manga characters, in both quiet, solemn images and high-tempo action comics. Like ukiyo-e artists, most manga artists are not afraid to exaggerate parts of the character's anatomy in either subtle or quite extreme ways. They do this to demonstrate a particular part of that character's personality. One of the main

appeals of manga art to me is that there is a strong mix of realism and stylization, which gives the artist a lot of room for expression and interpretation, and offers plenty of opportunity to demonstrate their character's personality.

Manga Styles

Part of the success of manga and the reason behind its growth is the diversity of its origin. To understand the different styles that have developed under the banner of manga you need to have two things in mind: the demographic and the theme. The styles within manga are often tailored to meet the needs and wants of whatever age group or sex they are aimed at. If the images are aimed at young females, they will look totally different to if they are aimed at older males. Obviously the target audience will also affect the

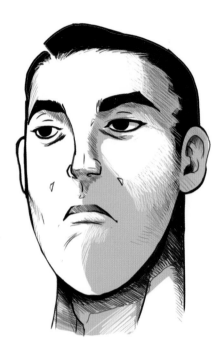

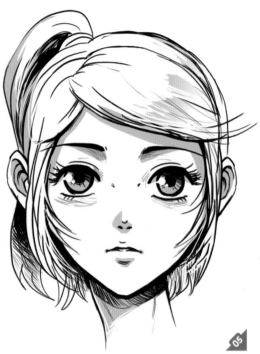

themes pursued and therefore the story. Again, if the product was a romance it would look very different from an action comic.

Some of these variations in style have specific names and can be identified as follows:

1: **Shōnen** – Aimed at young men. This type of manga is usually found in comics and animations that are adventure-, sports- or fight-themed. They tend to be visually dynamic and expressive, and the narrative is often fast-paced. In general, shōnen is the most easily recognizable style of manga and the one that most people will be familiar with. This is because of the success of some of the titles using this style (**Fig.01**).

Examples: *Dragon Ball* and *Naruto*

2: **Shōjo** – Slightly different to shōnen, in that it is aimed at young women and usually focuses on the romantic side of a dramatic story with an idealistic main character. A common subject matter would be a mixture of real-world events and fantasy worlds. Visually, shōjo characters look fairly similar to shōnen characters; however, because of the more relaxed narrative using this type of imagery, comics and animations like to dwell more on the general aesthetics of the fantasy world and the things in it (**Fig.02**).

Examples: *Berusaiyu no Bara* (*The Rose of Versailles*)

3: **Seinen** – Aimed at adults and usually males. This style usually lends itself to more serious themes and topics. An example of this would be something like a detective story

featuring serial killers, etc. Visually this style tends to be grittier and would probably not be recognized by most of the western world as manga. This style gives an artist a lot of freedom to experiment and try new things (**Fig.03**).

Examples: *Golgo 13* and *Tetsujin Ganma*

4: **Kodomo** – Aimed at children. This style tends to be used in humorous adventure stories. In some cases many of the elements of shōjo and shōnen are present, but they are always toned down. Aesthetically this style looks very friendly and the characters usually have rounded and cartoony heads. They don't usually look very detailed, but put great emphasis on expression and emotions (**Fig.04**).

Examples: *Doraemon* and *Hamtaro*

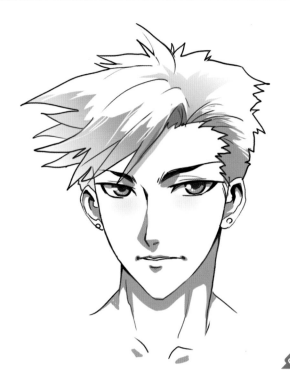

5: Josei – Aimed at adult women. This style looks as if it is an evolved version of shōjo that is aimed at a more mature audience. This style is usually used on projects with a cruder underbelly and is based on real-life events. Again, the stories adopting this style tend to be very idealistic and there is a big focus on the romantic relationship between characters. The stories tend to look at the deeper side of each relationship, which means that they don't always end happily (**Fig.05**).
Examples: *Paradise Kiss* and *Waru*

Manga Sub-Styles

Within each of these styles there are countless subsections and mixed styles that have developed over time. It would be impossible to list them all, but these are some of the more popular sub-styles:

1: Bishonen/Bishōjo – These are both styles that like to portray men as being very handsome and beautiful (**Fig.06**).

2: Maho Shōjo/Shōnen – This style is usually used on titles based on magical/fantasy themes, where the main character is a young boy or girl, and is aimed at a female audience.
Examples: *Cardcaptor Sakura* and *Sailor Moon*

3: Spokon – This is a style of manga most commonly used in sports-based titles. The characters depicted in this style often look almost like caricatures with a realistic twist and the comics tend to be humorous. The stories employing this style tend to be quite epic in nature.
Examples: *Captain Tsubasa*, *Slam Dunk* and *Noritaka*

4: Kemono – The characters illustrated in this style are usually cute, with very simple designs, and aimed at children. They often take animals and give them human characteristics, while still keeping large parts of their natural appearance. This style is particularly popular in the west (**Fig.07**).

5: Kemonomimi – This is a subsection of kemono, and in this style the characters look human, but have some features that you would find on animals, such as ears (**Fig.08**).
Examples: *Spaceship Sagittarius*, *Gon* and *InuYasha*

6: Mecha – This style is usually used in conjunction with sci-fi themes. Although the word "mecha" can be used to describe different types of images, it is usually associated with giant

robots. These robots often look a little vintage, even if they are set in the future. The artists using this style often make their robots look human, or even mix humans and robots.

Examples: *Mazinger Z*, *Gundam*, *Macross* and *Neon Genesis Evangelion*

7: Jidaimono – This style is used to depict historic events or stories set in the past. The stories usually consist of epic battles and the main protagonist is usually a samurai or Ronin warrior. This style can look far from realistic at times, as the main aim is to portray an ambiance and make the scenes look dramatic (**Fig.09**).

Examples: *Rurouni Kenshin*, *Lone Wolf and Cub*, *Samurai Champloo*, *Kamui Den* (*The Legend of Kamui*) and *Ikkyu*

8: SD or Super Deformed – This is not really a sub-section in itself, but more of a visual trend that is often adopted. Characters will sometimes be illustrated in a simple way, but with giant heads or other features. A further sub-section of this is chibi, which tends to feature small, cute, humorous characters that are often children (**Fig.10**)

9: Gekiga – Yoshihiro Tatsumi started this movement when he started to work on commercial comics in the early days of Tezuka. Tatsumi went on to develop this style years later. As this style was usually used in independent comics, it allowed the artists to try unique and new things, and explore different designs.

Examples: *A Drifting Life*, *Neji-Shiki* and *Adolf*

10: Gakuen – The titles using this style tend to be set in schools and the stories are based on high school life. This usually involves sports events, humor and drama. Visually there isn't really anything that defines this style.

Examples: *Harenchi Gakuen*, *Kimagure Orange Road* and *Kareshi Kanojo no Jijo* (*Kare Kano*)

11: Ecchi and Hentai – This is the erotic genre, which is often supposed to be humorous and crude. While ecchi is generally erotic and suggestive, hentai is directly explicit. This style is often used alongside different genres such as fantasy, etc., but the themes tend to be similar to those in gakuen. Visually the characters tend to have exaggerated proportions, in a suggestive way.

Examples: *Angel*, *Bible Black* and *Cream Lemon*

12: Yaoi/Yuri – The stories in this sub-section tend to be about same-sex relationships. Yaoi refers to males and yuri refers to females. The visual style is similar to that of shōnen and shōjo, but the theme is also regularly used in josei manga.

Examples: *Bronze*, *Maka-Maka* and *Revolutionary Girl Utena*

13: J-Horror – This is the Japanese horror genre and in many ways it is different to the horror that is popular in the western world. The main focus in this type of manga is building suspense and the themes tend to vary from supernatural horror to Japanese folklore (Yokai). There are also gory sub-sections within this, like ero guro-grotesque, which is very violent.

Examples: *Shōjo Tsubaki*, *Dragon Head* and *Uzumaki*

Introduction

By Gonzalo Ordoñez

Features and Expressions

By Gonzalo Ordoñez

Introduction

The most obvious place to start when learning to draw manga characters is the face. The face is one of the first things that you will learn to draw as a child, and at a young age you will learn what different expressions look like from your interactions with adults and other children. When you start to draw characters, this information will become very useful.

In manga art characters tend to be drawn in an idealistic way. That is why most characters appear young and healthy. It is this type of young character that we will look at first. You will find that there are some specific techniques and approaches that can be used and applied to all the characters that you draw, and it is these techniques that we will focus on.

Drawing Faces

We will start by considering how you should draw the face of both a boy and a girl. Most manga character's faces will start at a point where they all look fairly similar. Once you have established that starting point you can make small changes and add little details to show aspects of their personality and lifestyle, etc.

Let's look at how to create the face of the boy. The process starts with a simple shape and reference lines. The first thing that you should draw is a simple circle (**1**).

It is very helpful to use guides when drawing faces, so the next step is to draw a line straight through the middle of the circle to help you place features. Another guide that is useful to draw is the horizontal line, which should run just under halfway down the original circle. Again, this will serve as a reference to help you place features.

At the end of the horizontal line, draw the basic shape of some ears. These do not need to be detailed at this point. Depending

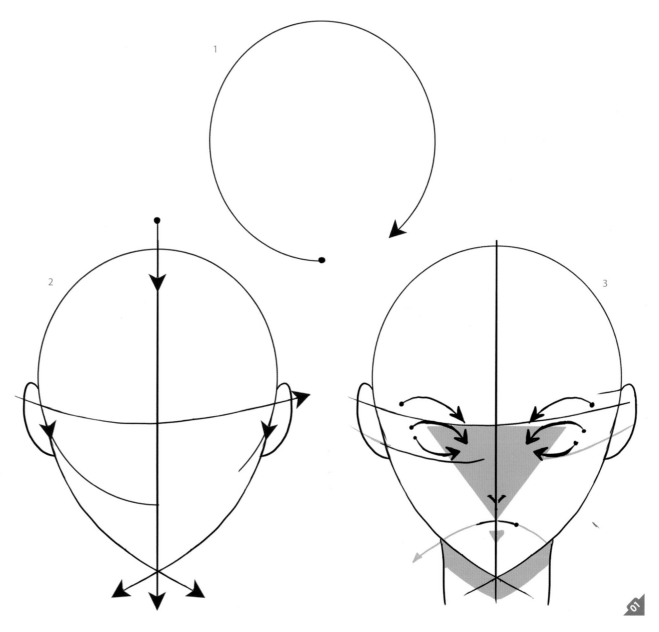

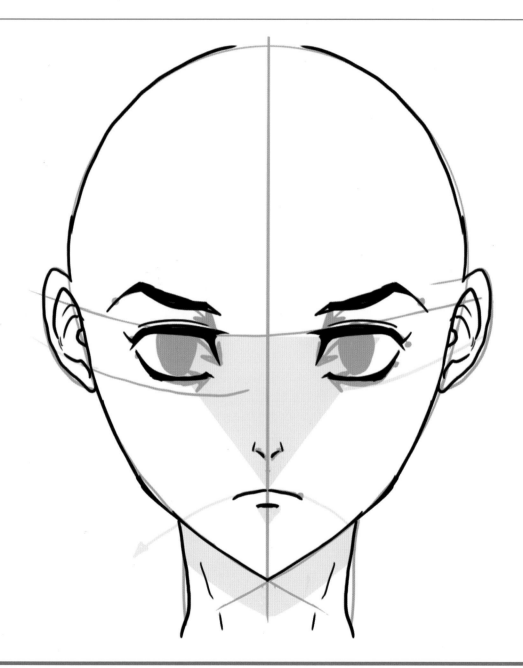

on the type of character you are drawing, you should then add the jaw line. As this is a young man, his jaw line is a simple curve that starts at the horizontal reference line and ends just below the circle on the vertical reference (**2**).

The eyes will be covered in more detail later in the book, but they should be marked on your drawing at this point. They can simply be marked with lines to show their position. You will see that they go just under the horizontal reference. A handy tool for positioning the mouth is to draw an equilateral triangle that originates from the center of the eyes. At the lowest point of the triangle, the mouth can be placed. This will give your characters a youthful look (**3**), although this approach won't be as effective on older characters. You can also mark the position of the nose and some guidelines for the neck (**Fig.01**).

The first steps were to help position the features. From this point we will be looking at how to clean up the image and draw the face. You may decide that you now want to continue your image in pen, so that it stands out over the pencil lines.

The ears can be detailed by simply looking at a reference and adding simple lines to demonstrate shapes. The eyes need more detail here and the best way to start doing that is to give them a thick upper and lower eyelid. The eyebrow can also be added and the pupils marked out for later. The neck and jaw line will require a little definition to show muscle tone, and some basic detail can be added for the nose and mouth (**Fig.02**).

You will see in the later example that the female character has a more subtle jaw line and neck. It is important to show this in your images to demonstrate the gender of your character.

At this point the face should look quite developed. It is always helpful to mark some guides for the hair before drawing the final version. Manga characters often have hair that demonstrates aspects of their personality, and in many cases this means they will have quite eccentric hair. Remember this when you draw your characters. Mark the hair out so that it just shows the basic shapes and flow of the strands (**Fig.03**).

The final step is to clean everything up and start adding extra details. When you add the pupil in the eyes, you need to decide where you want your light source to come from. The light source should always be obvious on the character's eyes to show that it is a reflective surface. Simple shadows should also be added to show some volume (**Fig.04**).

You will see that the hair is quite messy. This is to demonstrate the character's personality. Remember to give your character hair that suits his personality. Messy hair might show that they are a little rebellious; on the other hand, a bald head might show they are older, or some kind of monk. The story behind your character should always be demonstrated in their hair.

In **Fig.05** you can see how the same approach can be used to draw a female character. Virtually the same base can be used to create a new character.

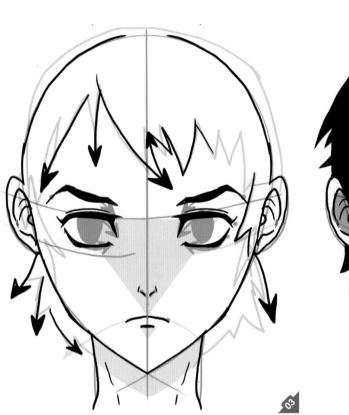

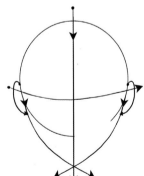
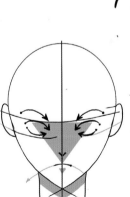
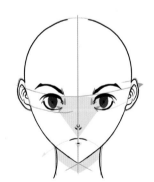
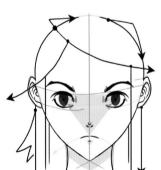
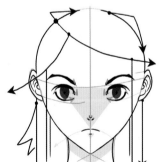

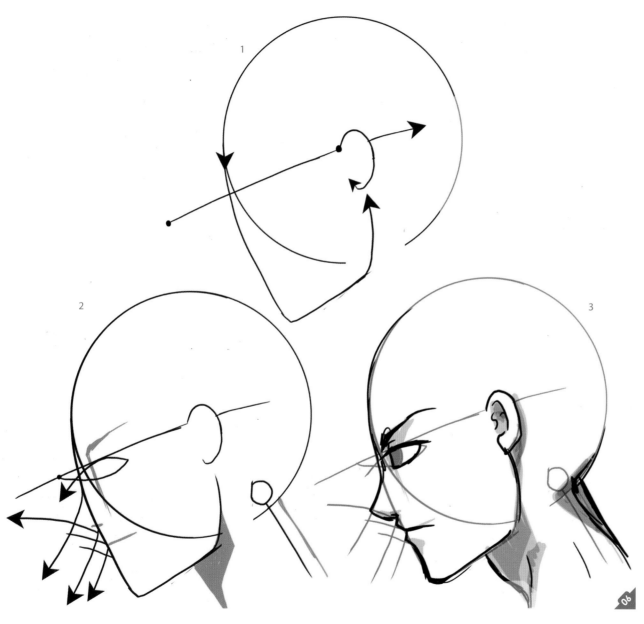

Drawing the Face from the Side

Drawing a face from the side is actually a very similar process to drawing it straight on. Manga artists tend to use a simplified version of a profile when drawing characters from this angle, particularly when it comes to drawing the nose and mouth. A detailed profile is usually only used when tackling an older character (**Fig.06**).

As you did earlier, start with the circle to show the shape of the skull. This will be adjusted later, but is perfect as a starting point.

The next step is to add the horizontal line again, but this time it will be tilted to show that the head is leaning forward. This will be used as a reference for the eyes later. The ear can be drawn on this line, just over halfway towards the back of the head. You will notice in real life that eyes are usually level with the ears, which is why you can use the same reference line. The last part of this step is to add the jaw line, which should come from the front of the face and wrap all the way round until it reaches the lower part of the ear (**1**).

Once this base is in place you can then start to add the eyes and mark out some other features. When drawing a face in profile the eye can be approached in a very similar way to how we did it before, however this time we will cut it in half. This means that you will also only see half of the iris. You will see in the image how you can use simple lines extruding from the character's profile to mark the shape and position of the nose and lips. You can also mark a reference on the neck to help you refine the shape of it later (**2**).

The guides are now in place and it is time to start refining them. A male's face has sharper features than a female's, so you can keep a lot of the sharp angles left from the guides in the image. Also, males tend to have a slightly thicker neck. You will see later how some of these features will differ slightly on a female example. Add some curvature to the neck and an Adam's apple to really show that it is a male (**3**).

As we did last time, the next step is to mark out the basic shape of the hair. Remember to make this reflect your character's personality. Again, the hair will differ on a female character (**Fig.07**).

The final step is to add the details and tweak everything until you are happy with it. This might involve you adding a slight curve to the jaw line and parts of the nose. Again, you can add shadow to show volume and refine the hair until you are happy with it (**Fig.08**).

In **Fig.09** you can see how a similar approach can be used to draw a female face. The main difference is that the lines on a girl's face tend to be smoother and curved, the neck is generally thinner, and the hair is obviously longer. A good technique to use when drawing a girl is to tuck her hair behind one of her ears, as this helps give your character personality.

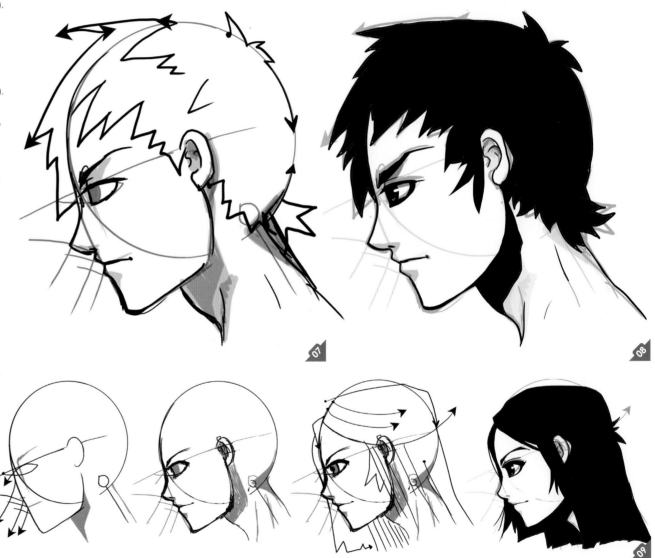

The Face from Different Angles

You will already know a lot of the basic skills that you should use when drawing a face. The next step is to consider how you can apply the same rules to draw heads that are posed or looked at from differing angles.

In many ways, the process you can use to do this is very similar to what we have already covered. You will continue to use a basic circle as a starting point, and then add the horizontal and vertical reference lines to it. Again, these reference lines will be used to help you place the features. The construction of the face is very similar; the only difference is knowing how to draw the features from a different angle. By drawing the chin or nose in a different way it will further demonstrate the angle that you are drawing the character from.

The angle and position of a character's head is really important as it will demonstrate the attitude of the character. A face looking up, with their chin raised, will look arrogant or defiant. On the other hand, a head facing down will look sad or thoughtful.

In **Fig.10** you will see an example of some different poses and their construction lines. It is important to not overlook the positioning of the chin as that will tell you a lot about the character. Also, notice how the neck muscles stretch and twist; this should also be seen in your images, particularly on males.

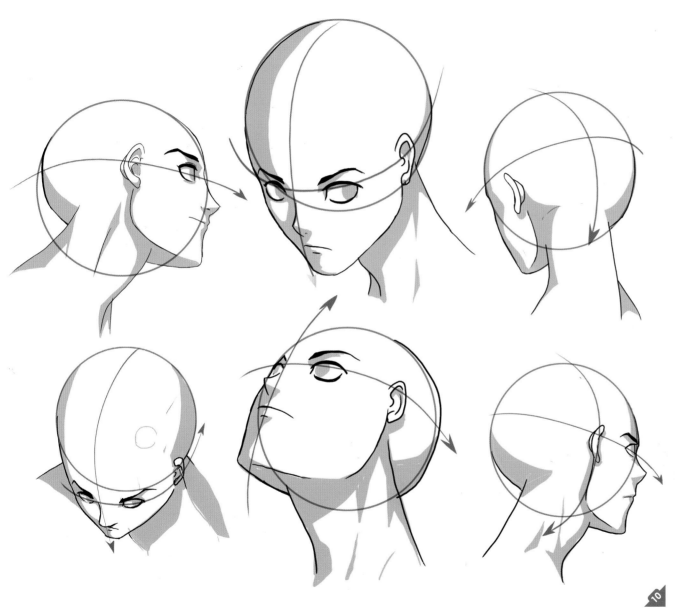

Detailed Faces

The examples that we have looked at so far have been quite simple so that the techniques can be demonstrated clearly. These rules can be applied to all manga characters, if used correctly. The important thing is being able to demonstrate personality and mix realistic features with the manga style. Once you have mastered this you can look at ways you can exaggerate the features to draw different characters (**Fig.11 – 12**).

In this image, the man has an older face. This will allow you to draw lines to show wrinkles, which will further demonstrate his expression (**1**). The same framework can be applied to him, but he should be drawn in a more realistic way, with stronger cheekbones and strong eyebrows. The mouth's shape is also very expressive.

The next variation is of a very thin man. He has a long face and forehead. Again, his cheeks and nose are very well defined. His face is very long and to make it look even longer, you can shorten the width of all of the features that run horizontally (**2**).

This character is clearly a villain. He has very small, narrowed eyes and a small nose. His mouth is very exaggerated and his teeth look sharp. His features are quite square to make him look like he is a tough guy. His neck is short and wide, to show his muscular shape. Unlike fatter people, his face is full of straight, strong lines. If you draw a character with a mouth like this it is important that you show the tension in his face in the corners of his mouth and his lips (**3**).

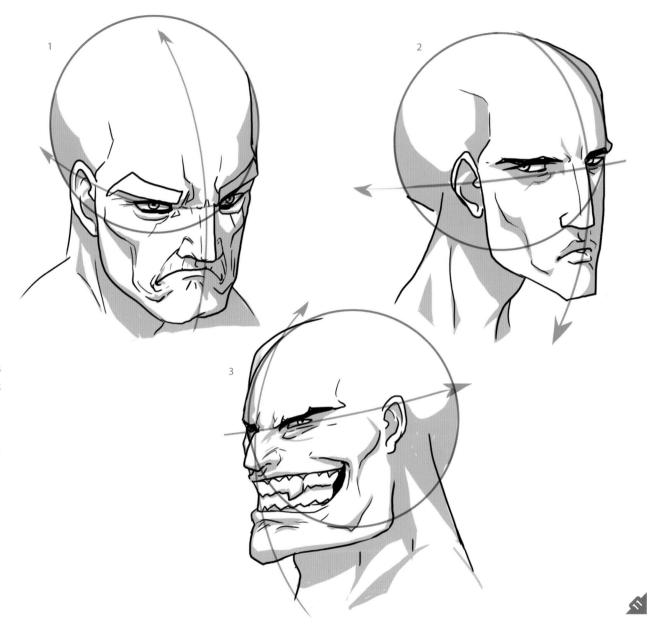

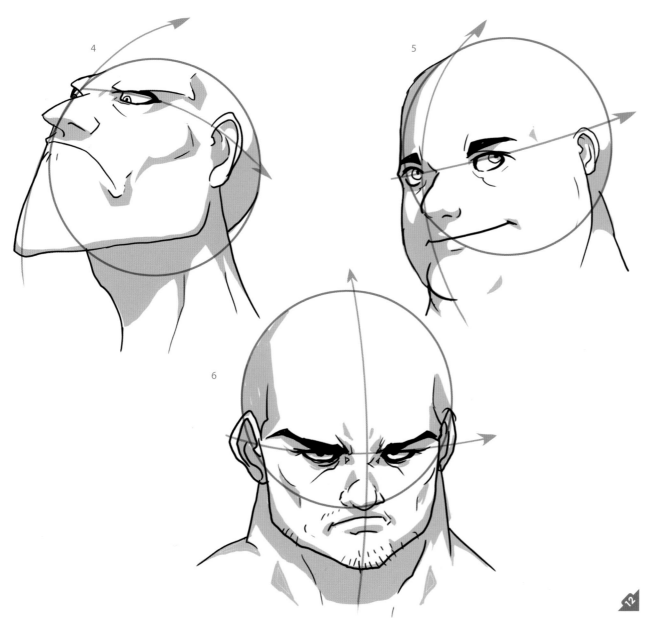

This example is of a man with much sharper features, and a very large and well-defined nose and jaw line. These long, drawn-out features help to demonstrate his personality. He would be a perfect villain (**4**).

This man is much fatter, which means that the lines used to draw him will be much smoother and more rounded. In fact, the only line that is straight on him is his mouth. When drawing fatter people it is important to make their faces look large, and to avoid drawing any strong cheek bones, etc. You will also notice how some of his jaw line has been removed; that is so it looks like his jaw is clearly rounded (**5**).

This guy looks a little like what you might call a "street boy". None of his features look subtle, his eyes are half shut, he is frowning and looking bored, which really adds to his personality. He has a wide chin and jaw line, and his face looks flat. He is very wide, but not necessarily as muscular as the previous muscular character. To add to his character there are a few signs of rough stubble, which make him look carefree (**6**).

Drawing Eyes

Eyes are perhaps one of the most iconic features of manga art. The eyes that are commonly used today have evolved from the way they were drawn by Tezuka years ago. The way eyes are drawn will vary between artists depending on their style of manga. The general rule of thumb is that rounder, cartoony eyes tend to be innocent young characters (shōnen or shōjo). Villains and evil characters tend to have smaller, thinner eyes.

Characters that are to be considered in a serious way tend to be drawn to more realistically. This is also often reflected in their eyes. The key in this kind of drawing is to carefully balance both realistic and cartoony elements. Let's look at some eyes and the approaches that you would take to draw them.

This is a classic example of a child's eye, the type that would be used in shōnen manga. You can see how to draw it by following the steps from left to right. You will notice that a lot of manga eyes have a very strong shadow under the eyelid, and you can see that in this example. Oddly, the pupil on this kind of eye is often oval rather than round (**Fig.13**).

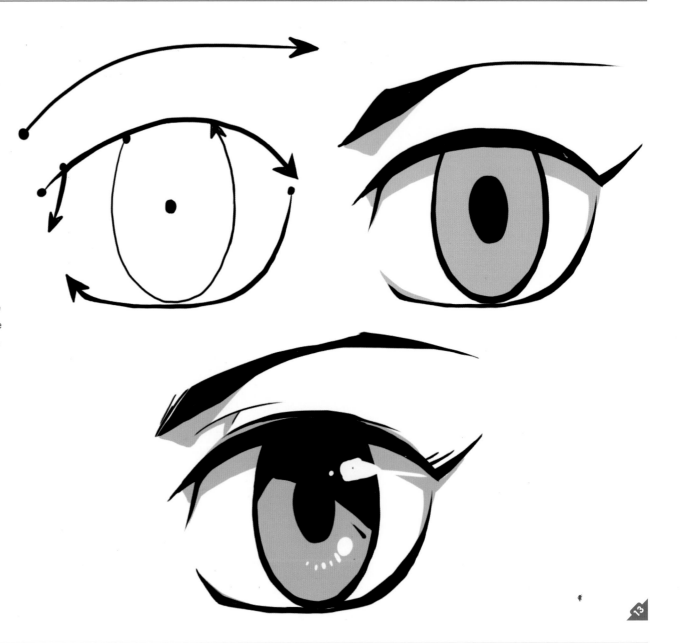

1

2

3

4

In **Fig.14** the example is very similar to Fig.13, but this time it is much flatter. As the eye is now flatter the pupil has become rounder rather than oval. This kind of eye is usually used on young adults. The approach to drawing this kind of eye is very similar to the first example, but it contains straighter lines and looks slightly more realistic (**1**).

The next example is even flatter than the previous two. By flattening the eye you will give your character a much more serious appearance, and they will begin to look more reliable and important. As you will see in the example, when the eye is narrower you will need to include more lines around it to show the tension and compression in the skin. Again, more straight lines are used (**2**).

This example is very different to the last one. It is a classic example of the eyes used in the shōjo style of manga. The eye is very wide open and the pupil is oval. The reflections on eyes like this tend to be very exaggerated. This kind of eye is very simple and is often used for the protagonist in stories (**3**).

A variant of the typical shōjo eye can be seen in the next image. You will notice how in some ways it resembles the eye of a cat. This is quite common in manga art and worth keeping your eyes out for. The pupil tends to be less oval and flatter. Also the line around the pupil tends to be more defined and exaggerated (**4**).

Each of these examples can be created by simply following the steps from left to right. Start by drawing the basic construction lines, then add the details, refine it and add the highlight.

14

Drawing Eye Expressions

I am sure you have heard the saying "eyes are the windows to the soul." This saying obviously reminds us that people can tell what we are thinking or how we feel by looking at our eyes. However, this saying is not just restricted to the eyes. It is also the position of the eyelids and eyebrows that help to demonstrate how we feel.

The way eyes portray your feelings is universal. If you open your eyes wide in shock it will be recognized across the world. Screwing up your eyes in pain would also be recognized by every nationality. This show of expression from the eyes is very important in manga and comic art as it can tell you a lot about the characters.

There are different parts of the eye that will change to show emotion. This could be the eyebrow, the pupil and iris, the eyelids or the size of the eye itself. By adjusting or moving around each of these things you can change the emotions demonstrated by the eyes of your character. Through the following examples you will see how each of these elements can be adjusted to demonstrate a different emotion.

Resting Eyes

This example shows eyes that demonstrate that the character is resting. There is nothing going on that is causing them any stress or extreme emotion. You will notice that the important features here are that the irises touch both eyelids, and there are small lines on the upper eyelids showing there is no tension in them and that they have folded naturally (**Fig.15**).

Anger

When portraying anger, the shape of the eyes doesn't actually change. The important changes here happen with the eyebrows. The eyebrows are lowered towards the center of the face, and stress and tension lines are added to show the muscles are pulling the eyebrows down (**Fig.16**).

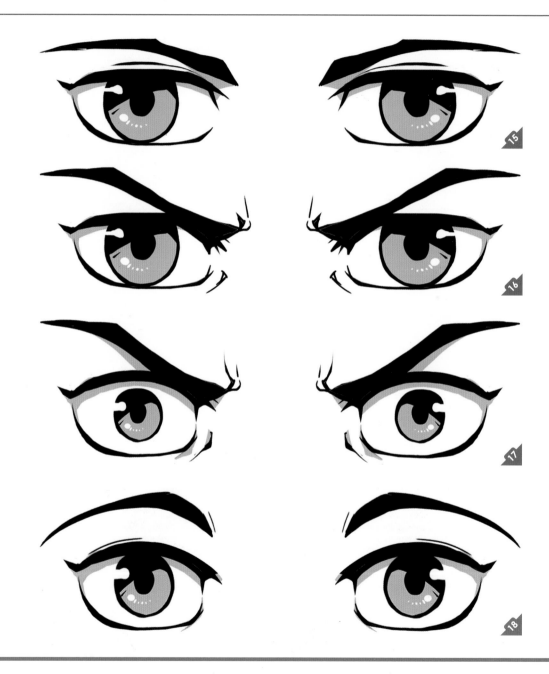

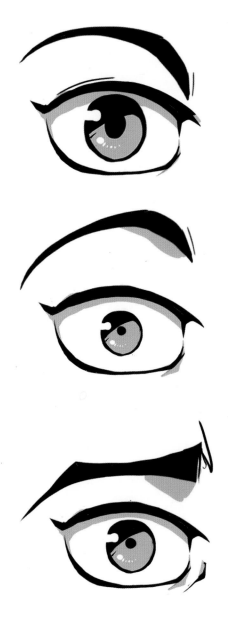

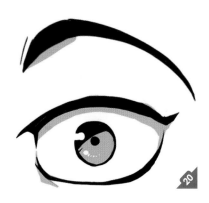

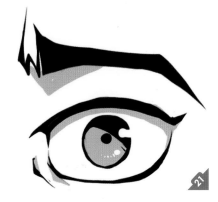

Wrath

Wrath is an extreme form of anger and in many ways, a more intense version of it. The changes that occur here are that the eyes are enlarged and the irises made smaller to give the eyes a dramatic appearance. The eyebrows will appear the same as they did in the example of anger (**Fig.17**).

Attentive

In this example the eyes are focused on something and the character is paying close attention to whatever they are looking at. The irises are fairly average in size again, but this time they only touch the top eyelids. Also, in this example, the eyelids are more arched (**Fig.18**).

Very Attentive

This is an exaggerated version of the previous expression. As this example is an extreme one, the irises no longer touch the top eyelids and the eyebrows are arched even more than before (**Fig.19**).

Positive Surprise

When you are surprised your eyes usually appear to be wider open and therefore the irises will shrink again. The irises should be placed in the center of the eyes. Again, the eyebrows should be arched and there will not be any tension lines as the skin will be stretched out and smooth (**Fig.20**).

Negative Surprise

In this example the eyes stay very much the same as they did in the positive example. The change here is that there is more tension and concern in the eyebrows, meaning that there would be some grouping of the skin and some tension lines should be added. The pupils should also be shrunk slightly (**Fig.21**).

Sadness

In many ways, this is the same as the eye which was at rest. The only change that needs to occur here is the shape of the eyebrows. The eyebrows should be dropped in this example and should curve upwards. The lines that were on the upper eyelids in the resting example should also be removed (**Fig.22**).

Deep Sadness

Deep sadness is similar to the sadness example. The changes are that the eyelids have fallen about a third of the way down the eyes, which gives you the opportunity to exaggerate the upwards curves of the eyebrows. This will mean that you will need to show the crease of the upper eyelids (**Fig.23**).

Panic

When someone experiences panic, a lot of their features are exaggerated. The eyes will become almost circular and there should be plenty of lines to show skin tension (**Fig.24**).

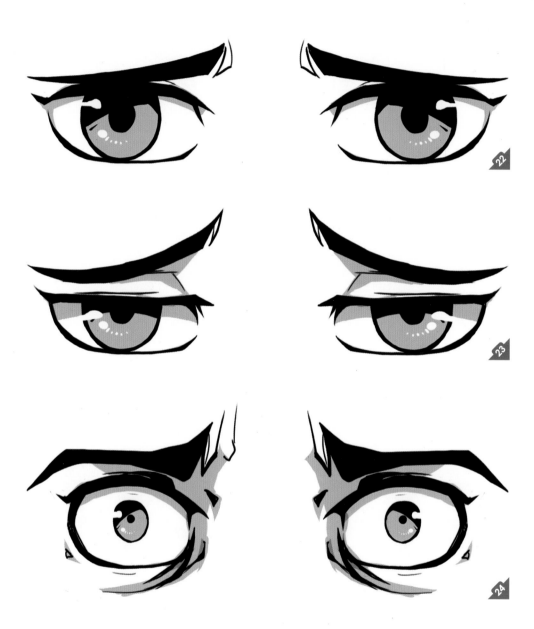

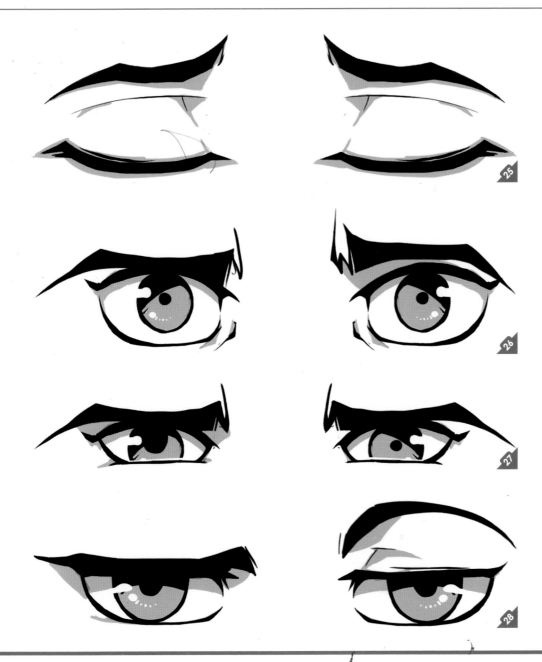

Closed Eyes

Eyes of this type can be used to show someone asleep, or who is meditating. The thing to remember is to show the shape of the upper eyelids around the eyeballs (**Fig.25**).

Uncertainty

This example is like a variant of surprise, as uncertainty and surprise are quite similar. The eyebrows change in this example and come down to touch the top of the eyes to make them look more focused (**Fig.26**).

Despair

This expression is usually seen when someone is really distressed. It is often an instant reactive expression. To accentuate this, the eyes should be flattened and the irises covered by both the top and bottom eyelid. The eyebrows should also be dropped dramatically. The pupil sizes are also important. A small pupil will show sadness in despair, while a large pupil will show extreme shock. The highlight is also important here as the eyes should look watery and almost teary (**Fig.27**).

Ambiguity

This feeling gives you an opportunity to break symmetry as there are often mixed emotions seen in the eyes with this emotion. In the example you will see how that is shown with the position of the eyebrows and eyelids (**Fig.28**).

Anatomy and Poses
By Gonzalo Ordoñez

Anatomy Proportions

The way that anatomy is drawn has gone through several changes over the years. Cultures throughout history have drawn the human figure in many different ways. A classic example of this is how the Egyptians, Greeks and Romans stylized the anatomy of people in their art. This can be seen throughout the art of cultures all over the world, and has developed throughout history. Japanese art is no exception to this.

You may be wondering why we started by drawing the face and head rather than the body. The head represents one eighth of the body, but in many ways will help set the base for the rest of the character. The face and head will act as the reference to help you define how the body should look. Everyone is different and their bodies will differ in proportion depending on their age, sex and even what part of the world they are from. However there are some rules that can be applied as a guide, and what is useful is that they all rely on the size of the head, which would have been drawn first. These are three of the rules you can use:

The Seven and a Half Heads Rule

This is the most common rule and can be applied to most people. This rule states that the character's head should be the same as seven and a half heads.

The Eight Heads Rule

This rule can be applied to athletic-looking adults. The body's length would be the same as eight heads.

The Nine Heads Rule

If the body is nine heads long, this usually means that the character is a superhero and the artist drawing him is trying to demonstrate his physical power.

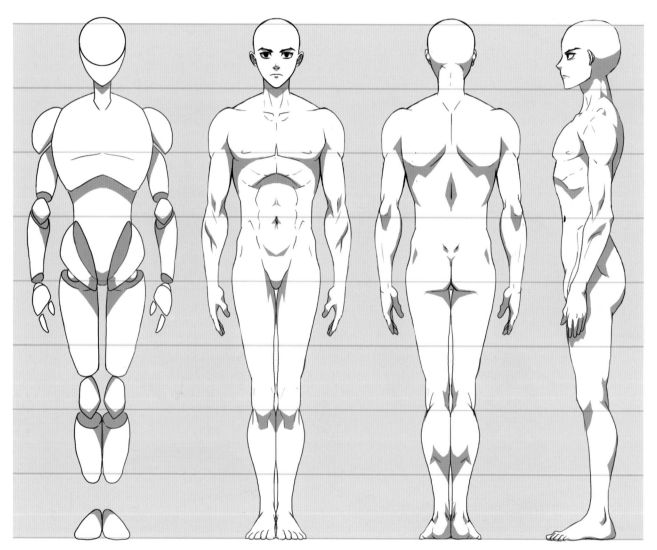

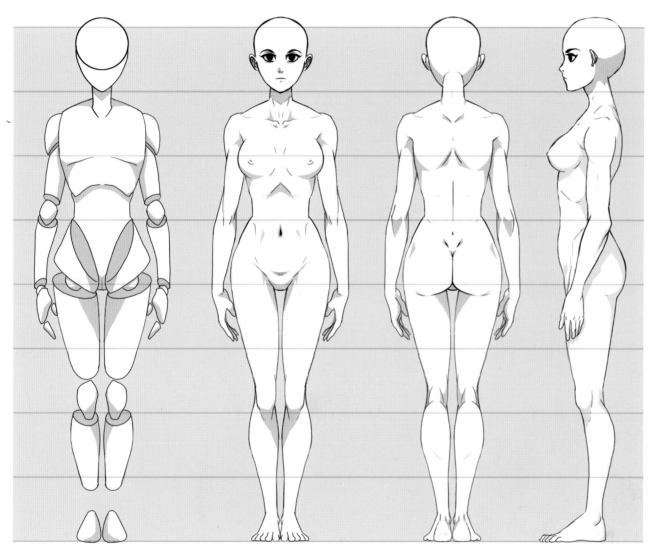

These rules can vary depending on age. For example, a one year old child's height would consist of about four of its heads, but by the time it is five its body would be about the size of five heads. A child of between five and ten would be about six heads high, but then any older than this and the character would be made up of seven heads or more. The only exception to this is elderly people, who tend to get smaller as they get older.

In **Fig.01 – 02** you will see a male and female example of a body that is eight heads high. The following breakdown will explain what should feature in each of the sections, starting with the head:

- **Head 1**: The head from the top down to the chin.
- **Head 2**: The neck and the chest.
- **Head 3**: The lower rib cage and the top of the abdomen.
- **Head 4**: The lower abdomen and the top of their hips. The forearm should also be in this section.
- **Head 5**: The hands and the upper section of the thigh.
- **Head 6**: The lower part of the thigh and the knee.
- **Head 7**: The shin.
- **Head 8**: The ankles and feet.

Using the Rules

When you are marking out your character, you can simply start by using shapes and lines to mark out the proportions and volume of the individual parts of the body. This will help you to follow this proportion guide without getting bogged down with detail. When you are doing this it is important to remember that men have wider backs and more muscle mass, while women have bigger hips and a softer, curvier shape.

Although these rules work and can be used, don't forget that they can also be manipulated to further demonstrate the cartoony nature of your images, if you are creating that style of art. The most common of these adjustments is to make the head a little larger.

Posing

Making it look like your character is moving or posed creates a new challenge. This time, we don't only have to draw accurate anatomy, but also need to give movement to our characters.

When you imagine a character you usually think of a basic standing pose. When you think of a character standing still you will picture something that looks symmetrical and which doesn't give you the impression that they are moving (**Fig.03**). This is because there are only two directions of movement: horizontal (along the hips and shoulders) and vertical (up through the legs, arms and neck).

To make the pose seem more natural and comfortable the symmetry needs to be broken slightly. The straight lines can be maintained, but by tilting them slightly it will make the character look more relaxed and natural. Once you have done this you will also need to demonstrate the tension in the muscles, which will be different if the character is leaning over. You can tilt and adjust the vertical and horizontal lines by raising or lowering the shoulders and hips, and by slightly bending some of the joints. By doing this you will give your character personality and a more natural look (**Fig.04**).

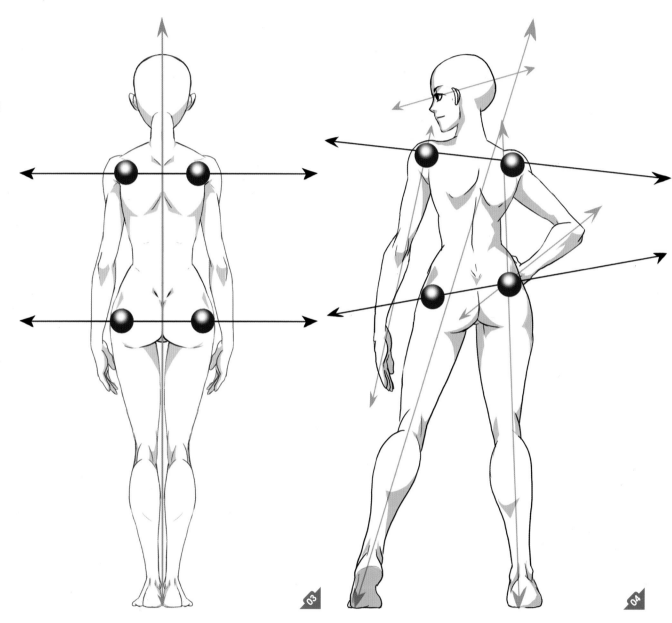

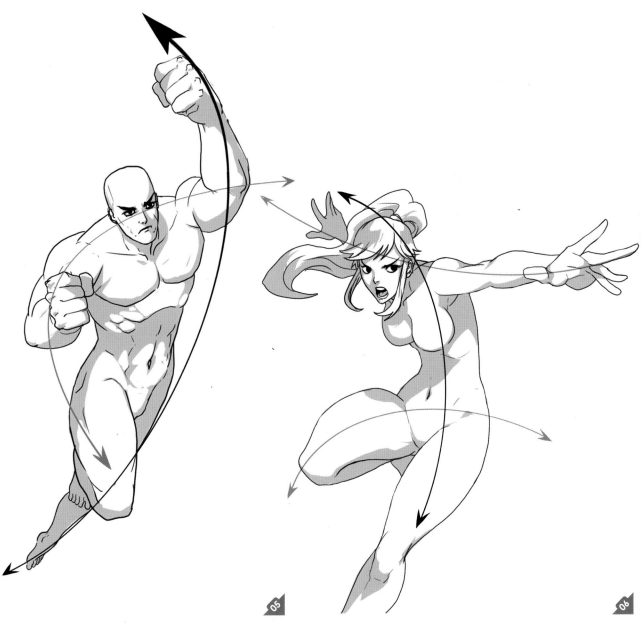

In **Fig.05** you can see a different and more dynamic example/ By changing the angle the character is viewed from, and using dynamic curved lines, you can create interesting poses that give the impression of movement. In the example you can see that parts of the character are moving towards the viewer. To make this look authentic and believable you will need to make features like the character's hand and arm look slightly bigger, so it appears that they are nearer to you. This is called foreshortening. The best way to do this accurately is to use references.

In **Fig.06** you can see another example of a character in a dynamic pose. This character consists of dynamic curves again, but also has limbs that spread out in different directions. This example also employs foreshortening, as well as curved lines that demonstrate movement.

The more complex your character is, the more curved or varied lines you will see in their pose. The best way to use these lines is to implement them at an early phase when you are drawing the basic structure of your character.

Clothing
By Gonzalo Ordoñez

So far we have looked at how to draw a character's basic anatomy, but without clothing on this character will be almost useless. The clothing will not only protect the modesty of the character, but will also tell you something about them, like where they are from, the era they are based in, what they do for a living and even what they are like as a person. Over time you forget how important clothing is as you are so familiar with it and the way it changes throughout history, but clothing is vitally important when drawing and designing people. Drawing it well will really help you define and fully demonstrate the nature of your character.

For this demonstration we will further develop the character that was sketched when looking at poses. Usually when you create a sketch you will start by marking out the shape of the character's body as a base on to which you will be able to add further details. It is important that you approach the process like this to make sure the structure under the clothing is correct.

The starting point is the structure that we mentioned previously (**Fig.01**). To your base you could add some simple details like the underwear. You may think it seems strange to draw this as it won't been seen later, but it is important to consider it as tight-fitting underwear might cause the character's shape to change slightly around areas like the hips. These details are minor, but add realism (**1**).

The next step is to start to add some simple lines to demonstrate the shape and design of the clothing. In this example I have gone for a sailors' uniform that is similar to a school uniform. This is very typical in manga art. When you draw these lines consider the effect gravity has on material and how there could be a breeze that moves the clothing. A reference can be used to do this. Also remember to use interesting contrasts in the clothing: use a mixture of loose and tight-fitting clothes (**2**).

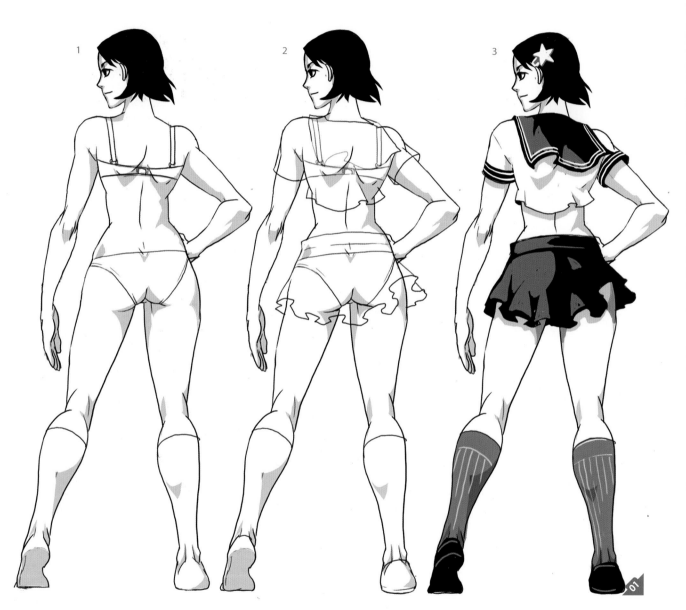

The final step is to add details like the shadow to demonstrate volume and the form of her body under the clothing. It is also important to add little details to make her appearance interesting, like the star in her hair. Also try to think about how you can hint at the textural look of some of the clothing. These kinds of detail will hint at elements of their character (**3**).

Over the last century fashion has changed drastically and therefore the characters that have been drawn will look very different. When you draw characters from different eras you can still apply the same technique and process as described previously. When drawing characters like this, try to think about what people would have worn at the time and reflect that in things like their hair. The final thing to remember is that you should use the hair and clothing to further illustrate the personality of your characters (**Fig.02**).

Character Design
By Gonzalo Ordoñez

Basic Shapes

When you were a child you doubtlessly looked at clouds and saw shapes and familiar forms that you thought looked like animals, monsters or even people. The reason that you would see these in clouds is that the human brain has the ability to recognize abstract forms and instantly associate them with other things that you are familiar with.

The truth is that you don't need a lot of detail within form to communicate a message. The detail is for once the viewer is focusing on something specific. If you look at **Fig.01** you will see on the left a detailed picture of a man. This is clearly a man and you could even guess at his age. The image to his right is clearly not detailed and simply shows the rough form as a silhouette. You can't see the details, but it is clear that it is a man. As we mentioned at the beginning, our mind sees things and draws associations even without the detail. By adding some minor detail to the silhouette of the man it can be changed quite drastically and the picture in our head will also change.

So it's clear that basic shapes can ignite images in your head. If you start your process with these shapes it can help you generate ideas and develop character designs. Start your process by creating random unique shapes, trying to find something original and that sparks your imagination. Don't be afraid to use quite extreme shapes as this will help you create interesting designs.

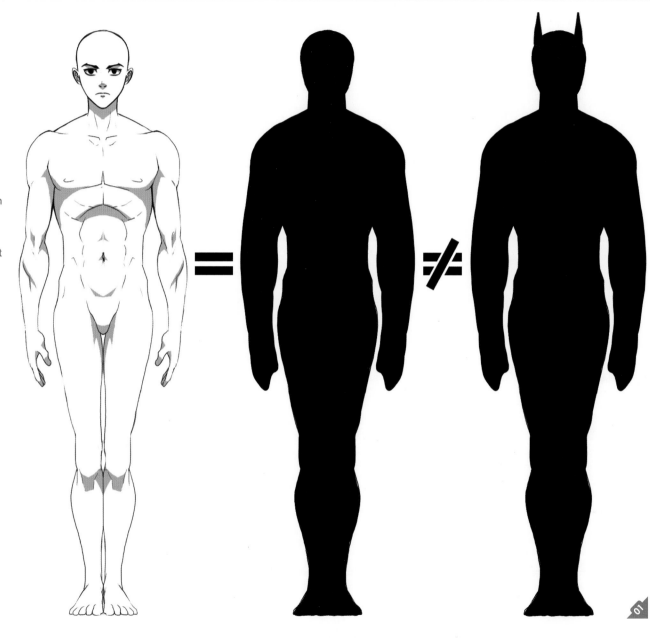

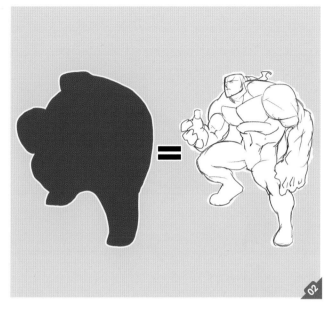

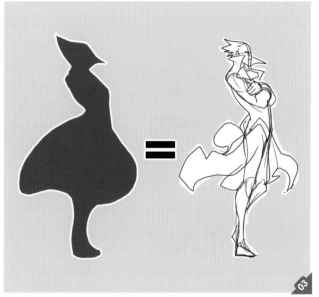

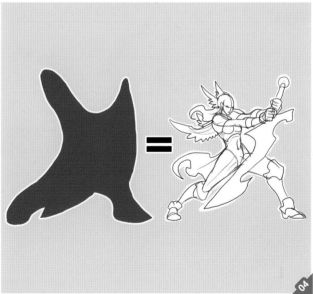

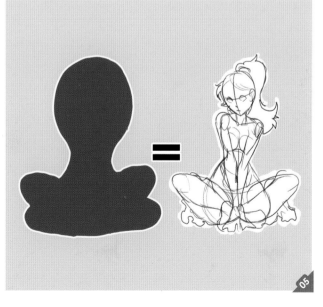

In **Fig.02** you can see an example of a character that started with a large circle and that has been adapted with big, bulky shapes. This pointed my mind towards a bulky, heavy character. Once the image is in your head you can start to think about how you want to draw the character, so in this case I drew a large upper body and arms, and small legs and head.

In contrast, **Fig.03** shows a character that is exaggerated in a different way. This shape is tall and thinner, implying that the character will also be this way. The basic shape, in many ways, started off looking a bit like a bird, but within this shape I could see a character wearing a big and baggy coat. With this information I could start to draw the character using the details that were imagined within the form.

In this shape it becomes slightly harder to visualize forms (**Fig.04**), but the curved shape gives the impression of a curved sword, and the two shapes coming from the bottom of this look like legs, so that can form the base of the character. Once you have an idea of the form of the character you want to develop, you can start adding the details and focusing on the shapes that you want to develop to create your character.

This final example may look like a tricky one to develop further. The shape doesn't have any obvious feet or obvious base, which means that a little imagination is required to develop it further. There is symmetry in the shape meaning a front view would work best. The way this shape was developed is to use the shape at the bottom to make it look like the girl is sitting down cross-legged. The space above would obviously house her upper body. To this frame, the details can be added (**Fig.05**).

A Step-by-Step Approach

Once you have used your "random shapes" approach to design a character, you need to know how to develop it further. I will now

demonstrate an approach you can use to develop your sketches and designs while only working in basic black and white colors. Throughout this book many more techniques and approaches will be demonstrated and explained, but here I will explain the approach I use to create my digital illustrations. This approach is widely used in the cartoon and advertising industry as it produces a very neat and clean final product. This approach is also very popular within the field of publishing. Digital and traditional tools are all useful when creating manga art, but for the purpose of this demonstration I will be using Photoshop due to its clean appearance.

The first step is to create a sketch using techniques covered previously (**Fig.06**). Generate a design and then develop it using the information about anatomy and the different features. Feel free to do this as loosely as possible at this point as everything will be refined later. Try to also think about composition and how you want your final image to look. Use grays to demonstrate the form of certain elements, and separate the clothing and the skin of the character. By doing this at an early phase it will make it easier to see where you need to refine the image.

Once you are happy with your base you can create some simple line art. If you are using traditional techniques you can do this with a fine pen; if you are using Photoshop you can do it with a brush about 3 pixels wide. Later this will be painted over when the shadows and volume have been added. Very little of the line art will be visible at the end of the process (**Fig.07**).

The next stage is to begin to correct any mistakes that you have noticed. Once you are happy with the shape you can then mark in the darker shadows. Try to think about how the shadows will look and start by working on the darkest areas, which you can add with large areas of black (**Fig.08**).

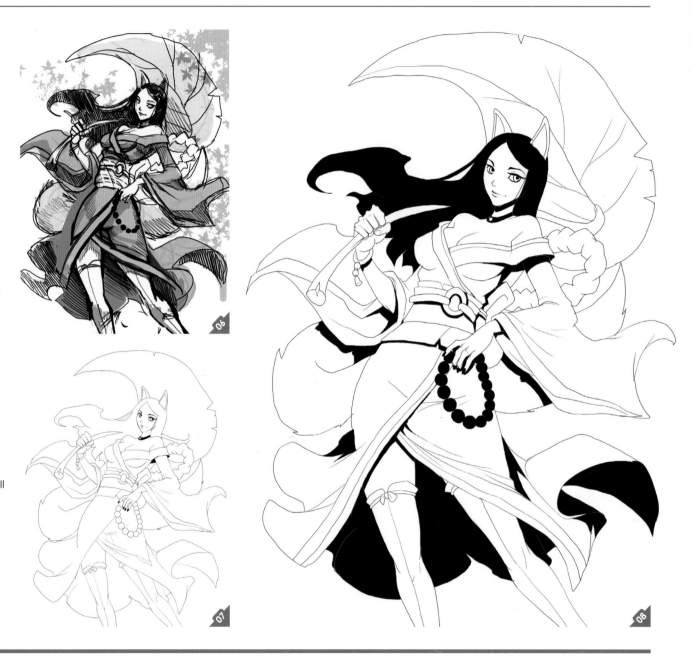

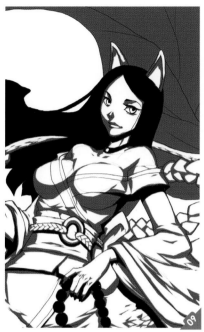

Once the darker shadows are established you can start to think about the lighter shadows that will demonstrate the volume and form of the character. Doing this digitally in Photoshop will really help as you can set the shadow layer to Multiply mode and tweak the opacity until you are happy. If you don't work with Photoshop it is best to test your grayscale colors on a separate page to make sure you are happy with them. When you start to add the shadows, try to think about the body's shape, the character's muscles and the way the material folds (**Fig.09**).

There is a trick you can use when creating a grayscale image digitally that is really helpful. Create a separate layer and go to Filter > Sketch > Halftone Pattern. Once you have selected this you will find some options. The size settings adjust the size of the pattern you apply and Contrast will adjust the contrast in the colors below this layer. Set Pattern Type to circles and dots (**Fig.10**). Play with these options until you are happy with how the image looks. When you are happy you can accept the changes and start to erase areas that you are not happy with. You can also lower the opacity of this layer if you feel the effect is a little too strong.

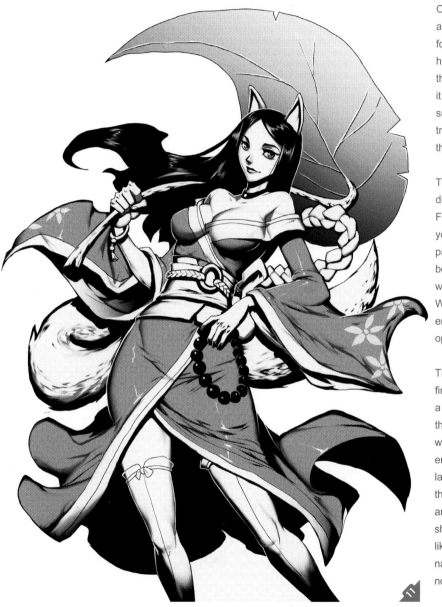

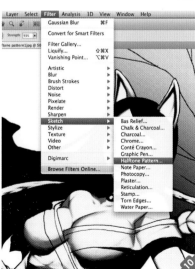

The final step of the process is mainly to retouch the image. To finish the image you can add a new layer set to Multiply and add a gray color to all of the clothing to separate it from the skin. Again the opacity of this Multiply layer can be tweaked until you are happy with it. You can also use the Pattern effect we used earlier to further enhance the clothing. Using an eraser or white brush on a new layer, you can then add things like rim light or strong highlights in the appropriate areas. Rim lighting is really helpful when separating areas, like on the legs where they now stand out from the dark shadow under her clothing. If you use strong highlights on places like the hair, you can use the Smudge tool to make them look more natural (**Fig.11**). So that is how you design and paint characters – now it is your chance to give it a go!

Designing Characters

With the foundation skills in place I'm sure you are keen to get stuck into designing and drawing your own characters. It can be difficult knowing where to start when tackling your own illustration. Should you do a male or female? Should you draw the head first then the body, or vice versa? In this section, skilled manga artists will be sharing their creative processes with us, demonstrating how you can approach drawing characters and discussing the tools and techniques that can be utilized to generate your very own manga masterpiece.

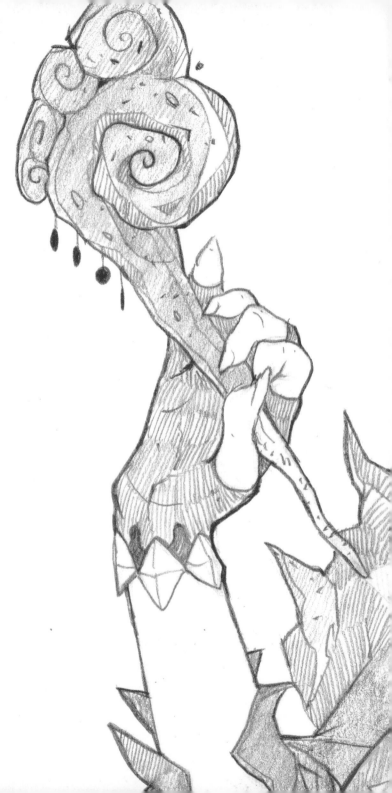

Drawing the Barber
By Israel Junior

Introduction

The design of a character starts before you pick up a blank sheet of paper and your pencil. It starts in your head. Before you start sketching ideas try to imagine the characteristics that you want to feature in your illustration. Having a good idea is the best starting point that you could have. You should start the drawing process by asking yourself the following questions:

- How old is the character?
- What is their gender?
- What do they do?
- What kind of personality do they have?
- What time period are they from?
- What kind of clothes do they wear?

Answering these questions for yourself is important as it helps to set a solid base for your illustration, and helps you focus on the important features that you want to show off to the viewers.

Tools Used
- Paper (roughly 180gsm)
- Pencil

Creating the Picture

When you have this solid base in your head you can move on to the picture. The first step is to find some suitable paper. I would suggest something slightly heavier than normal printer paper, maybe something around 180gsm or more. The next step is to choose the type of pencil you would like to use. I use a 0.5 mechanical pencil as it is good for small details, but you could simply use a standard HB pencil and a rubber if you choose.

As I started to draw I thought about the character I had imagined earlier when answering the questions I posed myself. I decided to draw a draw a girl posing on a barber's chair (**Fig.01**). I decided

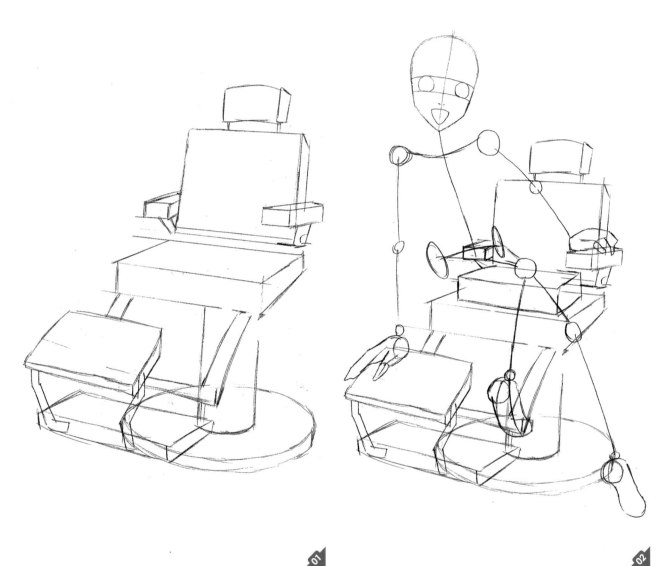

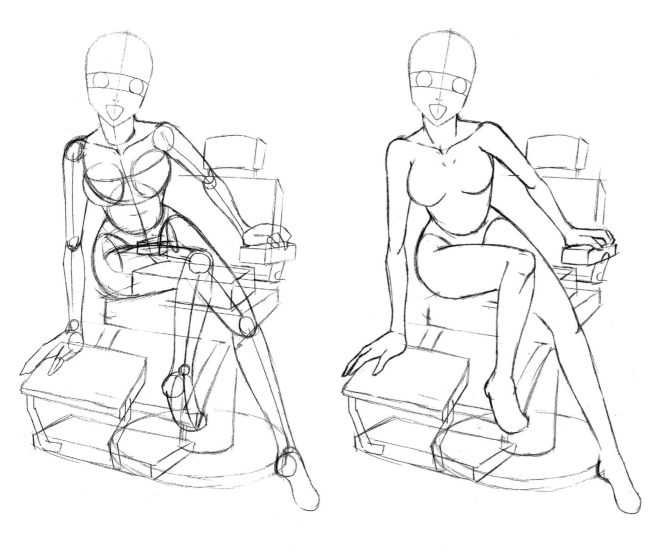

that it would be set in a fairly modern time and that she would be a fun-looking girl. Because of this I started by drawing a basic chair to set the base for my image. You might want to start by drawing something relevant to the character that you have in your mind.

With a pencil in your hand, try to imagine the body of your character as a skeleton or a wire frame. Draw the shape or frame of your character in its simplest form. While you draw the base frame try to consider the proportions of the character and how you can portray their personality in their pose. Always consider the idea that you began with at this stage; their frame and pose should further demonstrate the kind of character they are and what they do (**Fig.02**).

Artist's Tip: Changing Sketched Lines

When drawing the chair and the frame of the character, remember to use faint and delicate pencil strokes. You should be able to change anything that you don't like at this stage quite easily, and if you need to you can simply rub something out and start again. When you are happy with your drawing you can start to give your pencil lines more weight.

The next step is to add meat and volume to your character. This step is not about adding details, but is just about thinking about the correct body volume and the area on the body where there is more mass (**Fig.03**). Manga art is not about capturing all of the details and complex shapes of the human body, but it is about focusing on the simple forms. Observe real people to help you fill out the basic forms of your character.

Once you are happy with this you can rub out your initial sketches and frame lines so you are left with a shell ready for detailing (**Fig.04**).

The next step is to add the facial expression to your character, which has already been demonstrated in an earlier section of this book. Remember to try to choose a facial expression that demonstrates the characteristics you identified earlier.

At this stage you can also start to think about the character's clothing. Drawing believable folds in clothing is not easy, so I would recommend finding some similar clothing or photographs of clothing and drawing it from a reference (**Fig.05**).

Artist's Tip: Drawing Hair

The hair is another difficult part of the image. Sometimes when you draw hair it can seem flat and lifeless. The way I draw hair is to first practice on a separate piece of paper by moving my forearm for the long flowing lines and just my wrist for the smaller flicks of hair. If you practice this approach you can create some more natural and interesting curves.

When you are happy with your sketch you can start to remove all of the sketchy lines you created earlier. This will leave you with a clean and easy to follow sketch for when you start the inking. I mark all the areas I want to fill with black with a small X (**Fig.06**).

Before you start the inking of your character you need to decide on the tools you want to use. If you have worked in a large format you could find a good water resistant felt-tip pen with a brush nib. For a starter however I would suggest a simple ballpoint pen for most of the lines as it is easier to handle and you will probably be most used to this kind of thing. To make sure you don't smudge your drawing, rest your arm on a piece of paper.

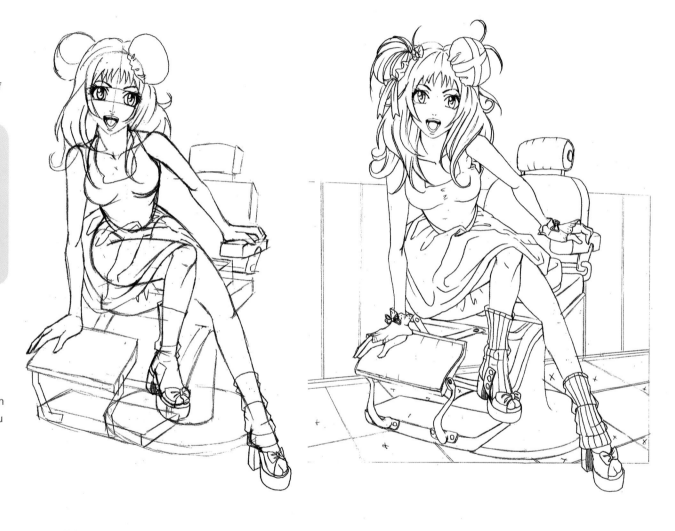

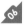

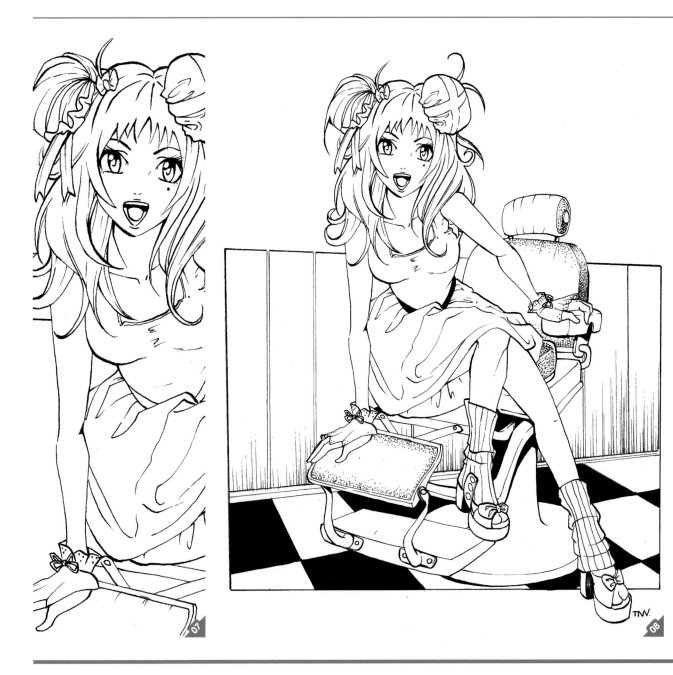

Again, before you start the inking I suggest you practice how you are going to draw your lines. You can use the same technique as you used on the hair to do the inking.

Many people make the mistake of thinking that inking is simply drawing over lines, but to make the image look more interesting you really need to add some weight to the lines by varying their thickness. You can see how I have done this on my drawing in **Fig.07**.

When it comes to drawing smooth curves you can use French Curves. If you are unfamiliar with French Curves, they are a simple tool that consists of a variety of different smooth, curved faces. These faces can be shuffled around your drawing to help you achieve the desired effect. One thing I would warn you about is that the ink can get stuck to them, making it easy to smudge your image, so make sure you wipe them clean regularly. You can also use a ruler when drawing straight lines.

After you are happy with the inking, you can fill in the areas you wish to have black and wait for the ink to fully dry. Once it is dry you can erase the remaining pencil lines and your drawing is complete (**Fig.08**).

Drawing Ayaka the Zombie-Slaying Idol Singer

By Steven Cummings

Introduction

One of my favorite tasks is getting to take an illustration from a concept through to a finished color image, especially when I know I can do it all by hand.

When I was asked to design a character I thought I would try and take something that is typically Japanese and meld it into my character. There are few things more unique to Japan than idol singers, so I took that as my starting point. But an idol singer just singing is kind of boring, right? So what if instead of her normally adoring fans she was suddenly faced with vacant-eyed, brain-craving zombies trying to rush the stage at her concerts? Bingo! There is my hook! Ayaka the Zombie-Slaying Idol Singer is born!

Tools Used

- Pencil
- Manga paper, paper for sketching
- Brush pen

Character Design

The first thing to do is make a rough sketch of the character (**Fig.01**). At this point you should not be interested in fine details, you just want to get the basic idea down on paper so that if you are happy with it you can move on to making a cleaner sketch of the character.

Artist's Tip: Design Thought Process

When you start designing your own character, I suggest spending a decent amount of time thinking about how you want your character to look before starting work on the final image. With this done you will have a better idea about how you want your final character to look and you may have discovered new ideas you didn't have previously.

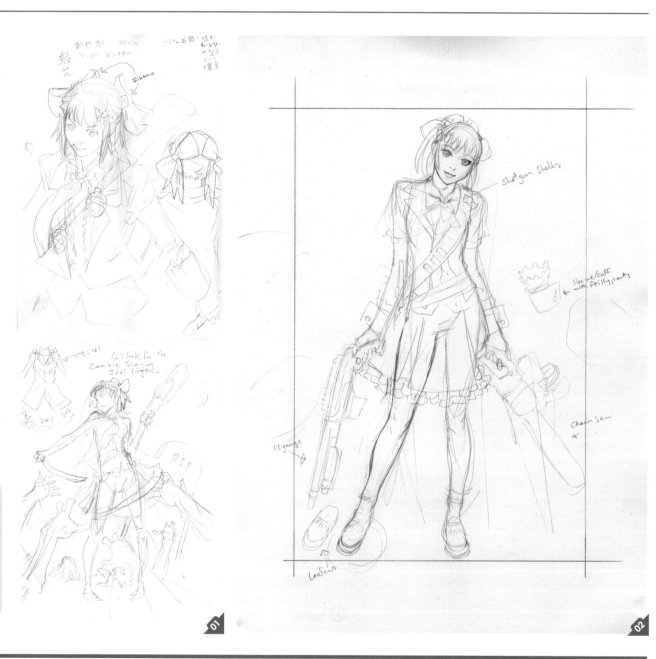

01

02

44

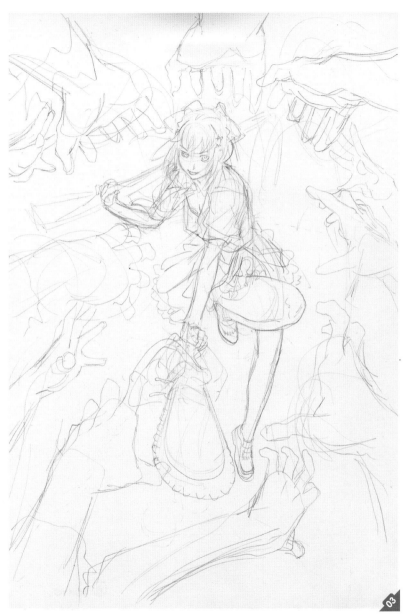

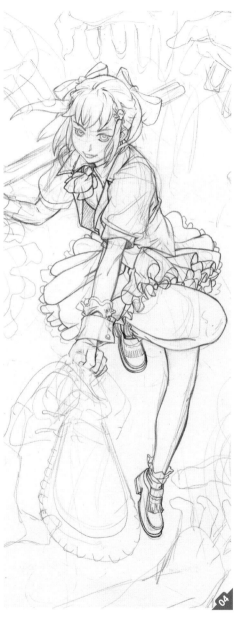

In **Fig.02** you can see my cleaned up character design. Although at this point you are just creating a sketch and not the final image, put a little bit of thought into the character's pose. This is so you can see a little more of the character's personality in the way they are standing.

At this point I am drawing on standard manga paper. Manga paper is special because inks don't bleed on it and Copic markers take to it very well. I use manga paper at this stage in case the sketch comes out really well and I want to develop it straight from the initial sketch.

The next thing to do is make a quick and rough sketch of how you want the actual illustration to look. At this point you need to think of a nice pose and consider the overall balance of the image. Don't worry about your image looking too sketchy; everything can be refined and finalized later in the process (**Fig.03**).

Now it's time to finish off the pencil portion of the illustration. Since I am happy with the pose all I really need to do is fill in the detail of the rough thumbnail. First ,draw the character; in my case this is Ayaka since she is the central part of the picture (**Fig.04**).

I then draw her equipment. It is best to do this using some references. In my image, neither the shotgun nor the chainsaw are based on any single real-world item, but are amalgamations of several examples I found in reference books I have (**Fig.05 – 06**).

The final step in the pencils is to finish the zombie hands surrounding Ayaka or any environmental features you may have included (**Fig.07**). Once that is done it is time to ink this piece!

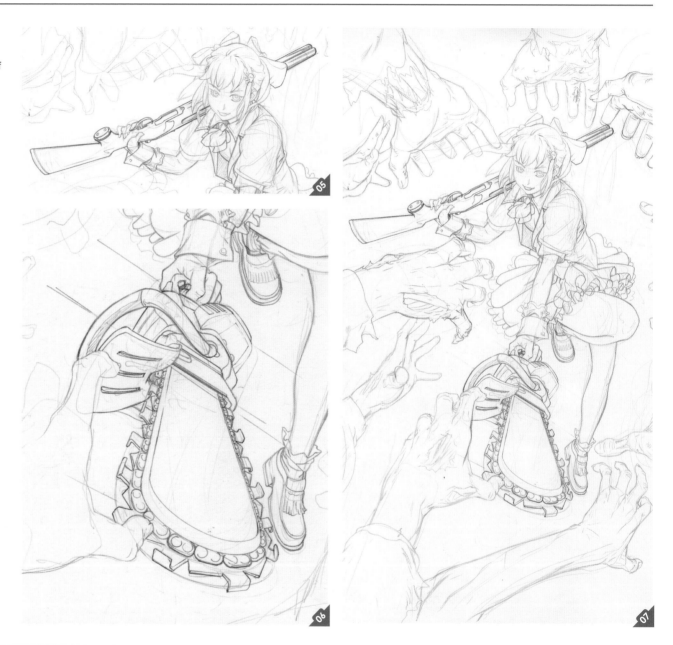

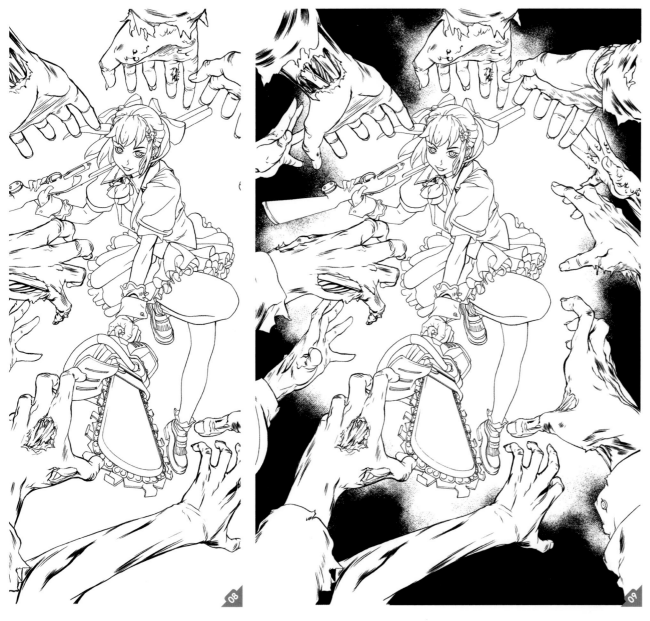

Inking

With this picture I am going to handle the inking in two separate parts. For Ayaka and her weapons I want to use my handy Zebra mapping pen to ink, which is well suited to details and fine lines. For the zombies I am going to use my refillable brush pen. I want to leave the zombies rougher around the edges than Ayaka and a brush is a great way to do that. It also allows me to have longer flowing lines and offers greater line weight options than the mapping pen. The tool that you choose to use will depend on the amount of detail that you want (**Fig.08**).

The last thing I do before moving on to the coloring stage is lay a little screen tone down between the zombie hands to really darken the edges and force the attention onto Ayaka. You may want to do something like this in your own image to focus the gaze of the viewer. I use a J-Tone brand of tone here and a cutting knife to get the tone down in the areas I want. Any area that has tone on it that I want removed is taken away by using a knife. Be careful to remove everything that you don't want as any remaining fragments on the page will leave unwanted marks (**Fig.09**).

Drawing a Female Warrior
By Phong Anh

Introduction
The very first step to creating your image is choosing the type of pencil that you want to use. Although it won't drastically affect the quality of the sketch, what is important is that you are comfortable with the tools you work with.

Tools Used
- Pencil
- Paper

Don't feel pressured to use different tools because someone else does. Use what you have and what you feel happiest using; it is by doing this that you will become more comfortable creating images. So with everything ready in front of you, let's look at how to start your image.

Getting Started
There are many tools that you could start your image with, however, a wooden pencil is regarded as the best tool for rough sketching – plus they are usually pretty comfortable to work with.

One question that manga artists are always asked is, "How do you draw a pose that looks anatomically correct and smooth and flexible?" The way to achieve this is to start by simply sketching stick figures. Drawing a variety of stick figures in different poses is a great way to develop ideas, while also making sure your focus is on anatomy and proportions rather than details. Once you have drawn some stick figures you can add some volume to them, again using simple shapes (**Fig.01**).

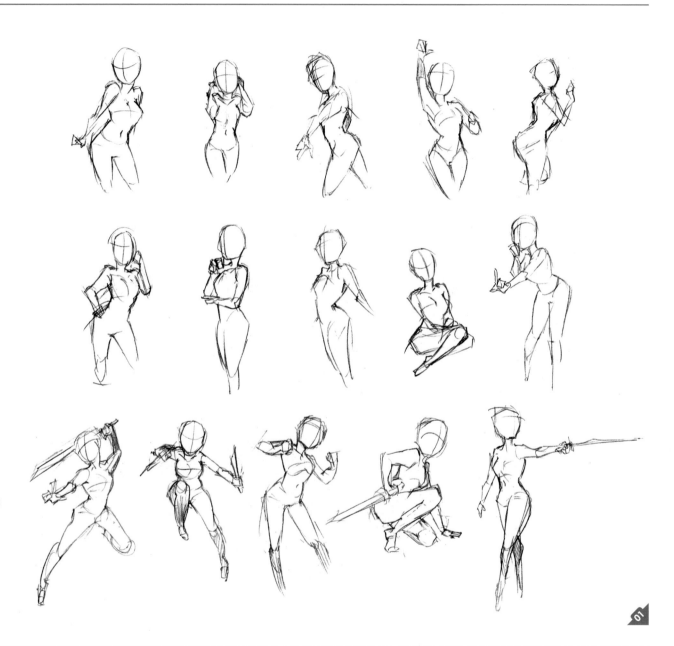

I would strongly advise that you look at your own body to achieve good anatomy. Try to put yourself or a friend in the pose that you choose for your image. This will be a great way to help you achieve something that is very hard to do from memory. Look at the position of the muscles in your references. For example, if you wanted to draw someone holding a sword downwards, get a friend to pose in that position and pay attention to the shape of the arm and the muscles that are visible (**Fig.02**).

Anatomy theory is important, but you can't expect to be good at it straight away. Practice drawing people and creating your images by using references. Once you have been doing this for a good amount of time, you will be able to draw poses from memory and construct dynamic characters from your imagination. It may take a long time, but it is worth the effort and after a while you will be able to construct quite complex poses (**Fig.03**).

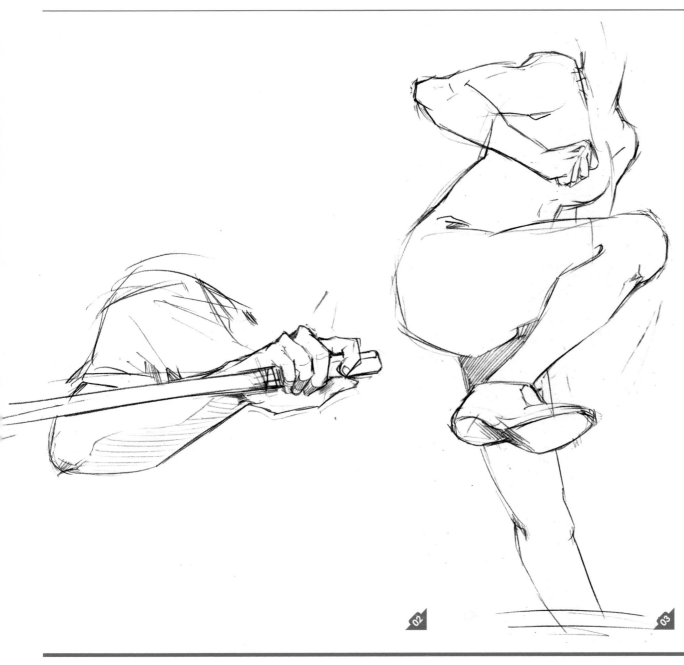

Action Poses

How about action poses? Many artists consider action poses the hardest to create successfully. The decisive factor is the line that runs along the body, frequently called the "action line". This line demonstrates the central point of the human body, which helps to show the character's balance and whether they would be able to stand or fall over (**Fig.04**).

Even when someone is not in an action pose, you should make sure that their action line looks balanced (**Fig.05**).

Artist's Tip: Media References

It is important not to forget all the references around you that you can use to discover interesting poses. Use all the media available to you or stand in front of a mirror. This will be really helpful.

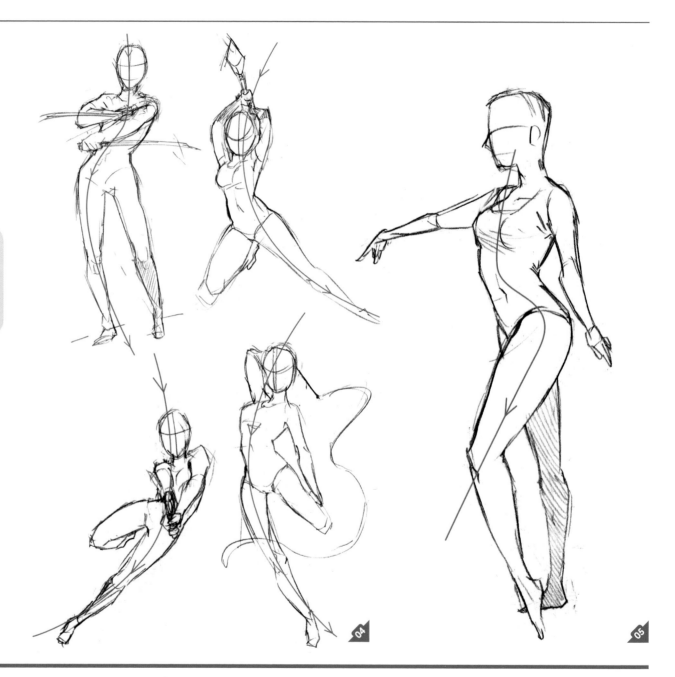

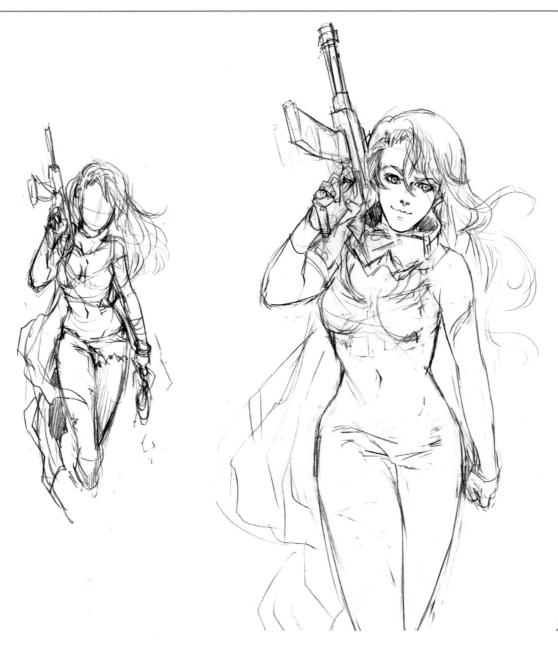

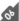

When you find a pose that you like or that you want to create, pay special attention to the positioning of features. Look at the tilt of the hips and shoulders, and consider how far the parts of the body are apart.

Drawing should be something that you do for fun. The reason that I mention that is that you will have more fun and feel more involved with your image if it is of something that you are enthusiastic about. If you are enjoying yourself you will feel more than happy to create plenty of sketches until you are happy with the one you want to develop. Another good thing you can do when looking for the correct pose is to overlay your pictures and think about how you can use parts from each of your sketches to come up with a new and interesting pose. Once you have done this you can settle on the pose and design of your character (**Fig.06**).

Artist's Tip: Avoid Small Sketches
Try to avoid drawing your images too small. By drawing your sketches large you will be able to see the mistakes and fix them quickly, without needing to rub out small areas and draw intricate parts again.

Expressions

After creating the preliminary sketch, move on to the detail. The first thing you should focus on is the facial expression of the character. Giving your character an attractive and easily recognizable expression will immediately bring it to life. To help to draw a believable expression, take a mirror and look at yourself as you make different faces. Choose the key elements of that expression and portray them in a simple way on some practice faces to help you decide what is important to include in your image (**Fig.07 – 08**).

Once you have experimented with a few expressions you will need to choose the one you plan to use in your image. The truth is that there are many ways to draw a happy face or a sad one, and so on. You will need to continue to look in the mirror and practice until you find the expression that best reflects the character you are aiming for. Also, remember that these expressions will look different for people of different ages and genders, so you may need to speak to friends and family, or search the internet for references.

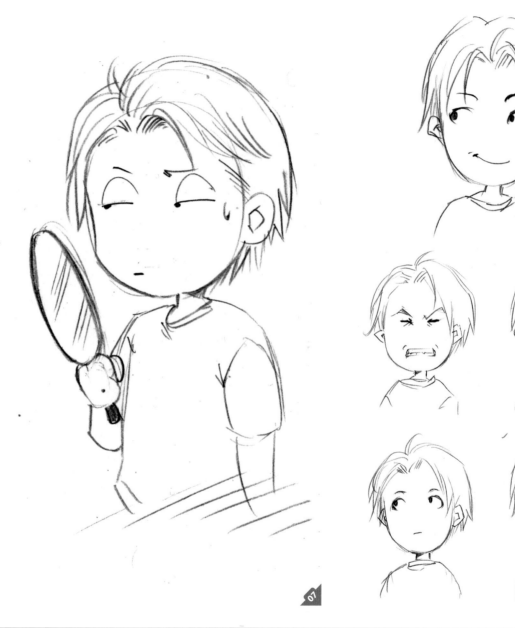

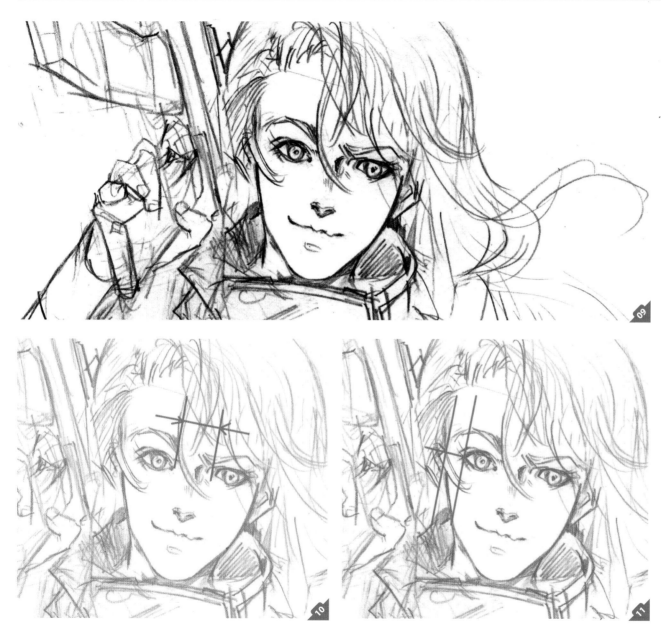

You will see in my image that I have drawn one eyebrow slightly lower than the other, and also turned up the side of her mouth. This demonstrates that she is strong-willed and stubborn. By mixing elements and experimenting with expressions you will find something that suits you and reflects what you want to see in your picture (**Fig.09**).

One rule that should always be applied when drawing a face is that the distance between the eyes is the same as the length of one eye (**Fig.10**). The distance from the edge of the eye to the side of the face should be roughly the length of half an eye, when looking at the face from straight on (**Fig.11**).

The Hair

To make the hair look natural, make it look as if it is flowing or moving slightly, as hair is rarely totally still, particularly on a female. When you draw the hair, use long, flowing lines (**Fig.12**). You will probably find that over-exaggerating the hair will make your image more eye-catching. It is something I do often to make my images more appealing.

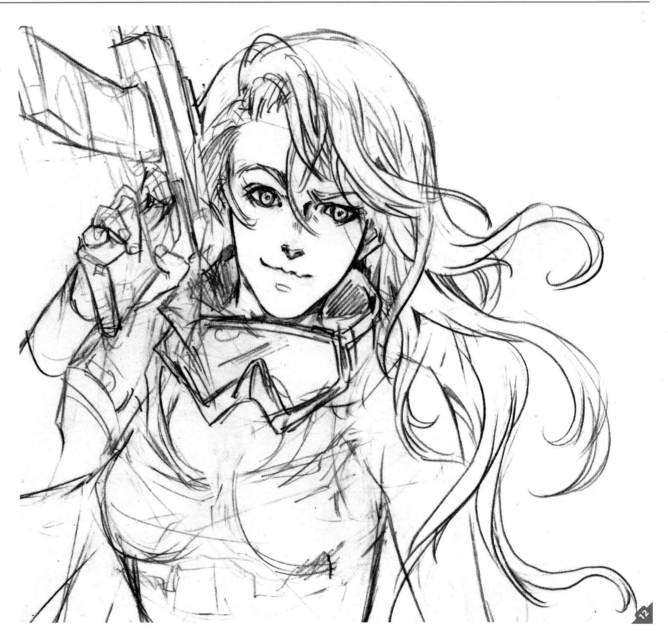

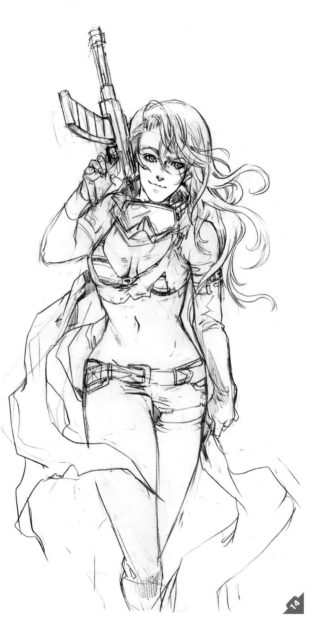

Clothing

As with all of the things that I have mentioned so far, drawing the clothing is mainly about observing the way these things look in the real world. Look at your own clothing and references online to help you do this. You will find that the fabric usually folds along the curves and joints of the body. In this case that is around the hips, elbows, shoulders and knees (**Fig.13**).

The process of creating a good manga character is about observing things in the real world, and then simplifying and stylizing them for your character. Although it can be very appealing to copy the style of existing artists, I urge you to find your own way using the method of simplifying what you see in the real world. This takes more patience than copying other people's work, but the benefits are much better and it will improve your ability as an artist.

Don't let people convince you that manga does not need to be a realistic style. Manga uses what exists and gives you the freedom to simplify it and make it unique. Because of this you need to try to make sure you understand and observe anatomy, to help you create believable and dynamic characters (**Fig.14**).

There are plenty of things to try out, work on and develop, but the most important thing to remember is to have fun!

Drawing Kléo the Cat Girl

By Mateja Pogacnik and Marco Paal

Introduction

Hello, our names are Mateja and Marco and together we form MP². In this tutorial we will show you how to sketch and create line art for a manga character, using traditional tools. Mateja is going to draw the character we have named Kléo, who is an original character designed by us. While Mateja does this I (Marco) am going to write up everything that Mateja does.

Hopefully the tips we share with you will be helpful and encourage you to create new characters of your own.

Tools Used

- Printer paper (for the sketch)
- Manga paper (for the line art)
- 0.35mm mechanical pencil
- Eraser
- A wing broom
- A curve ruler
- Copic liners
- Light box

Starting Your Sketch

Using a mechanical pencil you can begin your sketch by drawing a selection of circles and ovals on the printer paper. These shapes form the base of the character's body. Putting together these simple shapes is much easier than drawing anatomy on a blank page without a guide. Circles and ovals are used to do this instead of squares and rectangles, because they are much more organic-looking shapes and help demonstrate flowing and natural curves (**Fig.01**).

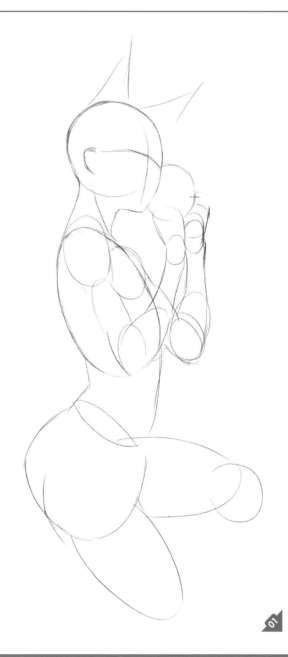

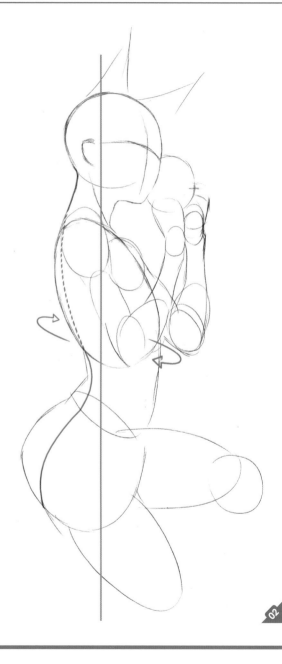

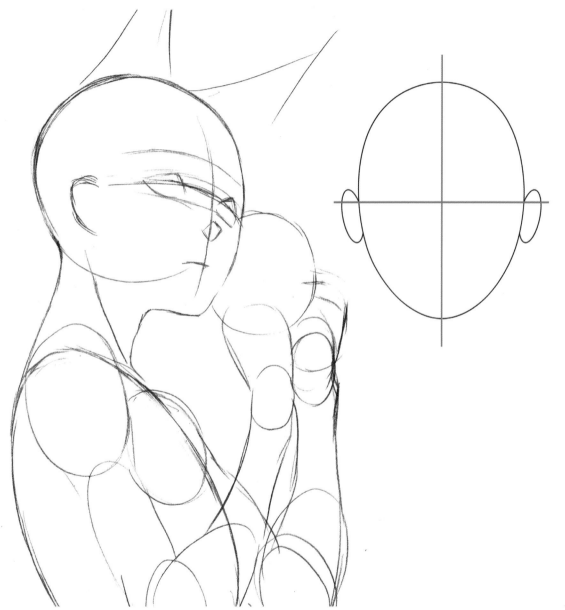

Kléo is a cat girl, and therefore is supposed to appear flexible and, of course, cat-like. When drawing a character like this their pose can end up being quite complicated. If this is the case, try drawing some guidelines to aid you. In **Fig.02** you will see a blue line that runs straight down the page. This is to ensure that the character looks balanced and isn't looking like she will topple over. The green line shows the position of her spinal column and demonstrates the twist in her torso.

Artist's Tip: Guideline Angles

It is quite easy to mark these guides when looking at the front of the face, as the horizontal line is exactly halfway down the head, and the vertical line is exactly half way across it. However, in the case of Kléo, her face is tilted slightly upwards and to the right. When you add the guidelines to the face of your character you will need to take this into consideration. Also remember that the face is rounded as this will mean your guidelines will be curved instead of flat.

The Face

Now that the base for the image is in place you can move on to the most important part of the illustration: the face. Guidelines can be used when drawing the character's pose; however, they should definitely be used when drawing the face. This is common practice, even by professionals (**Fig.03**). The horizontal lines mark the location of the eyes and eyebrows. The vertical line marks the center of the face.

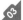

On this base you can now start to add more details. There are many variations of styles within manga, so how you draw the features is totally up to you. You may want to look at the different styles online and choose the style of features for your character that you think will suit them best. I suggest trying a few different types and styles as this will make your characters more interesting and varied (**Fig.04**).

The Hair

The hair is drawn as a selection of groups and strands. These are all broad at the origin point, and then go to a point at the end. When you draw these try to keep the hair flowing in a certain direction, but do include a few strands that run the wrong way as this will provide more variation and will look more natural.

The Hands

Beginners and novices usually find that one of the more difficult and intimidating parts to draw on a character is the hands. The process of drawing circles and ovals will be helpful here as well. Draw larger circles for the palm and back of the hand, and then smaller ovals for the different sections of the fingers. Once you have done this you can draw around them to create the outline of your posed hand. When you have practiced this a few times you will find it easier than you thought.

At this point the head and hands are finished. If you find them distracting you can erase the rough lines you started with at this point. If you have one, use a wing broom to wipe away the fragments from the rubber to avoid smudges. If you don't have one I suggest using something other than your hand to wipe away any debris from the eraser (**Fig.05**).

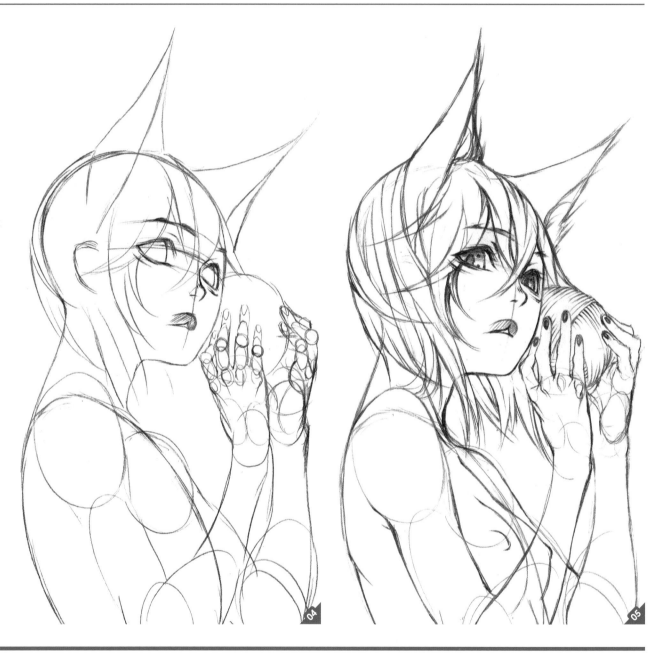

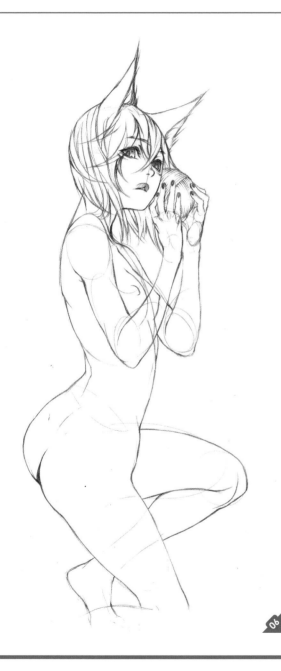

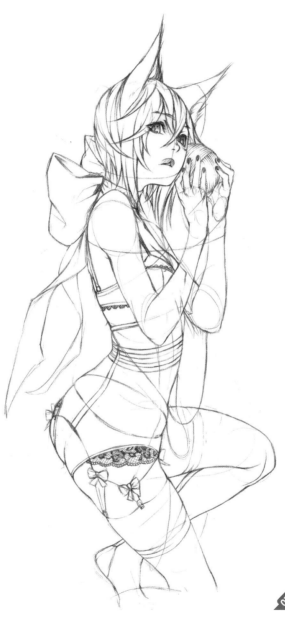

The Body

Use the same technique you used for the hands to draw the shape of your character's body. You will notice in **Fig.06** that Kléo still hasn't got any clothes on. It is really helpful to start your drawing without worrying about your character's clothing. You can draw the clothing later. By creating the base of the character without worrying about clothes, you will make it easier for yourself to achieve better proportions and anatomy.

When you start to add the clothing you will need to think about the personality and attitude of your character. For our character we decide to do something sexy; after all, she is a cat girl. We drew some lingerie for her to wear and tried to make sure that by the end she wouldn't be showing too much skin (**Fig.07**).

Clothing

One thing Mateja always does before drawing the clothing is research. She looks on Google at plenty of references to make sure that the clothing will look realistic. It is important that you are willing to look up references for the clothing your character will wear, as it will make your image more believable. Make sure you pay special attention as to where the seam goes on your references and the materials that the clothing is made from.

> ### Artist's Tip: Manga Clothing
> Whereas most forms in manga art are simplified or abstract, clothing tends to be quite realistic and accurate.

You might have noticed that Kléo's haircut has now changed a little. During the process of sketching it's normal to sometimes change your mind regarding different aspects. Mateja does that quite often, in fact.

Creating the Line Art

It is now time to create some line art. The lines for the image of Kléo are done using Copic multiliners, the curved ruler and the light box I mentioned earlier. In the case of this image Mateja uses a fresh piece of paper to do the line art on.

To use a light box simply place your new piece of paper over your sketch and place them on top of the light box. This will make it easy to add inked lines on your clean piece of paper by tracing the image below. If you use a light box, tape down the image as this will mean that nothing will move around when you are creating the inked lines (**Fig.08**).

Artist's Tip: Manga Paper

Using a fresh piece of manga paper to create the line art is beneficial as it means that you will have no smudges or remnants from the sketch to deal with when you do the coloring.

Manga paper is ideal for the line work as it is much better quality than standard paper, and it helps stop things like smudges and other marks.

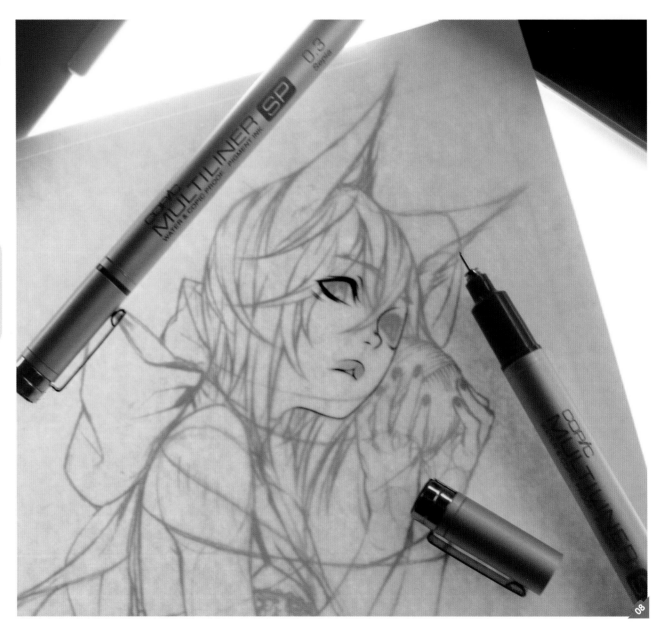

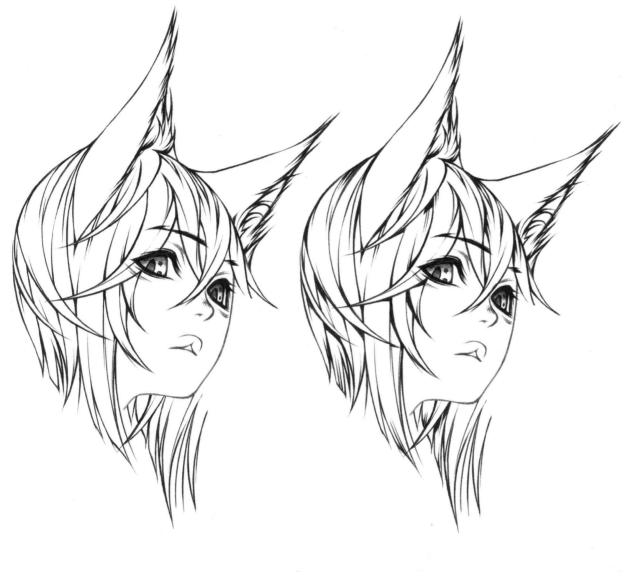

When starting the line art, begin with the head. This is probably the hardest part of the image to do, and it is also the area where an error is most likely to happen. If an error occurs on the face after you have done the rest of the body it can be very frustrating (**Fig.09**).

The face is usually the part of the image that commands the most attention. Because of this you need to be careful to capture the right expression. This line art and paper will be the ones we use for the final image. This means that you can't use masking fluid to get rid of any mistakes because coloring over masking fluid is a problem.

For the hair, use a black multiliner or equivalent pen. Mateja has used a sepia tone for the face and eyes, and a purple color for the lips. These colors will blend with the colors used later for the main coloration. When you are doing your line art you may want to think about the colors you plan to use, as this may make you decide to use a variety of colors for the line art, although simply using black is fine.

The nice curves in the hair have been created by using the curved ruler I mentioned earlier. This gets rid of any evidence of a shaky hand and provides a great finish.

If you look closely at the hair you can see that there have been some dark shadows added in between the strands of hair. This adds a bit of depth and volume to the hair. These shadows will be added all over the image as it is inked (**Fig.10**).

Although it can be tempting to jump around an image, moving from one feature to the next, it is better to move down the image from top to bottom. This way you will draw more flowing lines and avoid smudging as all the lines will be above your hand (**Fig.11**).

You will see that purple has been used to do the ribbon around her neck. Again, a little shadow was added to demonstrate depth and volume.

In **Fig.12** you will see the almost finished lines, but there are still some difficult tasks that need to be done. One of the difficult tasks that still remains is to add the lace to clothing and to achieve a semi-transparent look to her girdle.

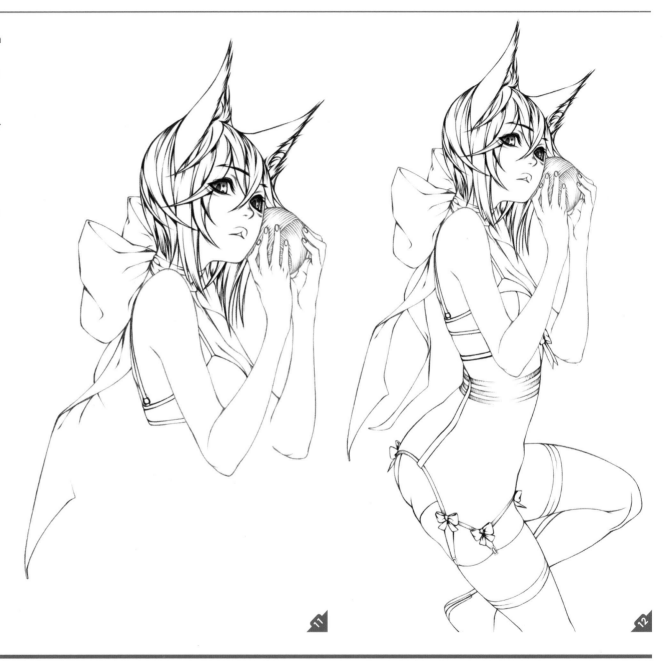

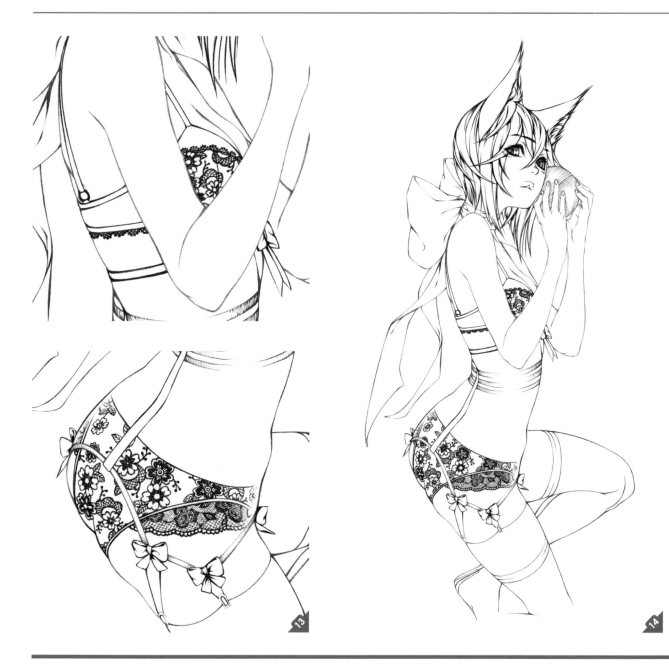

Again, we use references to draw the detail on the bra and panties. If you find it hard to draw this detail you can sketch a pattern or create some detail on a separate piece of paper and trace it using the light box (**Fig.13**).

Parts of the girdle are lined with the same black pen, but the parts towards the center of the body have been inked with the sepia color. This is because this area is covered by a thin material and it will look thinnest towards the center of the body. This will be clearer when the image is colored (**Fig.14**).

Drawing the School Girl
By Giovana Leandro da Silva Basílio (Eudetenis)

Introduction

I would like to draw your attention to the materials I will use throughout this tutorial. They are all materials that I would recommend that you use in your own workflow.

Tools Used

For the pencil lines I will be using:

- Graphite pencil 2B
- Rubber pen
- 0.7 mechanical pencil
- Set squares
- Ruler

For the inking I will be using:

- Nikko holder
- School Pen nib
- Kuretake Sumi Ink Calligraphy & Comic pen

You can use other pens and pencils to create good results, but it is a must that you use a ruler for straight lines and a good pen for the inking. It is also important to use a ruler when drawing perspective lines as these tend to look very strange if they are incorrect, plus it is easier with a ruler. When choosing a pen to use for the inking, it is best to choose something with a good tip, which doesn't fragment or break as this can ruin your inking. Also, use something that distributes ink cleanly.

The Sketch

First make one or more quick sketches of an idea that you would like to develop. For my design I chose to portray a girl on the roof of her school. While you sketch don't worry too much about the anatomy or the small details; just try to make sure the proportions are accurate and the elements are positioned in places that make the scene interesting. In the sketch you can also add a few hints as to the direction of the lighting, etc., (**Fig.01**).

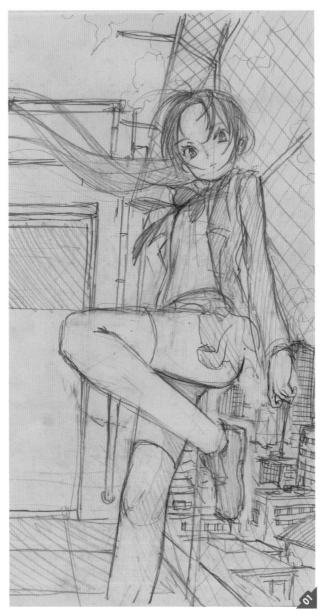

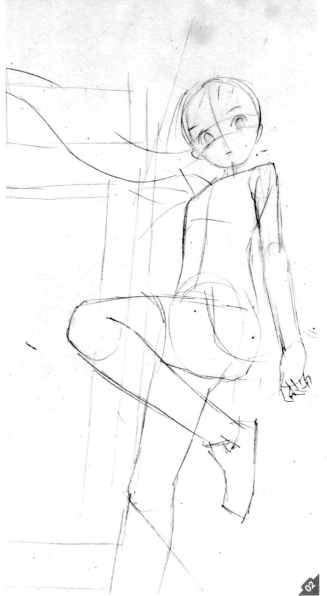

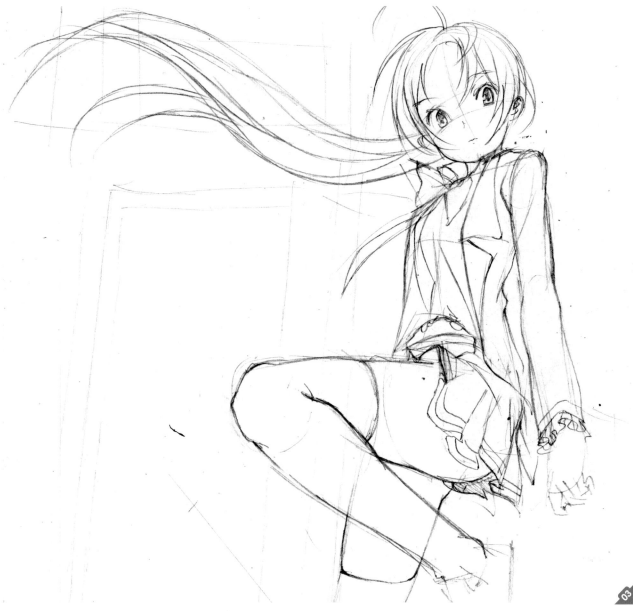

Once the sketch is in place you can move on to the final image and begin by lightly sketching in the character's basic structure. At this point you can refine some of the forms from your initial sketch by making sure that the different parts of the anatomy are sized correctly. You will need to make sure that you keep the same compositional balance that you achieved in your sketch. If you were happy with your character's expression in your original sketch try to maintain it in your final image, as expressions are extremely important in manga art (**Fig.02**).

The next step after you have set your base is to settle on how you want the eyes to look. These will act as a guide as to what the expression on your character's face should be.

At the start we set the base for the character and considered proportion, etc. At this point we need to think more about anatomy. You can use references to make sure that your anatomy is correct, but try to use references that are relevant. My character has an arched back and has inhaled, which means her chest is being pushed out. Consider details like this when you are drawing your sketch (**Fig.03 – 04**).

Also carefully consider the clothing of your character and remember to think about how gravity acts with lighter materials. In my scene I also have the complication of the fact that she is on a tall building and the wind is blowing her clothes. Try to demonstrate the force of gravity and environmental influences in your image.

Although manga characters are made up of simplified forms, it is important that you don't use this as an excuse to not include details that add interest to your work. For example, in my image I have showed where the sock elastic would tighten around the girl's leg (**Fig.05**). When drawing these features in try to remember where your character is being viewed from; in my case it is a low angle, looking up at the character.

Once the character is done it is time to create the scene. As perspective is important in this scene I used set squares to make sure everything was accurate (**Fig.06**).

Artist's Tip: Pencil Angle

If you use a ruler, remember to tilt the angle of the pencil to more than 60 degrees as this will make your lines smoother.

The fence that the girl is leaning on is quite tricky as the wiring will need to reflect the perspective to look correct. To make it look believable I needed to increase the angle at which the lines would run down the fence. If you include any features like this it is easier to mark them with a ruler first and then detail them.

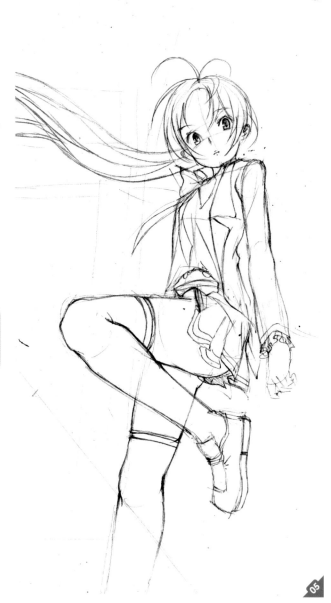

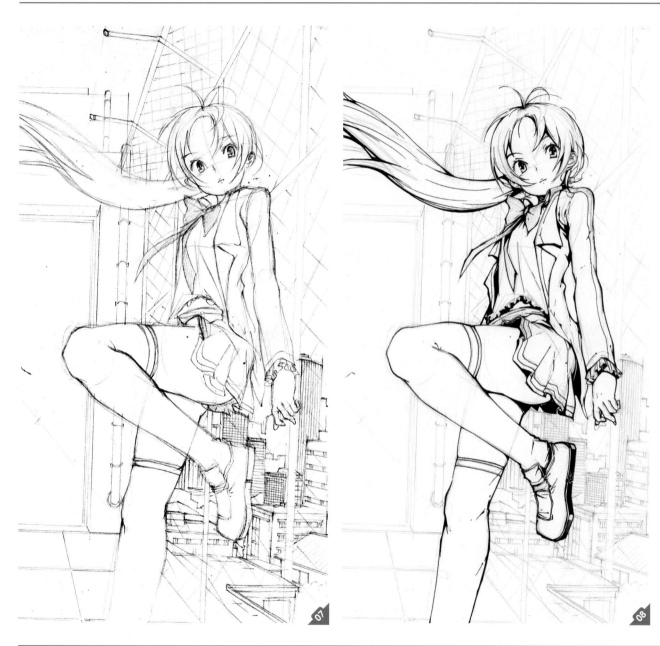

To finish the sketch you will need to complete all the fine details that you want to feature in your image. In my case this was the buildings in the background and some hints at the texture of some of the materials, like the walls and the girl's clothing. You can also start to hint at the light direction in the scene at this point. This doesn't have to be perfect at the moment though, as it will be refined when you ink the image (**Fig.07**).

Inking

Now that it was time to start the inking I moved over to my Nikko holder with the School Pen nib. I mentioned earlier that the eyes are a really important part of the image so that is where you should start you inking. Go over your sketch lines, but make sure that you maintain the highlight on the eyes as this reflects their glossy nature.

When you ink the hair try to use smooth lines that get thicker in areas where there would be shadow. This will make the hair seem more believable and give it depth and volume.

Once you have identified the direction of the light on the hair etc., you can apply it to the rest of the image. In my case I knew that it was coming from above and to the right. I also filled areas that would not be hit with light at all with black, like the inside of her jacket and skirt. The folds in the clothing should be done with thin lines (**Fig.08**).

To get the most out of this sort of pen you should vary the thickness of the lines, using both thin and thick lines. This principle applies whatever pen you decide to use, as the change in thickness and thinness demonstrates depth and volume. I always recommend Japanese pens because they hold ink really well, which helps when drawing smooth lines and makes drawing thick lines easier.

The same rules of varying the thickness apply to the environment. Make sure that you continue to use a ruler for the straight lines and wipe it clean after each stroke so that you don't smudge ink across your page (**Fig.09**).

Once the scene is inked, turn your attention to refining the shadows in the scene. Thicken the black lines in areas where there would be shadow, but also remember to leave some lines incomplete where there would be strong light in order to demonstrate light reflecting on a surface. You may want to imply some texture using inks. This is fine, but I would suggest sketching it in pencil before you commit to it in pen (**Fig.10**).

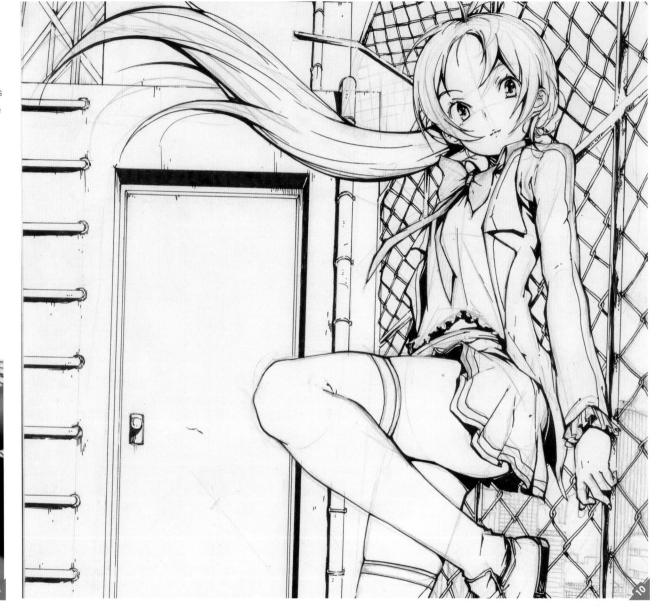

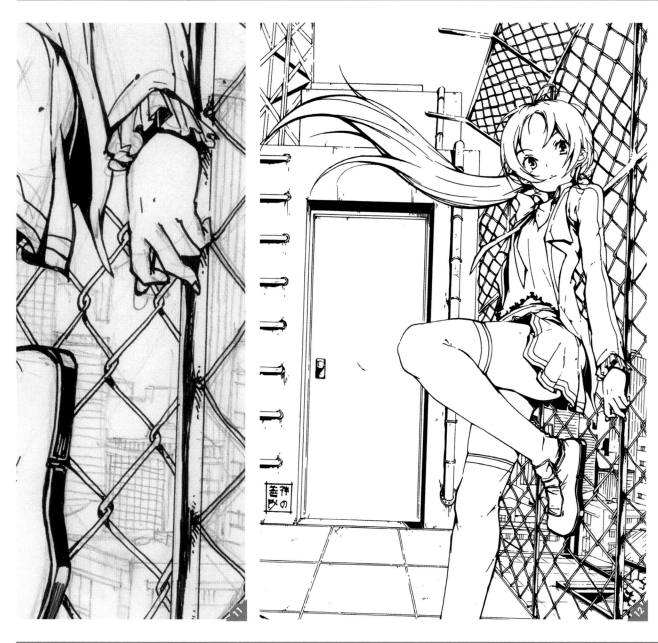

The fence has to be inked carefully, bit by bit. As the girl is leaning on the fence and it is a flexible surface, I had to contort the fence slightly to match the stresses on it (**Fig.11**).

Finally you can go on to develop the details in the background. This can be done without needing to focus on the details as this is not the focus of the image, but you should still try to portray correct perspective and shadow.

You can then rub out your pencil lines as your image will be completely inked. If there is anything you don't like about your image you can use white ink to delete it (**Fig.12**).

Drawing a Manga Duo
By Supittha Bunyapen

Introduction

Before you start any image the first thing to do is make sure that you have the correct tools to work with. Over time you may find that you want to try different tools and equipment, but when you are starting out and practicing you can simply use a normal HB pencil and printer paper. As you will no doubt know there are plenty of different types of pencil available, but I would recommend a mechanical pencil, since they give you nice, sharp lines and you don't have to keep sharpening them.

Tools Used

- HB mechanical pencil
- Paper
- Eraser stick

Sketches

The first step in creating your own manga image is to make a couple of rough sketches of the kind of character you would like to draw. When I create my sketches I also like to give an impression of what the clothing on the characters will look like (**Fig.01**). You will notice that the characters are in varied poses, ranging from simply standing to action poses. By creating multiple sketches from different angles you will come up with new and interesting ideas.

Artist's Tip: Character Turnaround

You may want to create a turnaround of your character by drawing it in a simple standing pose from several different angles. This will help you when adding the details to your final sketch later in the process.

Composition

To draw the composition of the final image I work on a computer using a graphics tablet. This has its benefits as digital programs allow you to move elements around at will. However, the same steps can easily be reproduced using traditional media. You could sketch your composition on one piece of paper and then create the final sketch on a separate piece (**Fig.02**).

When sketching the final pose and deciding on the composition of your image, don't feel too restricted by details and anatomy. These will all be refined in later steps. The aim at this point is to get a good idea of how you would like the image to look.

Creating a Base

Once you have settled on the appearance of the composition, start working on the base structure of the characters. This should simply be done using shapes and lines (**Fig.03**). Use lines for the substantial bones and simple rough shapes for the main masses of the body. This is a great way to work on the pose, and concentrate on proportions and anatomy, while not being distracted by the details.

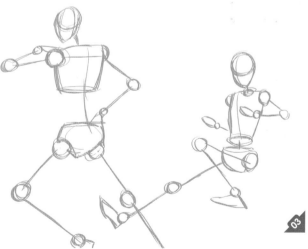

Adding Volume

To make the figures look more complete, fill the skeletons with muscles and curves. The body form depends on the gender and age of your characters. The front character has a smaller figure than the character behind, so I decide to make his figure quite slender, like a young teen. Since his body hasn't fully developed yet the forms of his muscles are not that noticeable (**Fig.04**).

Unlike the front character, the character at the back is an adult. There are some differences that we should be aware of when dealing with different ages and genders. The most obvious of these is proportions. An adult's body is thicker and broader than a teenager's ,and the muscles are also more noticeable. The shoulders and the waist areas are definitely wider than the front character. Pay careful attention to the muscles to make them look believable. As you are also drawing clothing over the muscles you don't need to worry too much about getting them accurate. As long as the correct shape is in place, the viewer will read the image as being accurate (**Fig.05**).

Artist's Tip: Anatomy Research

Spending time studying anatomy is a great thing to do, but it can be tricky. I recommend reading up on anatomy and using references when creating your own art.

The Face

To start the face, place a vertical line that divides the head in half. The line is to indicate the center of the face, which will help with the placement of some of the facial features, like the nose and the lips. Draw two further vertical lines to split the two halves of each side of the face. Add a horizontal line about the center of the entire face where it meets the ears. Where these lines cross is where the eyes will be placed.

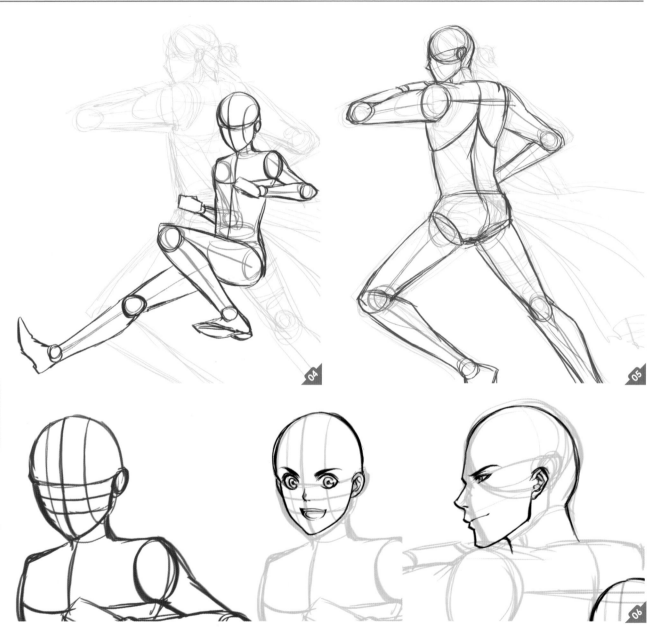

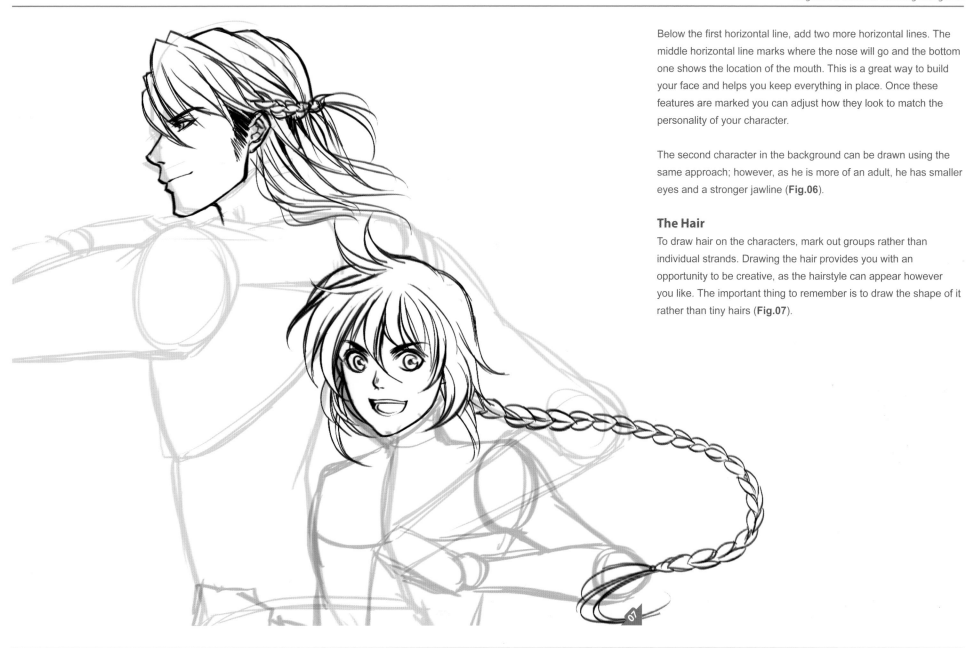

Below the first horizontal line, add two more horizontal lines. The middle horizontal line marks where the nose will go and the bottom one shows the location of the mouth. This is a great way to build your face and helps you keep everything in place. Once these features are marked you can adjust how they look to match the personality of your character.

The second character in the background can be drawn using the same approach; however, as he is more of an adult, he has smaller eyes and a stronger jawline (**Fig.06**).

The Hair

To draw hair on the characters, mark out groups rather than individual strands. Drawing the hair provides you with an opportunity to be creative, as the hairstyle can appear however you like. The important thing to remember is to draw the shape of it rather than tiny hairs (**Fig.07**).

The flow of the hair should demonstrate the movement of each character's body. Normally hair hangs because of gravity (except spiky and short hairstyles). However, if a character with long hair moves quickly then their hair will hang in the space they previously occupied, very temporarily. This means that hair will demonstrate the flow and direction of your character's movement.

Clothing

Plan what kind of outfit your characters will wear in advance. You should have created some sketches at the beginning; if you did these will be helpful now. When you draw the clothing remember to vary the tightness and add wrinkles in the clothing. This will make the clothing look more authentic. There is no need to spend time drawing all the detail straight away; focus on the form first, then develop the detail (**Fig.08**).

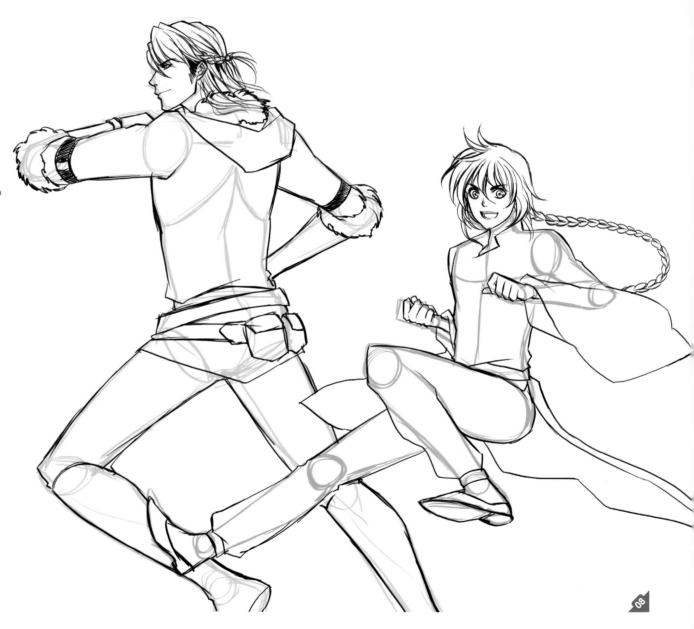

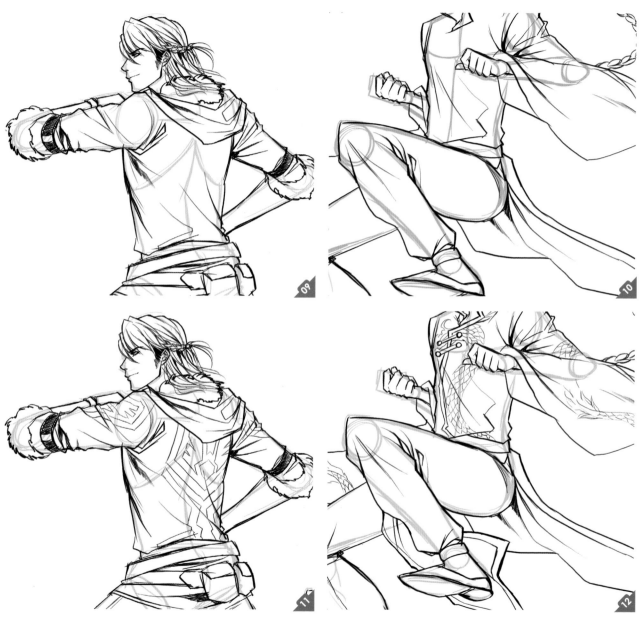

Once you have completed the overall shape of the clothing, add creases and wrinkles to the fabric to make it look more natural. Wrinkles help to define body movement and add believability; however, be careful not to overdo or underdo them, as this can be damaging to your final image. The wrinkles and creases you add should match the movement of the characters. The creases usually originate at a joint and fade away as they enter the main body of the clothing (**Fig.09 – 10**).

Artist's Tip: Clothing Details

When you add the patterns and details to the clothing remember to make the pattern match the creases in the clothing, otherwise it will give your picture a flat and lifeless appearance. You may find a reference helpful when doing this.

Details

Adding patterns and details helps make your characters look more complete and interesting. Things like buckles and different fastenings give an impression of authenticity (**Fig.11 – 12**).

After I had added the details to my image I felt like there should be more elements to convey movement, so I added extra material and clothing to increase the notion that they are moving (**Fig.13**).

The Environment

There is no need to cramp thousands of props in the background. Simply create piles of rocks and planks of wood on the ground. Put more details on the closer elements, but not too much to disturb the presence of the characters. For the items in the distance, don't spend too much time sketching them. Simply use silhouettes to suggest the shape of the rocks and other features (**Fig.14**).

Final Adjustments

I feel that the composition needs to change, so I move the placement of the characters around, which is easily done when working digitally. If you don't use a computer and a graphics tablet to sketch, use a light box to trace the sketch and change the composition. When you are satisfied with the overall look, erase the unwanted lines or lines that overlap each other (**Fig.15**).

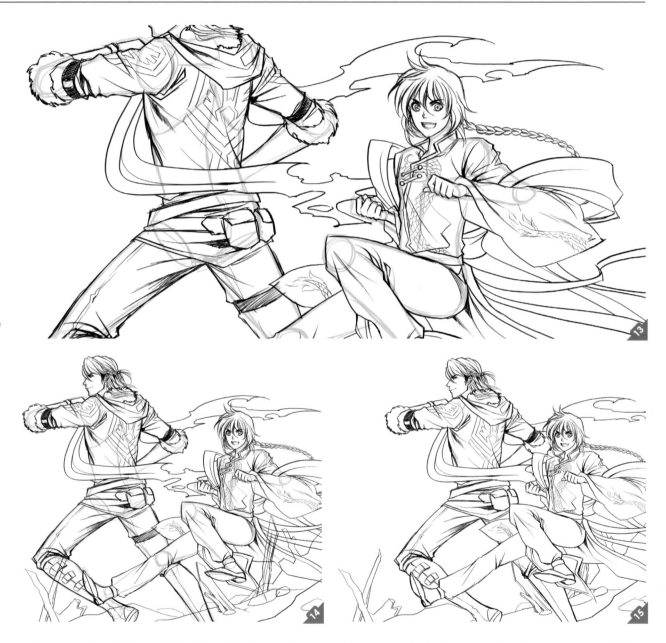

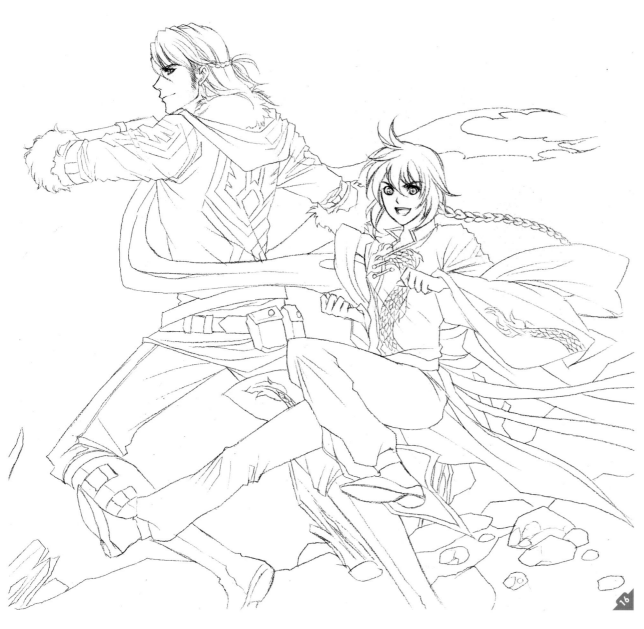

The Line Art

Now it's time to prepare clean line art for coloring. Since I sketch digitally, I print a hard copy and use a light box to trace clean line art onto watercolor paper. Place watercolor paper on top of the print out and start to outline the image using a mechanical pencil. Normally lighter leads like H, HB, or 2B pencils are good enough. Try to avoid darker leads such as 4B, 6B, and 8B because they leave dark smudges and other marks (**Fig.16**).

If you prefer to ink your line art, you could use a waterproof pen like a Pigma Micron pen, Copic multiliner or Prisma pen (the brand doesn't matter, but it should be waterproof).

Drawing the Angel

By Sandra Chlewińska

Introduction

Before I say anything about the picture, I would like to point out a few important things about choosing the right tools and paper for traditional artwork. Firstly, if you're planning to use color pencils try to use smooth, thick paper. Grainy paper may cause little dots on the picture, which are very hard to cover. If I want to use markers, keep in mind that thick or grainy paper absorbs more ink than thin, smooth paper.

Tools Used

- 2B and B pencils
- Paper

The Sketch

When you draw manga characters regularly you will develop routines for drawing your images. When I draw a character from a side angle such as this one, I start by drawing the head and hair. The main reason for doing this is it means you will ensure that the head, which is the focal point, remains in a prominent position on the page. The last thing you would want is to draw an excellent body, then come to draw the head and find that it doesn't fit on the page.

Artist's Tip: Leads for the Base

Use harder and therefore lighter leads to create the base of your image. Once you are happy you can move onto softer and darker pencils.

The next step is to start marking the location of the facial features. To do this, draw a vertical and horizontal line that pass through the center of the front of your head shape. There are some very basic rules you can apply when drawing these features. The eyes should be on the horizontal line as they are halfway down the head.

The ears should be attached to the head at the same height and therefore on the same line (**Fig.01**).

Using this format of creating basic shapes, mark out the rest of the shape of your character's body. The process for doing this has been covered in detail at the start of this book (**Fig.02**).

I decided that I wanted to give my character wings. You can do something similar if you like, or you can be totally creative with the background, it is up to you. To mark out the feathers I simply sketched the letter W around the character loosely, which looked a bit like the bottom edge of feathers.

I recommend picking up your image, flipping it over, holding it up to the sun or a light and looking at it from the other side of the paper. This will help you identify parts of the image that look incorrect or disproportioned.

Line Art

Now that the sketch is finished you need to work on the line art. I don't recommend using pencils to create the line art if you are going to color your image with color pencils. This is because you will probably smudge your pencil lines when you are coloring.

I wanted to keep the lines on my image very clean, so I used a 0.5 black pen. Draw over your pencil lines carefully and smoothly. Apply slightly more pressure in areas that would appear in shadow to add weight and volume to the forms (**Fig.03**).

Artist's Tip: New Pens

If you are using a new pen for the first time, scribble on a piece of paper with it and test it with the other tools you are going to be using in advance. This will ensure that it doesn't react adversely to your other equipment.

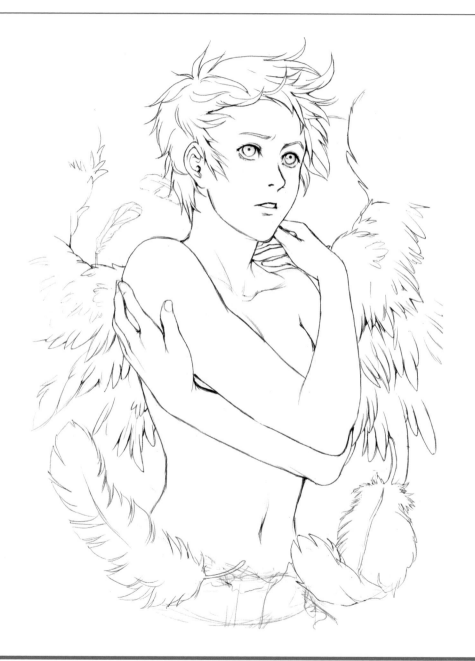

Drawing a Forest Spirit

By Valentina Remenar

Introduction

Creating an interesting manga image doesn't mean that you have to use expensive or complicated tools. Great results can be achieved by simply using pen and paper. A solid base for your drawing and a good idea are much more important than the materials that you use.

Tools Used

- Bleed-proof paper
- Pencil
- Fountain pen

Creating a Concept

When I start a new image I always begin with a concept sketch. On a regular piece of a paper, I sketch a few concepts and ideas. By doing this you can choose your favorite concept without starting numerous images you are unhappy with. When you have done this, try to choose the sketch that benefits from the best composition and that has interesting details in areas that you want the viewer to focus on. You can see my chosen sketch in **Fig.01**.

In the coloring section of this book I will tell you more about how to select the colors and use them carefully in your image. However it is important to make sure that you are thinking about color when you are creating and choosing the sketch, as it may help you to think about the mood and pose of your character.

Once you have created your basic sketch you need to start work on your actual drawing. Although this is the final image, you are still just setting the basic frame so don't get bogged down with details at this point. Start by using basic shapes to mark out the position of the head and by marking in the proportions of the rest of the body. You can use references to help you do this if you like.

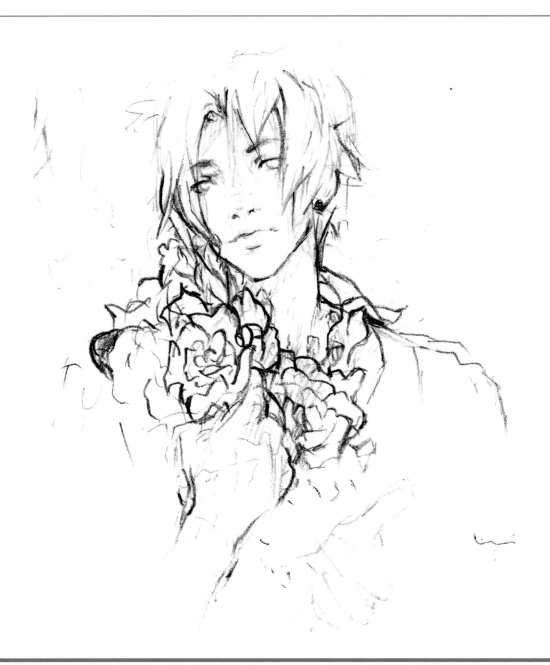
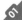

At this point you need to move onto the piece of paper that you plan to use for the final image. I tend to use a bleed-proof pad that means that the pens and other tools I use won't run and smudge on the page, or soak through the paper.

Setting a Base

When you start sketching, try to think of everything in its most basic form. For the head simply draw a circle and draw a line through it, top to bottom, to mark the center of the face. Then you can simply mark the eyes with circles. The eyes should be halfway between the chin and the top of the head. Again, the mouth, nose and ears can be marked out by using simple lines and shapes (**Fig.02**).

Once you have the face marked out you can move on to the body. It's important to consider the differences between male and female anatomy. For example, a man has much wider shoulders so you should make sure this kind of thing is obvious in your drawing. To identify the position and pose of the arms, draw a small circle at the joints and use basic straight lines to mark where the arms will be. This same technique and method of marking out the basic structure of the body can be used to create the base for the wrists, arms and other limbs if you choose to draw an entire character.

The Face

Once this base is in place and you are happy with it, it is time to move on to the details. In **Fig.03** you can see that I started adding details to my image in the middle of the character's face. How to draw the individual features of a character's face was covered in the first section of this book. The important thing to think about when you start drawing them in is their position. You may want to use a reference again to make it easier to position everything. Don't restrict yourself to having to draw features where you marked them in your original sketches.

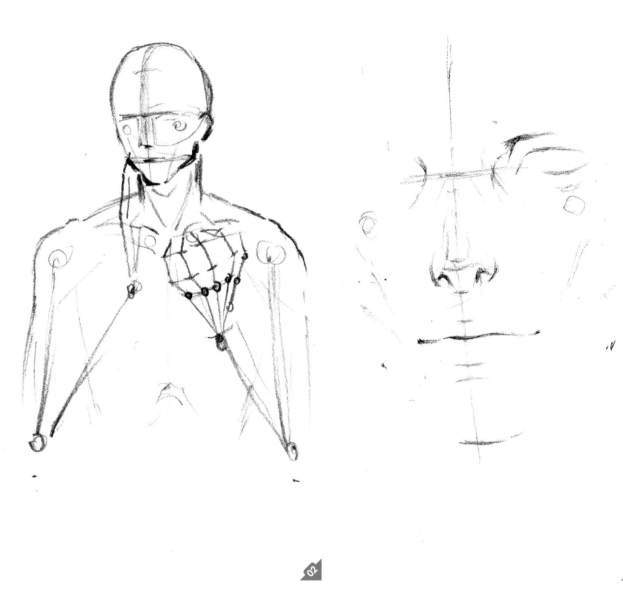

It is good practice to draw faces slightly from one side, rather than straight on, as it adds a sense of depth and believability. However, this will mean that when you draw lines around the round head to mark features and the position of things like the eyes, you will need to take perspective into consideration.

Artist's Tip: Facial Sketching Guides
The vertical line down my character's face is not parallel to the edge of the paper due to the tilt of his head. Remember to make sure the lines that run around the head are always at a right angle to your center line when it crosses it.

If you decide that you don't want to draw the vertical and horizontal lines I would recommend starting your drawing with the features in the middle of the face, like the nose, mouth and chin, as these are symmetrical and will help you position other features, like the eyes, etc. When creating a manga image it is typical to make the jaw of male characters look a little more angled and strong. This is another way of differentiating between male and female characters.

Drawing the eyes is a simple case of using circles and ellipses. Imagine that the eye is one big circle, then draw two ellipses over it: one for the upper eyelid and one for the lower. You will see how you can create the shape of an eye after practicing this a few times. You can also use the upper ellipse to mark the location of the eyebrow (**Fig.04**).

The ears should stretch from roughly the same level as the eyes down to the bottom of the nose.

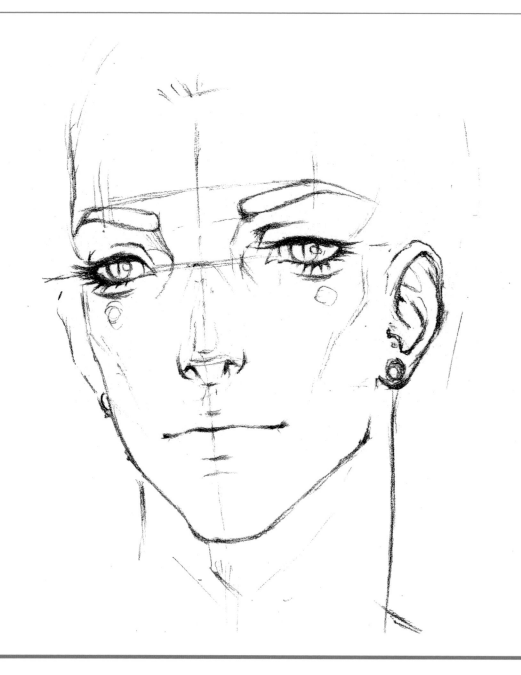

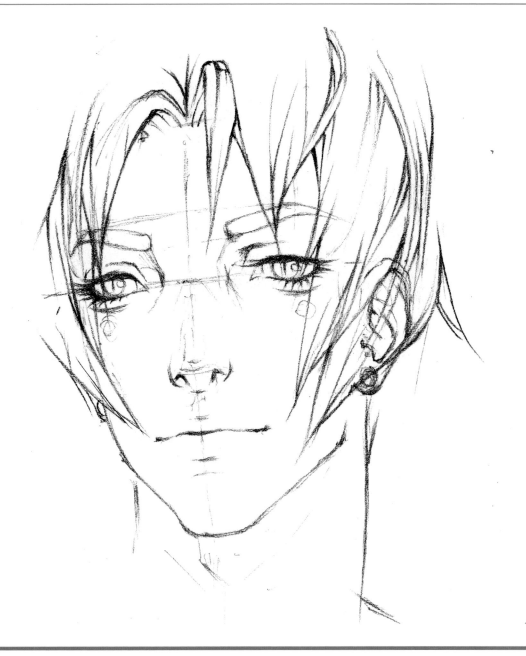

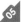

The Hair

You will eventually have to draw the shape of the head, if you didn't do it earlier when drawing your circle, as the next step is to start on the hair. The hair should be drawn from the scalp outwards. Try to think of a style that would suit the personality of your character, and draw the hair in sections from its origin on the head to its point. Because of the fact that this is manga you can concentrate on the overall forms rather than thinking about the individual pieces of hair, which is what you might do if you were creating a realistic painting (**Fig.05**).

The Body

Once you have done your character's hair, the head should be finished. It is now time to move onto the neck and body. If, like me, you have drawn your character's head at an angle, remember to consider this when you draw the neck, as you will see less of the side of the neck that is turned away from the viewer. You can also mark where the Adam's apple is, although this should be done carefully using faint lines as there are no strong edges or lines in this area.

Drawing the collarbone is, again, fairly simple. The collarbone is more or less a straight line that runs just below the neck, in line with the top of the shoulders. As I mentioned before, remember to demonstrate that the character is male by including wide shoulders. It is important to consider correct anatomy, even when drawing a simplified form of it, which is what manga is. To give yourself the best chance of doing this draw a line down the center of the character's body, the same as you did for the head. It will help you when placing muscle structures and the overall form (**Fig.06**).

You may notice that the final image in this tutorial shows the character fully dressed; however, I have sketched some of his torso as if he is not wearing clothes. This is because it is best practice to ensure you have the correct anatomy and body shape for your character before trying to draw in complicated details and clothing.

The next step is to start to work on his arms and hands. You will remember how I marked those out earlier using simple lines and balls for joints. This is where they become helpful. At this point the aim is to add volume to your pre-posed and pre-located lines. To do this, add cylinders over the straight lines you drew earlier and refine them to demonstrate areas of muscle tone. Again, it is helpful to use a reference or anatomy figure when doing this as it will ensure that you are adding extra volume where it is required (**Fig.07**).

Clothing and Details

Once the body of the character is in place it is time to think about more of the details that you want to put in your image. You may have a good idea about how you want your image to look from your concept sketch, or you may still be unsure about how you want your final image to look, but what is important is that you carefully consider the make-up of everything you do draw. For example, I drew my character in a shirt and a waistcoat. When observing these things in the real world I realized that the main difference was that the thinner and lighter nature of the shirt meant it contained more wrinkles than the waistcoat. By including this type of difference, it gives the viewer a better idea of what the materials in the image are. Also, the roses were drawn by looking at images of roses (**Fig.08**).

I decided that I wanted to add some butterflies to the scene and, again, used a photo reference to sketch them. You will also notice that I have added some tattoos to his arms (**Fig.09**). If you decide to draw something like tattoos remember that the surface of the arm is not flat as it appears in the image. It is a curved surface, with volume, so the pattern on the tattoo will distort as it starts to disappear around the character's arms. If you draw a repeating pattern, like I have, you can use guidelines that you draw around the arm to set the framework for your design.

What you include in the background of your image can be totally up to you. I decided that I wanted to continue the rose pattern that I had started around his chest area. This was to tie the character into his background (**Fig.10 – 11**).

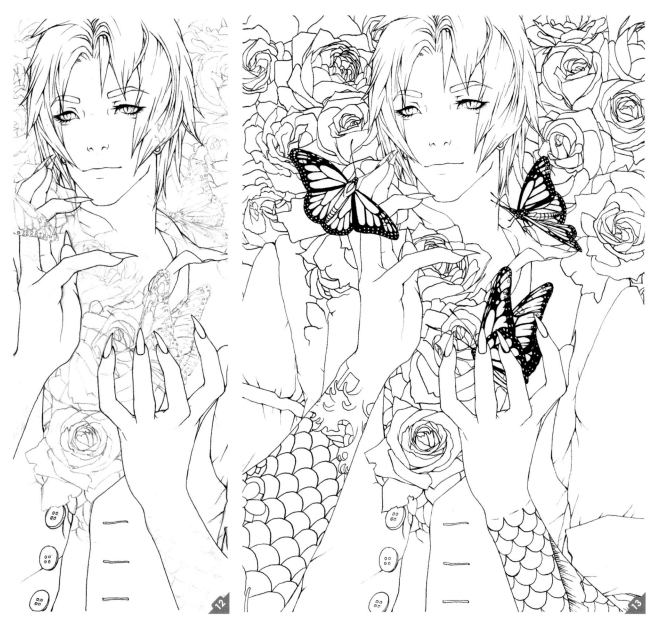

At this point I had a completed sketch that I was happy with. When you are at this point you might decide that you would like to continue to develop the image by inking it and then coloring it. Many different artists will use different tools to ink their images, depending on preference. I use a fountain pen, which is dipped in ink, to do the lines. Simply draw over your sketch carefully, trying to draw the smoothest lines you can (**Fig.12**).

Once you are happy with all of the inking that you have done and the ink has dried, you can then use a rubber to erase all of your sketch lines. At this point the image is ready for color (**Fig.13**).

Drawing a Japanese Warrior Boy

By Georgina Chacón

Introduction

Whether you're intending to draw a new or previously designed character, it's always useful to start a new image by doing a couple of design sketches to get an idea about what you want to achieve. For this tutorial I decided to draw a Japanese-styled warrior boy, using both traditional and digital tools.

Tools Used

• Mechanical pencil with colored leads
• Paper
• Photoshop (if you would like to create digital line art)

The techniques and approach I'm going to use to draw this character can be used to draw any manga character with most art tools. If you have yours ready then it is time to begin.

Sketching

The initial sketches can be as detailed or simple as you want them to be, but for my image I decide that I want to go for an action pose. When I sketch the character I don't worry too much about the anatomy as that isn't important at this stage, although it will be later (**Fig.01**).

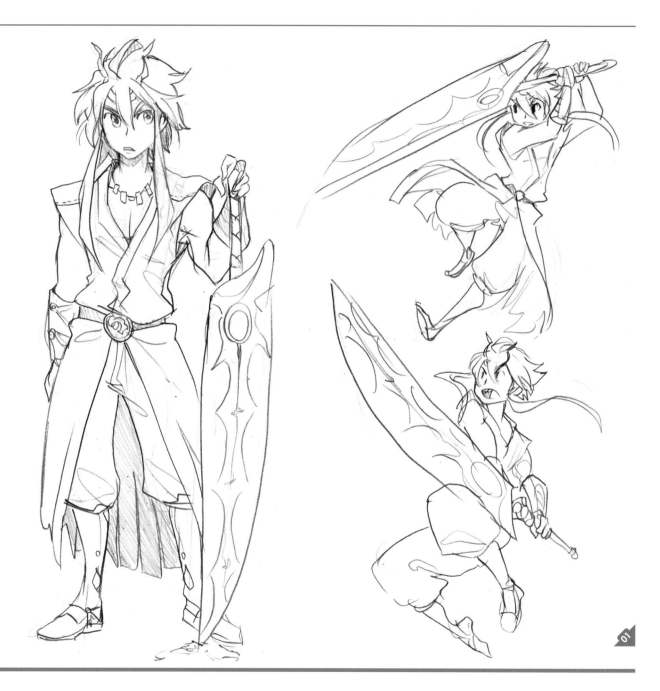

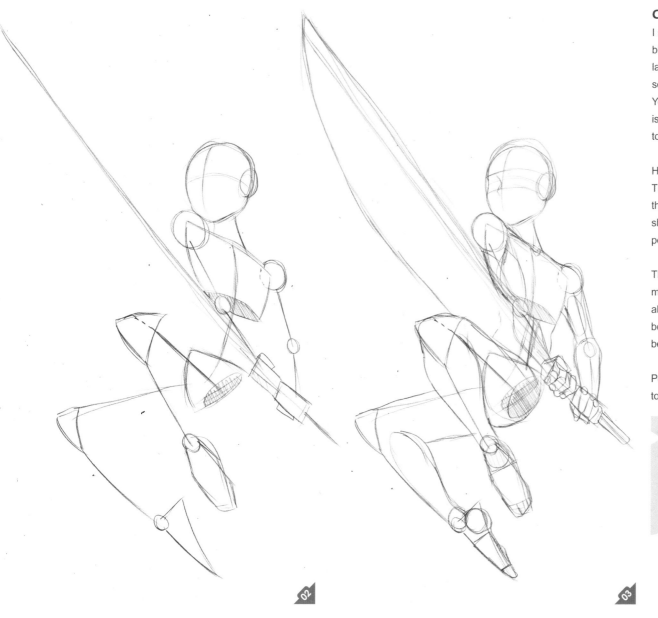

Creating a Base in Blue

I start by using a 0.5mm mechanical pencil with blue leads. The blue color is easy to distinguish from the pencil tones I will use later. With your sketch at your side, begin your drawing by drawing some very basic guidelines to set the base of your image (**Fig.02**). You may find drawing basic lines and circles a bit boring, but what is important to focus on here is the length and size of the body, torso, head, arms, legs and sword.

Here comes the part where you have to test your anatomical skills. This may be a boy, but he's also a warrior. Remember to consider the nature of what you are drawing when you fill in the volume and shape. He will need to have a muscular and athletic form to make people believe he is a warrior.

The next tricky part is where to put the sword. It's very big and it may cover most of the waist, not to mention that both hands are also on the hilt. Let's start by a looking at how it interacts with the body. The nearest part of the body should be his left leg, so this will be in front of the sword, obscuring it from our view.

Positioning the arms and hands is not an easy task. The best way to get it correct is by searching for references online (**Fig.03**).

Artist's Tip: Taking Reference Photos

If you can't find any helpful references take a picture of a friend holding a broom handle or something similar. You may look silly, but it will provide you with an accurate and useful guide

Adding Some Detail to the Sketch

When you start placing the clothing and hair, consider what the character is doing. This warrior is in a jumping position and is actually in mid-air. He's traveling at speed and gravity's effect on his loose clothing will be adjusted as it won't just hang down any more. The same applies to his hair (**Fig.04**).

Detailing the Sketch in Black Pencil

At this point I move over to a black HB 0.5mm pencil. The blue leads are hard to erase around the new black color, but keep them for now and we will get rid of them later (**Fig.05**).

Artist's Tip: Changing a Design

It's okay at this point to change some parts of the design; for example, I didn't like the sword, so I gave it a new shape.

Keep working on the sketch until you feel satisfied with the outcome. Don't worry too much about how smooth and detailed the lines are; these are also just guides for the line art, which for this image will be done digitally (**Fig.06**).

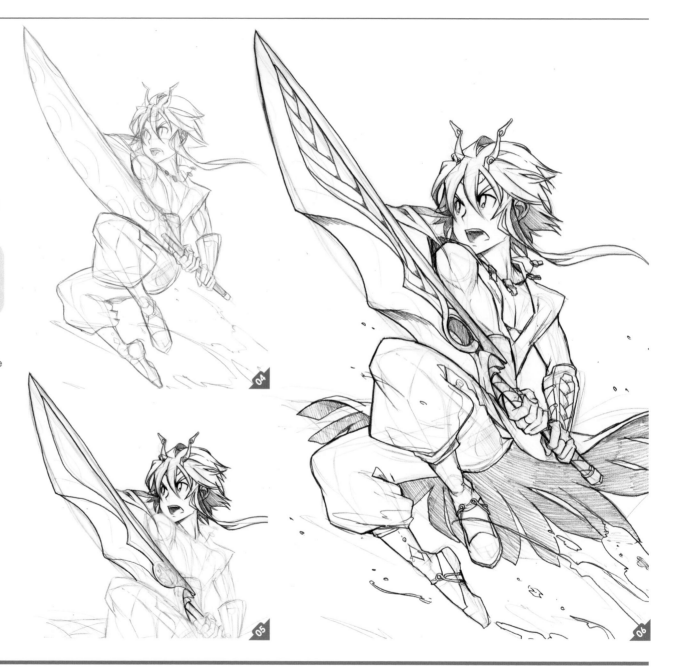

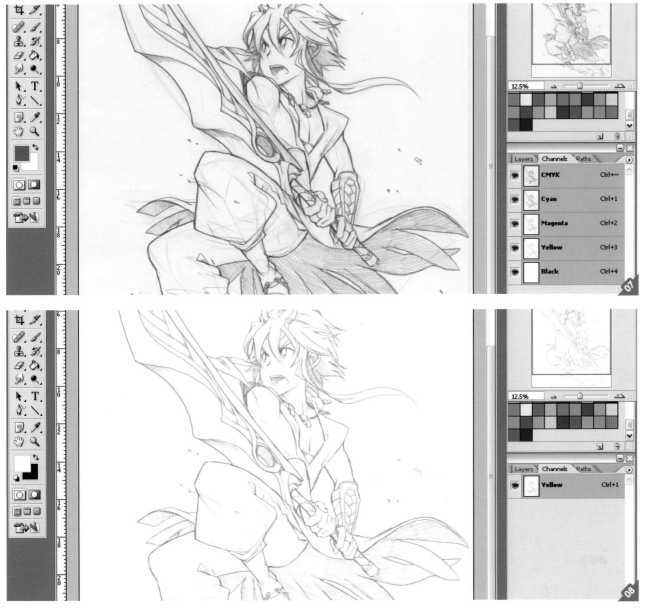

Creating Digital Line Art

If you choose to you could simply use a black pen to ink this character and then color it traditionally after rubbing out the lines, but we will now look at how you can do this using Photoshop. Time to use your scanner! It's very important to adjust your scanner resolution. A scanner normally scans at 72-150dpi, and it looks nice on a screen, but this isn't high enough quality when it comes to printing and it will leave your drawing looking pixelated. If you plan to print the image set the scanner to a minimum of 300dpi.

After you have scanned the image, open it in Photoshop. The next thing you need to do is switch the color mode to CMYK by clicking on Image > Mode > CMYK color. In the Layers window on the right you'll notice a Channels tab; click it and you'll see four color layers (**Fig.07**).

In the Channels tab delete all the colors except for Yellow. When you do this all the blue lead will disappear, leaving your drawing clean, but lighter in color. Switch the color mode to Grayscale by going to Image > Mode > Grayscale to preserve the image and switch the color mode back to CMYK. You must remember to do this otherwise you won't be able to add color to the image (**Fig.08**).

The drawing is still too light. To fix this, adjust the levels (Image > Adjustments > Levels). A little window will appear. There are three little arrows to modify the shadows, mid-tones and highlights. Move them freely until you get a correct balance of blacks and whites (**Fig.09**).

Sometimes what you see on the paper is not the same when you put it on the monitor. This is usually due to the angle you look at your work from when you are drawing. When looking at my image again on the screen I don't like the position of the left leg. To fix this you can crop and rotate and move that part of the image. You can see what I've changed in **Fig.10 – 11**.

There may be a few blank areas once you have done this. You can easily fix these later when you are creating the final line art.

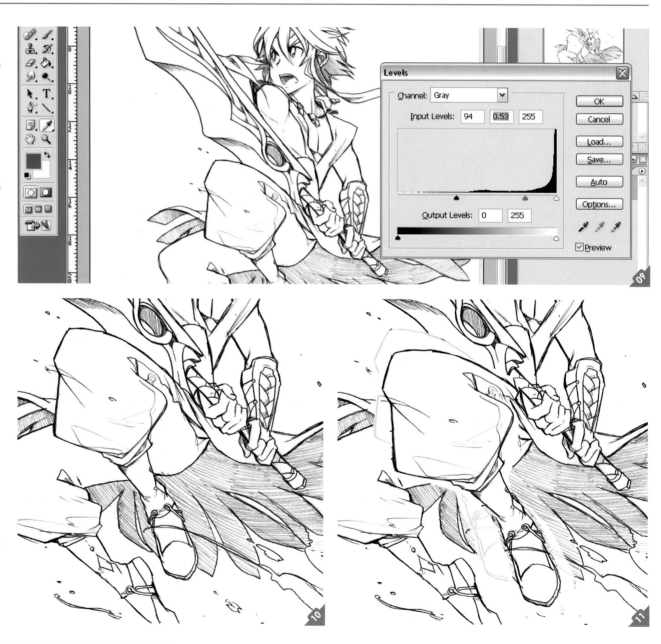

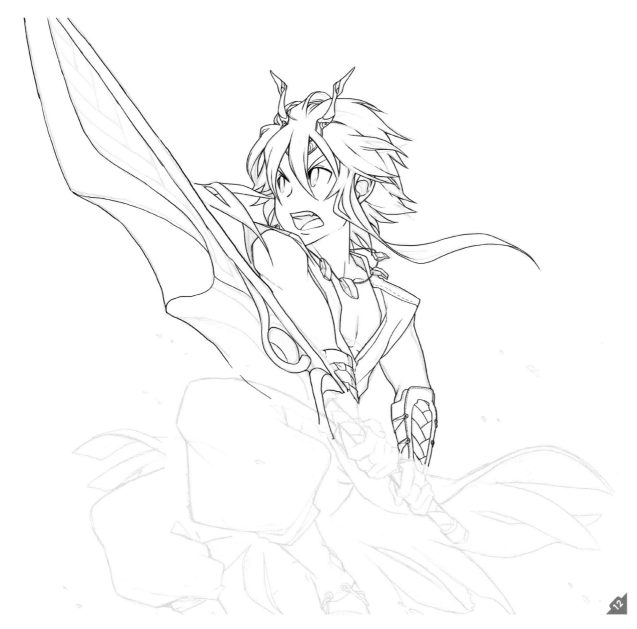

To get ready for the inking process, lower the opacity of your sketch to 10-20%. If your sketch layer is the base background you won't be able to modify the opacity. To fix this you will have to duplicate the layer (Layer > Duplicate Layer) to enable the option.

Now go to your Brush tab and select one of the first basic brushes, as most of them will be fine to create the line art. Select the size of your choice. Even if you like thin line art don't be too tempted to choose a very small brush, because if you print the image you will not be able to see the lines.

Inking long, straight lines can be hard if you haven't got a perfectly steady hand. You can see an example of this in **Fig.12** where I have tried to draw the lines for the sword freehand. To get good, smooth lines create a new layer and instead of using the Brush tool, use the Pen tool. Make sure you set the Pen tool so that it leaves the vector path and doesn't fill the shape with color. Trace over the line drawing.

Once you have traced the shape, right-click and an options window will open. Select Stroke Path (**Fig.13**). A little window will open, in which you will need to choose the Brush tool and then click OK (**Fig.14**).

This will leave you with a smooth and clean line. You can add as many of these paths to your drawing as you like, but don't abuse them otherwise the paths will look strange against the parts of the image you did freehand (**Fig.15**).

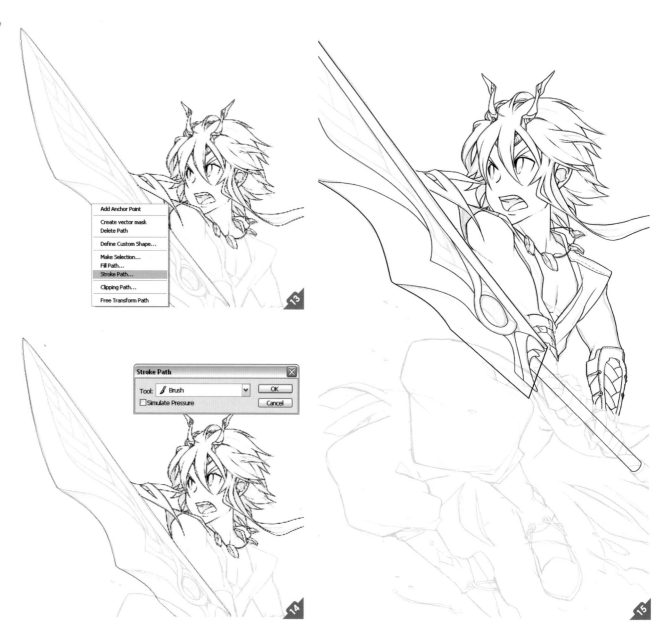

Continue inking until you're finished. When you are done you will have two layers of ink, one for the sword and the other for everything else (**Fig.16**). Erase the overlapping parts and merge the two layers (Layer > Merge down).

All that is left to do is erase or turn off the visibility of the sketch layer and save your file (**Fig.17**). If you erase the sketch layer remember to save the new file under a different name in case you want to use the sketch again.

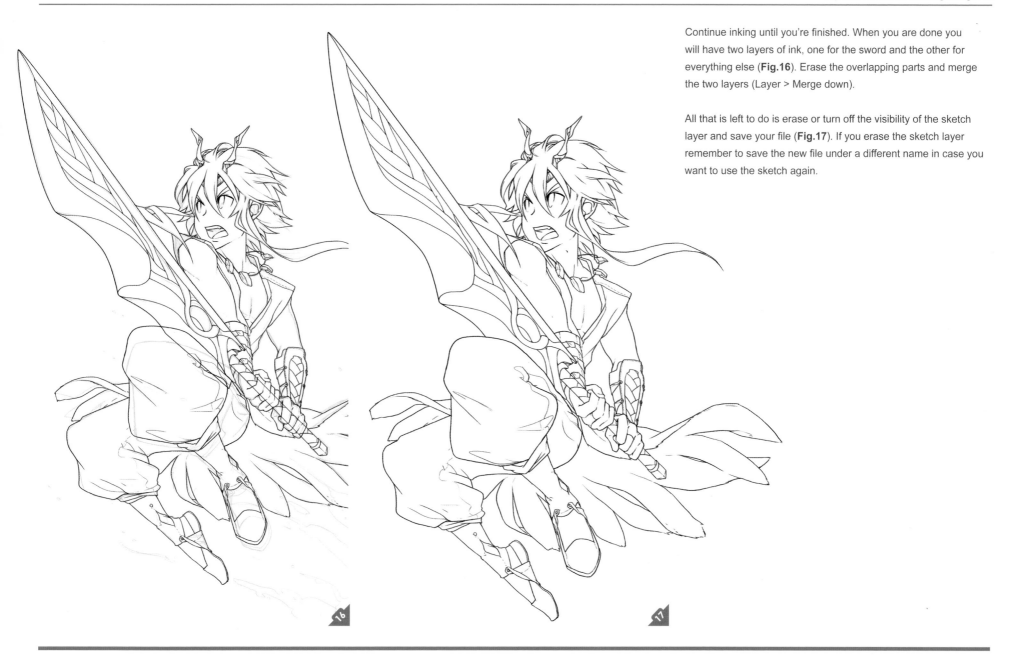

Drawing a Lychee-Obsessed Girl

By Sandra Chlewińska

Introduction

When I am planning to work on a full color image instead of just a sketch, I start by doing a few things to engage my imagination. This is a great way to get you drawing something that you wouldn't usually draw. Look at fashion magazines, watch movies and listen to music – all of these can help point you in a direction.

Tools Used

- Pencil
- Paper
- Paint Tool SAI

Inspiration

For this particular piece I was inspired by a bottle of lychee drink and a lacy yellow sweater I found in a magazine. I decided that I was going to draw a lychee-obsessed girl on vacation. Once you have your idea, start sketching a few poses on paper with a mechanical pencil using B leads (**Fig.01**).

Creating the Sketch

After you have chosen the best pose and have decided on the composition, continue by adding details to the picture (**Fig.02**). The sketch at this point can be really messy as you are still in the process of working things out. As you start to refine the sketch you can begin making clearer lines on the sketch to help you with the line art later. If your sketch gets too messy, trace it onto a new piece of paper using a light box.

Artist's Tip: Mirror Image

I recommend helping the accuracy of the poses you draw by looking at yourself in the mirror and drawing from life. This can also help you think of more original poses.

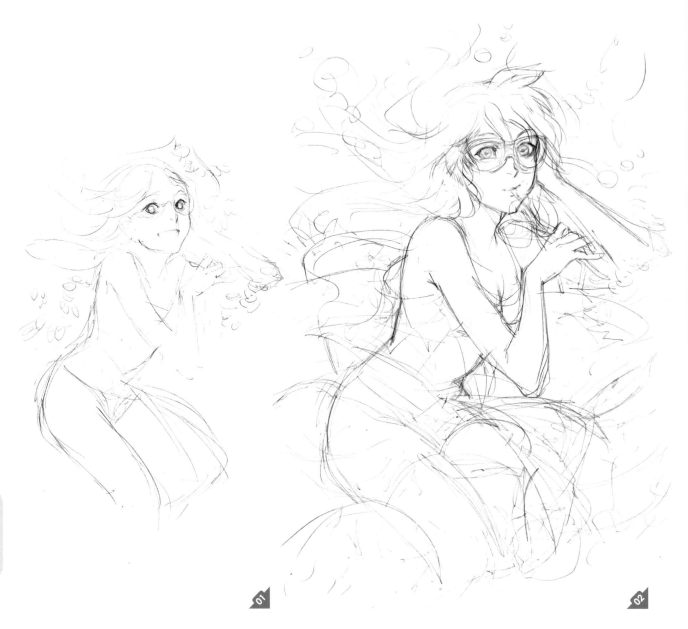

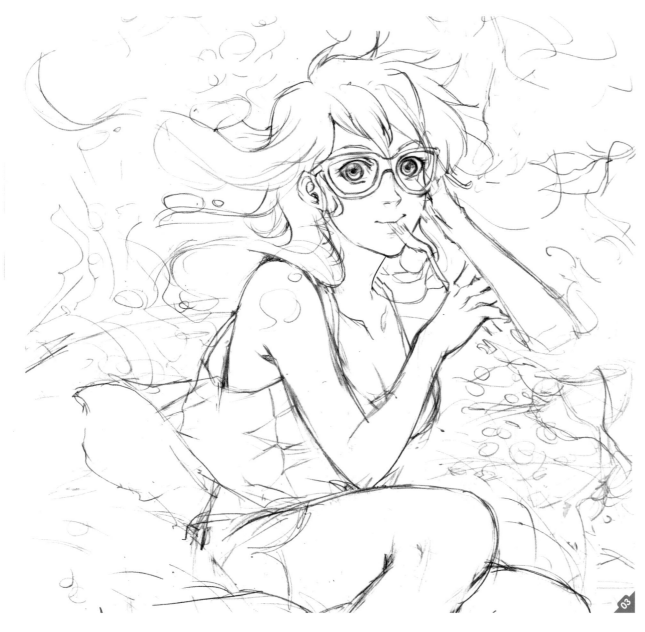

I traced my image onto a fresh piece of paper to help me clean it up (**Fig.03**). To continue drawing the rest of this image I used a popular program called Paint Tool SAI. I scanned my sketch and imported it in to the program. SAI is perfect for creating line art. It also has benefits over Photoshop in that it uses a lot less memory and works faster. On the negative side though, SAI won't let you work on a big image because of the file sizes. If you experience this issue then you may need to scan in your image in parts, line them up and then string them together in Photoshop.

Once I was in SAI, the first thing I did was to change the size of her head as I felt it was a little too big. The benefit of using programs like this is that it is very easy to adjust things if you want to. I simply used the Lasso to select her head, pressed Ctrl +T and held Shift as I resized the head to match her body.

Creating Digital Line Art

Once you are satisfied with the sketch you can set the sketch layer to about 50% and start your line art on a separate layer above the sketch using the Black Pen tool. I like to make my line art clear, but not too thick. To do this I set the brush size to 3.5. You will find it much easier to draw around your sketch using a graphics tablet than you will if you use a mouse. You can, of course, create the line art using traditional tools like a black pen if you don't have the computer equipment required.

Artist's Tip: Drawing Upper Eyelids

Always draw the upper eyelid thicker than the bottom. This is simply because there are more eye lashes on the upper eyelid than the lower.

As you move further back into the image, try to make sure that you use thinner lines. If you don't it will confuse the viewer into thinking far away items are nearby.

Don't try to draw realistic hair or individual strands. Draw the hair with long, flowing lines that come to sharp points. Manga images tend to simplify forms, and hair is no exception to this. Try to draw your character's hair moving in different images as it will make your image more dynamic and appealing (**Fig.04**).

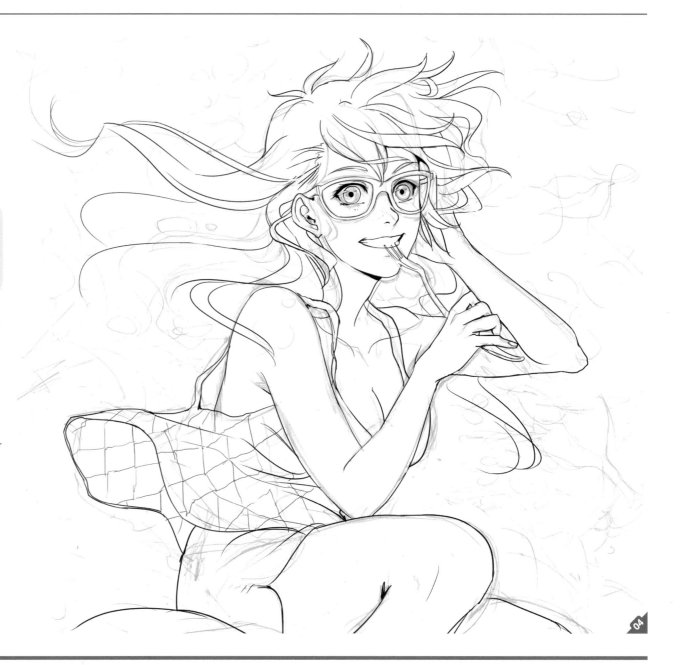

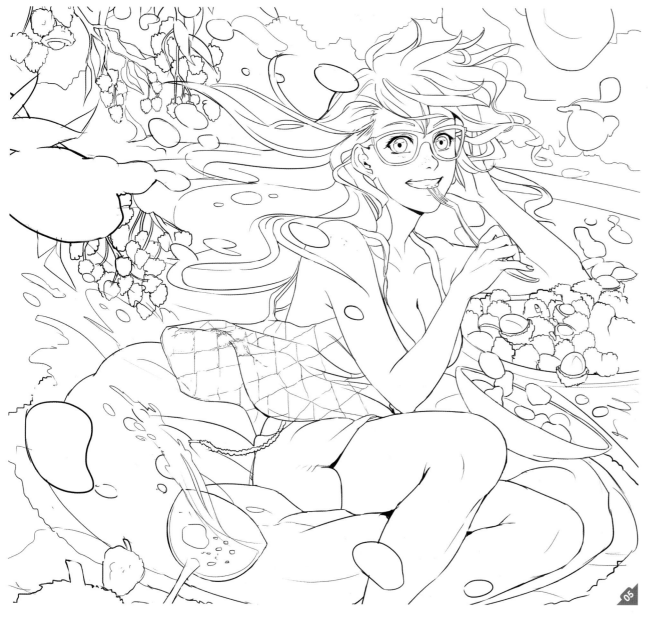

Completing the Line Art

I expanded my canvas to the left as I felt it made the image stronger compositionally and more dynamic. There are many different rules and suggestions about composition. I tend to try to build my composition by including three points of interest that a viewer will settle on. In this image these points are the lychees in the foreground, the girl's face and the lychees on the tree.

If you do use digital tools, flipping the canvas is usually very simple. Do this from time to time to spot mistakes and unbalanced parts of the image. Try to be self-critical when you create an image. If something doesn't look right, change it.

The final job before coloring is to make sure there are no holes or errors in your line art. Check your lines carefully, rub out mistakes and add to areas that need detailing. Putting in effort here will pay off later (**Fig.05**).

Drawing a Fantasy Elf
By Christopher Peters

Introduction

To create a manga image you will need several different tools. These can be things such as pencils, inks, pens, brushes, graphite, etc. Although there are many different things to choose from, the tools you use can be very simple. For example, I only used the following:

Tools Used

- Mechanical pencils (No.05 and 07, with blue and black lead)
- Rubber
- Paper

Your choice of pencils, leads and paper is very important as they will all have an impact on your final result. Personally I like No.07 2B leads as they give you strong and defined lines. To add all of the detail I use No.05 2B leads because they produce a clean stroke and help you when drawing smaller details. So let's see how we can use these tools to create a manga image.

Stroke

The strokes you use are really important. Drawings that look good don't only consist of dynamic poses and cool ideas, but usually employ interesting strokes. A clean and defined outline will help to define and intensify details and form. When you start sketching, try to use fast and fluid lines. Don't spend much time drawing things carefully and slowly as it can make your sketch look lifeless (**Fig.01**).

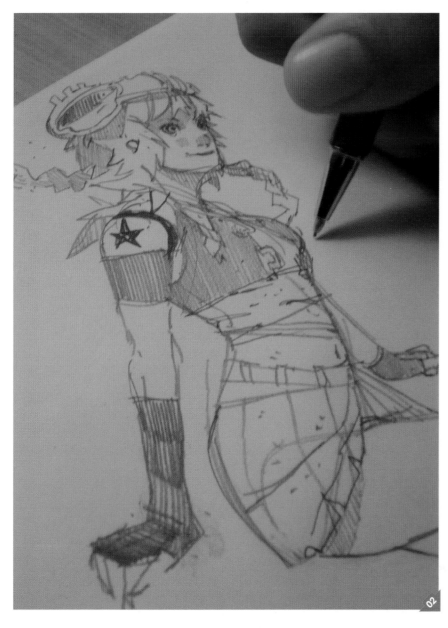

Hatching

There are many techniques that can be used to enrich a drawing. Sfumato, hatching and pointillism are just a few of your many options. The techniques I prefer are hatching and crosshatching. I use them to indicate shadows or dark areas, and to generate contrast. The main aim of this technique is to create the illusion of volume, texture and shading. To get a nice result try to draw close, parallel lines that flow in the direction of the form. If you want to create areas of contrast just change the direction of the lines! You will see this effect used in my image.

Creating a Concept

When creating a character it's very important to think about the concept and what we want to draw. Like all things, it is important to start at the bottom and work your way up. The success of the final image will be influenced by how carefully you have thought out your sketch at this early phase.

What you draw in your concept depends on what you want to portray. Try to think about the pose, facial features, clothing and hair, etc. There are no restrictions on this so try to be original.

As it was a manga character I wanted to think about how I could do something a bit different. I wanted something fun and original, so I started to create several different ideas (**Fig.02**).

I then started to draw crazy, girly frogs, because I really love frogs and those little dudes are funny. I was really excited about this, but that idea didn't work so I discarded it and returned to the drawing board (**Fig.03 – 04**).

I've always liked dark, fantasy images, so I decided to design a dark, fantasy, manga girl. My final idea was to draw a curvy, female elf that looked dark and magical. I decided to call her Dascha.

Pose

The pose is important as it reflects the attitude of the character. For example, we know that a powerful, evil character should have a pose that reflects authority, with crossed arms, a head high, a scary glare and things like that. This character is an elf so I needed to think of a pose that reflected her attitude; for example, sensuality, sweetness, innocence, mysteriousness, etc.

Try to see the shape of your character as a simple silhouette to begin with, as this will help you focus on a pose without being distracted by clothing and details. To begin, create some silhouettes that explore all of the ideas that you have. The more of these you create, the more likely you are to stumble across something that you like and that is more original (**Fig.05**).

Artist's Tip: Quick Silhouettes

Try to create as many rough and quick silhouettes as you can in a short space of time. This will encourage you to be original and stumble across something new.

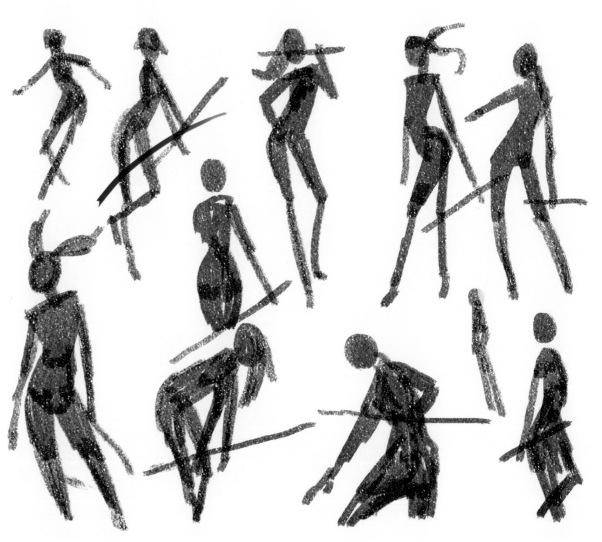
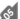

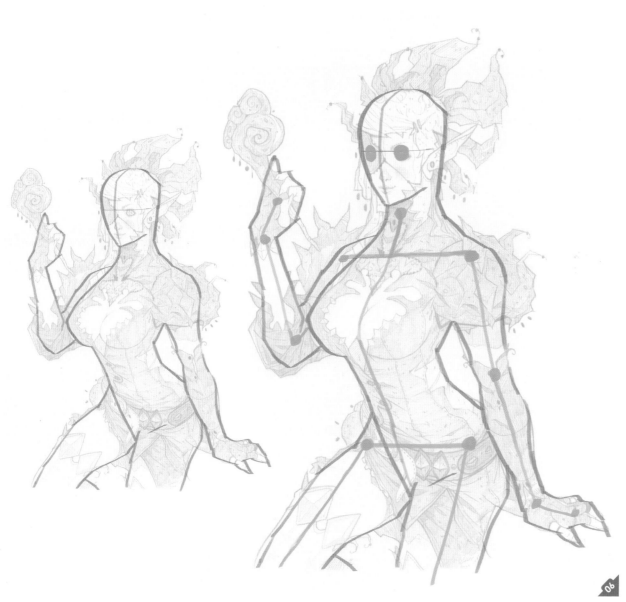

The Sketch

The main goal at this point is to bring all of your random sketches together to create a guide for your image. I used blue leads at this point, which are really helpful when drawing sketches and quick doodles. Create a sketch that you can use as a guide to help you when you create your final image. You don't need to show all of the details here, but you should show the pose and character of your subject.

The Structure

Once you are happy with your sketch and pose, you can begin on your final image. The first step is to define the structure of your character. To start doing this, draw a very simple skeleton that mimics the structure you drew in your sketch (**Fig.06**). The one thing that you have to do at this point is to make sure that you correct any proportion issues that may have come up in your sketch. It is much easier to do this when drawing the basic structure of the character than when drawing the details. You can use a reference to help you do this.

The Drawing

The next step is to move across your image, sketching in all the details and clothing, etc. I recommend starting at the top and working your way down as this will help you avoid smudging your image (**Fig.07**). Remember to use the quick and fluid pencil strokes mentioned earlier, whilst still being careful to work around the structure you have in place (**Fig.08 – 09**).

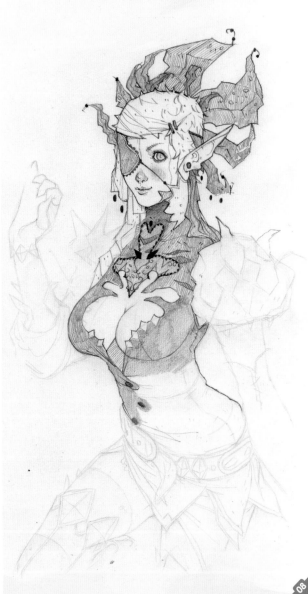

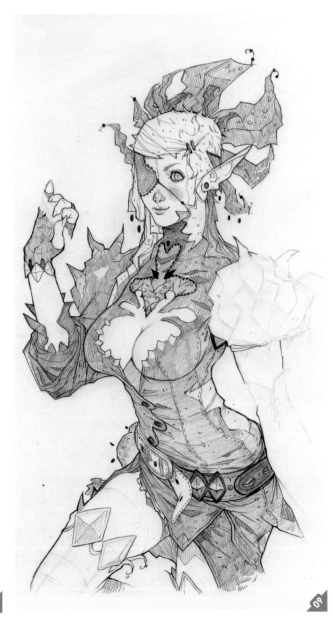

Continue to develop your image, being careful to stick to the framework you started with. Add hatching to those areas that require more texture and volume. When you use hatching remember to change the direction of it to demonstrate the different faces of the surfaces. Use references to help you match the way materials act and appear (**Fig.10**).

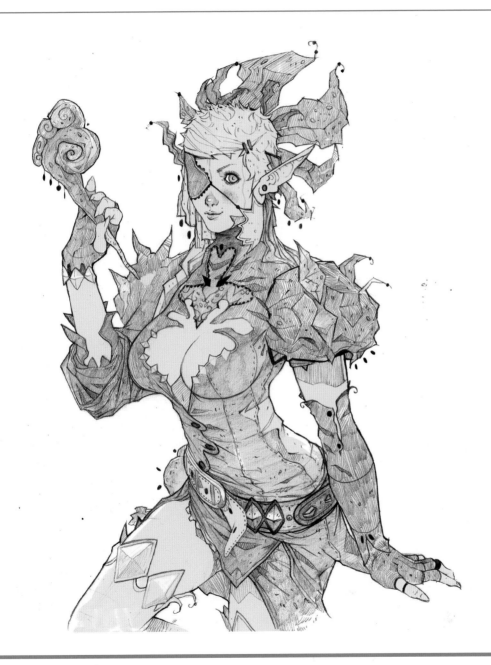

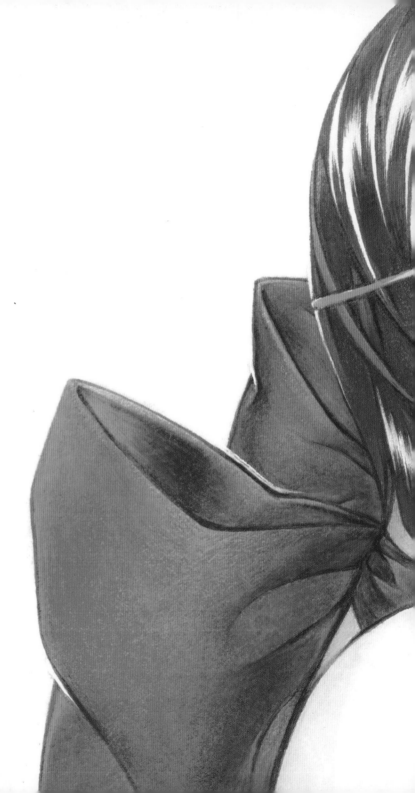

Coloring Characters

So you've finished your line drawing. What should you do next?
You could leave it as it is and feel happy that you have created
a cool character design, or maybe you could be brave, take it all
the way and create a full color illustration. If you fit into this brave
category, where should you begin? What tools do you want to use?
What colors should you choose and how do you give your line
drawing volume and life? In this section our skilled artists will add
colors to their own line art, while talking you through their coloring
process. The artists will be using a variety of tools and approaches,
from Copic markers to pencils, to traditional paint and digital
painting in Photoshop. So what will your tool of choice to color your
line art be?

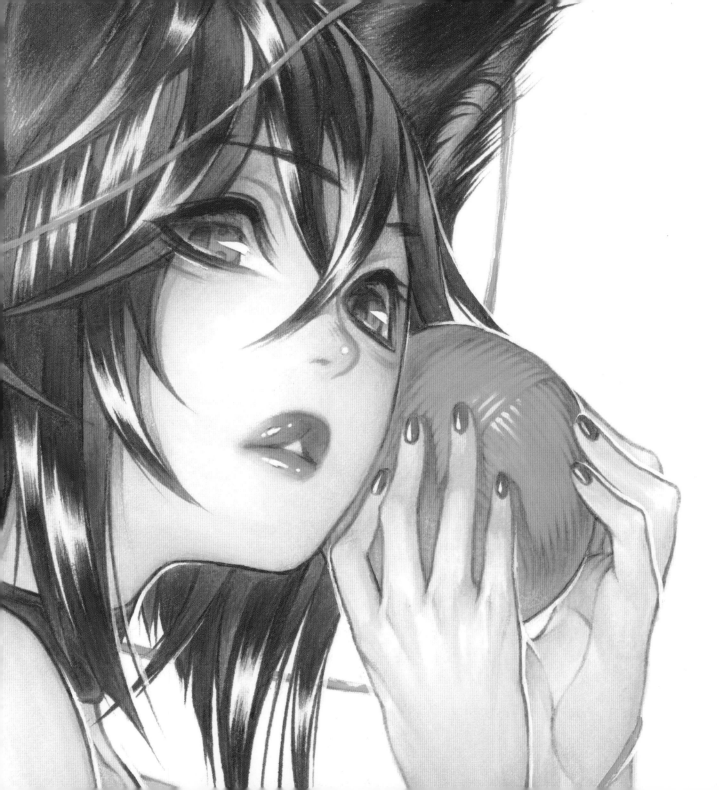

Coloring the Barber

By Israel Junior

Introduction

If you followed my first tutorial in this book you will already have a finished image ready to be colored.

Tools Used

- Indian black Ink
- Indian colored Inks
- Soft bristle brushes

Painting

The first step before adding color is to make sure that all traces of pencil have been erased. Pencil will not disappear or be hidden if it is painted over, so you will still be able to see it which will be annoying and ruin your image.

Once your character is ready for inking it is time to start using inks to add color. The first area to tackle is the skin. This is where you will need your yellow, red and white inks. Drop two drops of yellow ink into a small amount of water. Then using a brush, start to add small amounts of red to the mixture. You can also add a drop of white to lighten the color. When you have a good skin tone, split the mixture in half and add a little more water to one of the inks to lighten its overall color.

Dip the brush in the ink that is diluted and paint the lighter tone of the skin (**Fig.01**). This tone will cover most of the character's skin.

With the other ink, which is less diluted, paint the areas of shade on the skin, remembering to try to demonstrate the form and shape of your character. If you like you can drop another very small amount of red ink into this mixture. When adding shadow to a manga character you can use a variety of techniques, but I tend to add the shadow in blocked sections, rather than using a gradient (**Fig.02**).

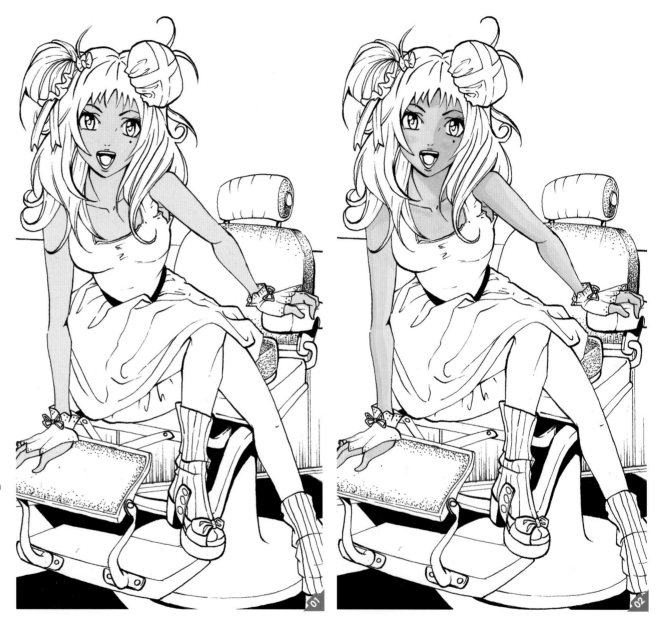

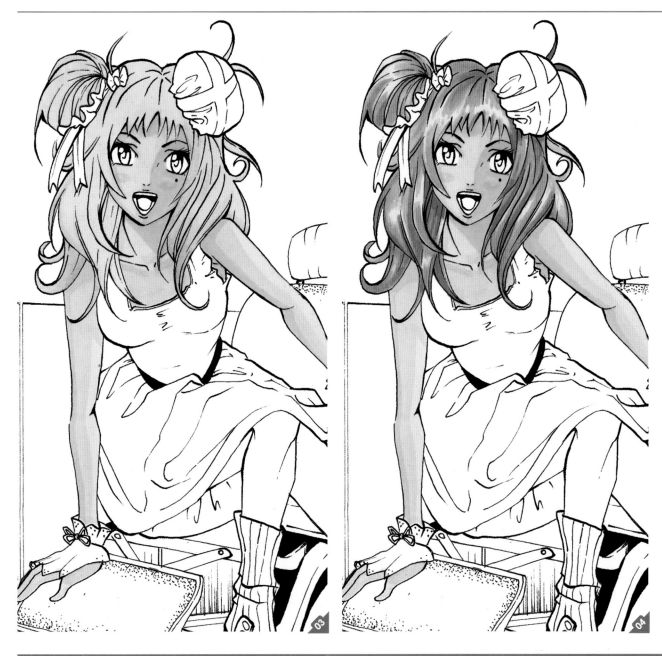

Using the tone that you used to add shadow to your character's skin, paint a base color over your character's hair (**Fig.03**). Add some red to this mixture to create a color nearer to pink. If you add too much red by accident, use white to tone it down.

Paint the shadowed areas of the hair using strokes that follow the flow of the hair (**Fig.04**).

Artist's Tip: Hair References

Look at real-world references when painting shadow on your character's hair. Hair can be very reflective, so you don't want to get too carried away.

Using the pink color you created for the hair, add a little more water to the mixture and use it to paint the lighter base color for the tights. Although it is good to re-use previously mixed colors, at times you do need to start again and mix a new color from scratch. Create a pink color from red and use this to paint the shadowed areas on the tights, and the base tone on the leg warmers. Once you have done this, add a very small amount of blue to this color to paint the shadow on the leg warmers (**Fig.05**).

To paint the chair's upholstery, use Indian ink. Start with a basic red color and add a small amount of yellow to it until you have an orangey-red color. When you have done this, do the same as you did previously: separate the color into two parts and add a little water to one of the mixtures. Use the diluted version to paint the base coat, but while your painting is still wet use the stronger color to add the darker areas. By painting this way you should be able to blend the colors together nicely to created a graded effect (**Fig.06**).

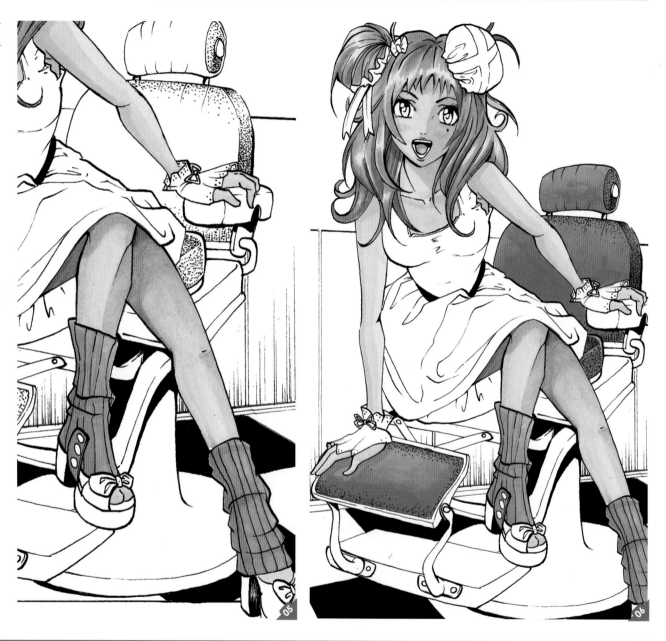

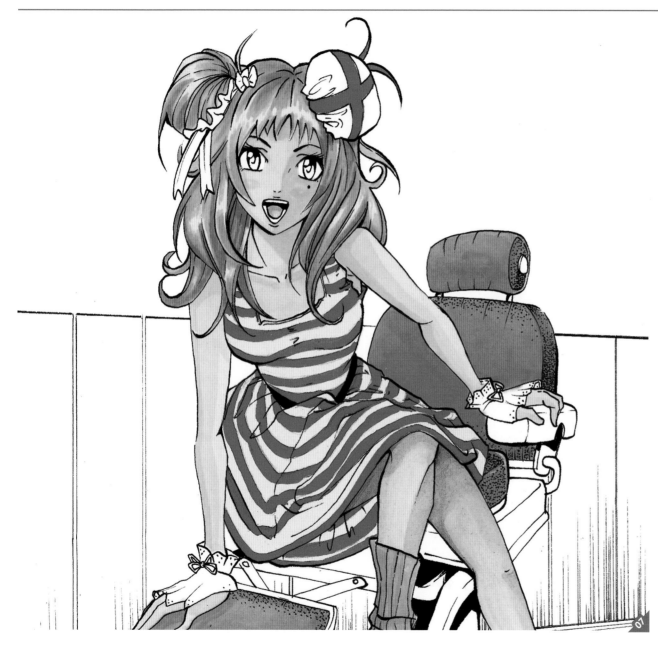

With the red Indian ink, paint the stripes on her dress and the detail on her hair ornament. Be careful when painting stripes to make sure they follow the shape of the dress and the format of the folds (**Fig.07**).

The next step is to work on the metallic effect on the chair, and the remaining areas of her dress and shoes, which will be painted using diluted, black Indian ink. Get four small containers and add water to them one by one, increasing the amount of water slightly each time. By dropping the same amount of black ink in each one you will create a grayscale that you can use to paint the gray and black areas of your image.

With the lightest tone of gray, paint the metal on the chair and the shading on the gloves and hair ornament. With a mid-tone, paint the shadowed area on the dress and a second layer on the metal on the chair, remembering to leave areas white for metal highlights. With the darker colors, detail the darkest areas on the chair and shoe (**Fig.08**).

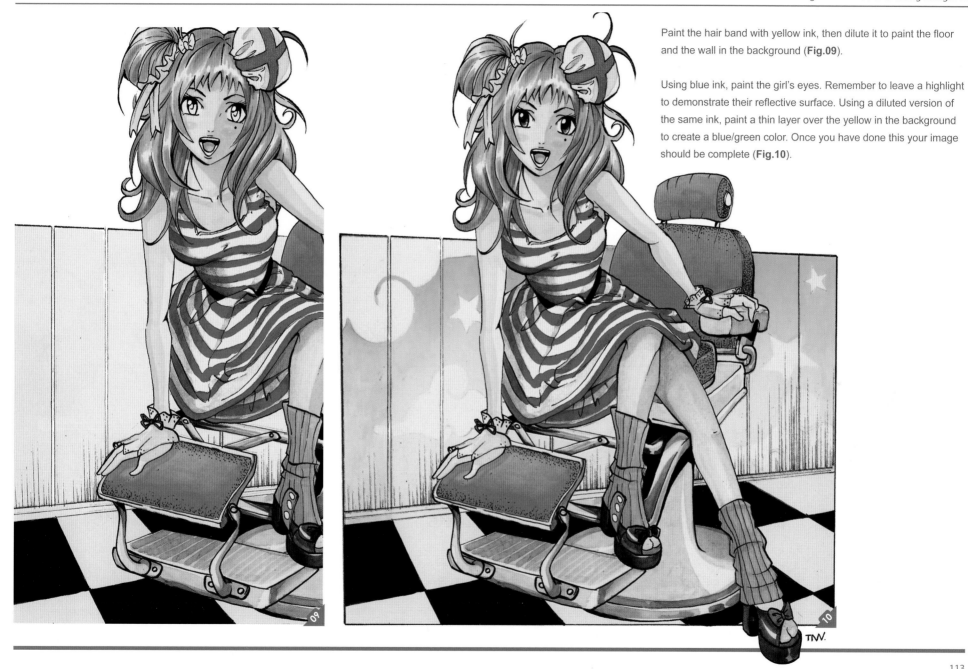

Paint the hair band with yellow ink, then dilute it to paint the floor and the wall in the background (**Fig.09**).

Using blue ink, paint the girl's eyes. Remember to leave a highlight to demonstrate their reflective surface. Using a diluted version of the same ink, paint a thin layer over the yellow in the background to create a blue/green color. Once you have done this your image should be complete (**Fig.10**).

Coloring Ayaka the Zombie-Slaying Idol Singer

By Steven Cummings

Introduction

After creating the design and sketch for Ayaka it is time to look at how to color half-rotten zombies, Ayaka and her zombie killing weaponry.

Tools Used

- Copic markers
- Manga paper
- Pencil crayons

Copic markers are a fantastic tool to use in traditional manga art work; read on to find out how to use them to create stunning results.

Choosing a Color Palette

It's now time to color the sketch that we created earlier. Before actually starting to color the image, make several printouts of the picture and try different color combinations to figure out the color palette you want to use. In some cases I make several different versions until I find the right one (**Fig.01**). This is important because knowing the colors you plan to use in advance will really speed up the process. If you spend too much time thinking about what colors you plan to use when using Copic markers, the ink will dry, the colors won't blend well and you will end up with uneven colors.

Now that you have decided on a color scheme the first thing to do is print out a copy on manga paper. The benefit of doing this is that if it goes wrong you can print out another version and start again.

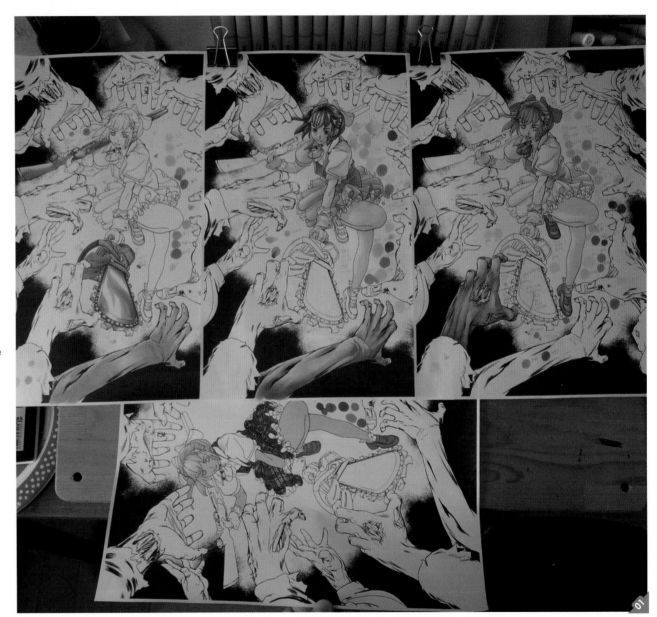

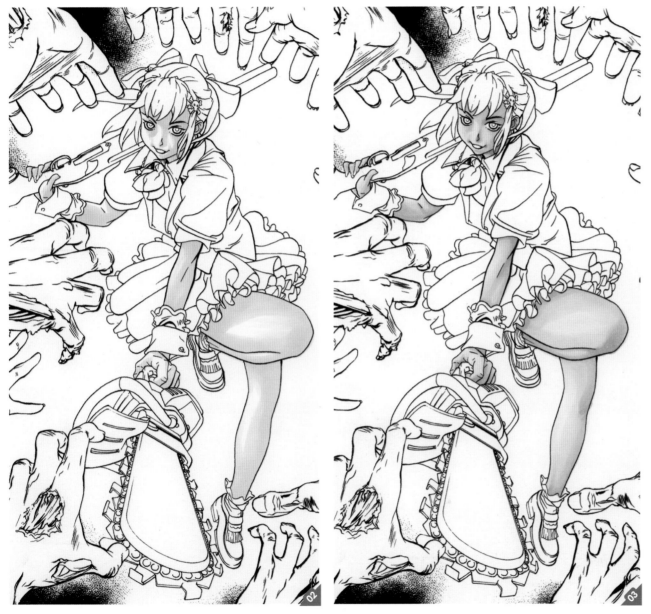

The Skin

The skin is the only real place of concern for me. If you make little mistakes on the clothing they can usually be covered up or worked around, but if the skin goes wrong or looks botched it can't really be corrected or fixed using Copic markers. If you work on originals and haven't made copies you are in trouble if something goes wrong. For that reason, scan your image into a computer and save it in case you need to start again.

In **Fig.02** you can see how I have started laying down some flesh tones using an E00 marker as a base for the skin. Leave areas white that you want to have highlights on later. When using Copic markers it is best to work in small areas, and slowly make circles, to avoid streaks that can be caused by long strokes with the markers.

Once you have laid a base for the color, go back over the basic skin tone you used and add some E02 to help deepen the color. Also use E11 and E13 for shading to help make the skin look like it is curved (**Fig.03**). Once you have used these colors to give the skin depth and volume, go over them using the E000 marker to blend the different colors together. In general, try to use light-colored markers for blending instead of colorless blenders as this helps to unify colors better.

Hair and Eyes

Next use the E13 Copic marker as a base for the hair and eyes, but leave some highlight areas like you did with the skin. You will repeat this process in most areas. Add a base layer and leave highlights, then bring in new colors to add depth and volume (**Fig.04**).

Continue to work on the hair using the E35, E37 and E51 markers to add more depth. Try to use these colors to increase the sense of movement (**Fig.05**).

Artist's Tip: Coloring Hair

When coloring hair it is important to color in the direction of the hair to keep things looking natural, rather than clumpy. After all, this is a pop idol and they wouldn't have greasy, knotted hair would they?

Clothing

It is then time to move on to Ayaka's clothing. I use the gray colors C0, C2 and C4 as the base and filler for the outward ruffles on the skirt and sleeves. I then use R20, R02 and RV000, in that order, to do the same on the skirt and vest. Remember to use small circles where you can when putting color down. The ribbons and bows are also colored using the same pens used to color her waistcoat (**Fig.06**).

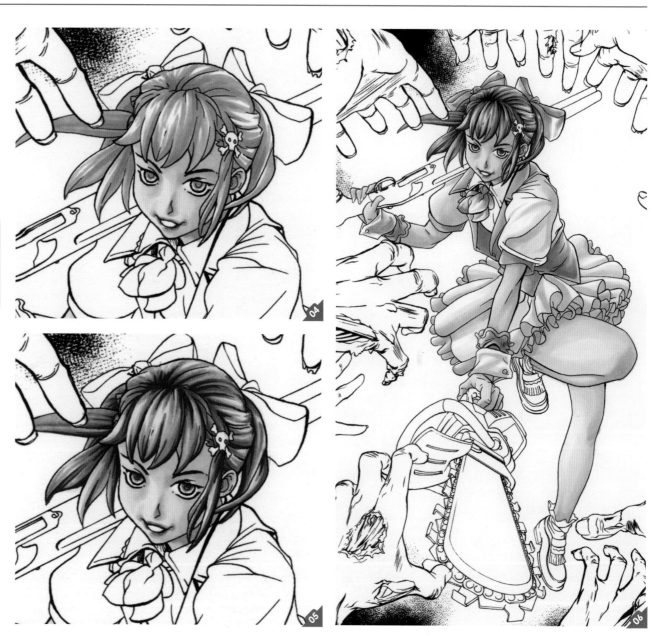

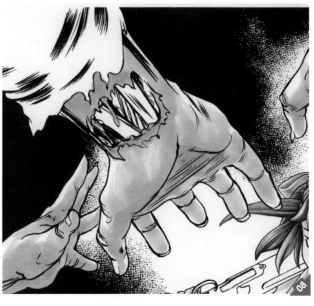

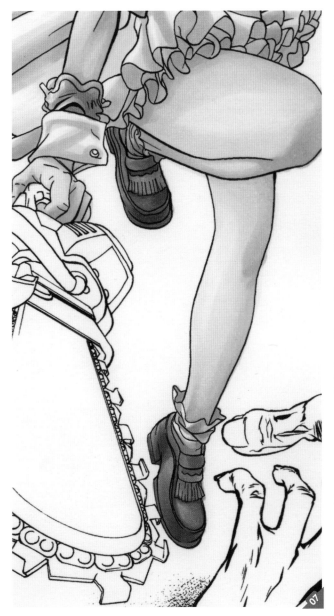

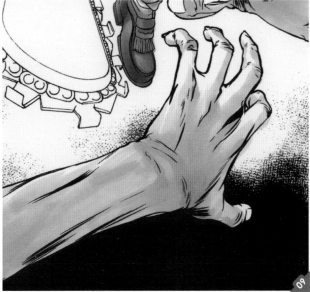

Once the bulk of the clothing is done you can move on to the shoes. Again, start by laying a lighter base; in this case I have used an E43 marker, then an E35, to deepen the tone and add some shading (**Fig.07**).

Artist's Tip: Building Depth and Volume

A trick that you can do with Copic markers to build up depth and volume is to use your base color to go over your base. This will deepen the tone of your base color and help you demonstrate volume.

The Zombies

Zombie time! Remember a few paragraphs ago when I said color in small circles to avoid streaking? Well, when coloring zombies throw that idea out the window. In this case, a streaked or mottled look could actually help give the zombies an unhealthy look. Intentionally lay down the colors in a way that avoids them looking smooth and even. To start with, use an E11 as the base color for the zombie skin and follow it up with a little R02 in the areas you want to look a little deeper (not darker). Be careful to keep the skin tone off the open wounds (**Fig.08 – 09**).

To make the zombies look truly undead, use some B21. This blue should be applied in the same way as you put color on the zombies earlier; avoid trying to maintain an even look. The blotches and streaks that will occur are what will sell the idea of these creatures being undead (**Fig.10**).

Now that the zombies' skin is done, use the E40 and R12 to lay a base for the flesh wounds, nails and exposed bones. A little R24 and Y00 (mixed with E40) will help to further add some depth and color to the wounds. Follow this up with some darker red pencils to increase the intensity of the red and smooth out the area. After that is done, move on to the clothes. Use the same approach here as you have done for the rest of the image. Lay down a base color then work more colors into it to demonstrate form (**Fig.11**).

The Gun and Chainsaw

The final parts of the image to color are the shotgun and chainsaw. Again, the same approach as before can be used for these. Browns and grays are used for the gun and yellows, and oranges for the chainsaw. Once you have used the base color, use as many colors as you like to build the form and demonstrate the volume (**Fig.12**).

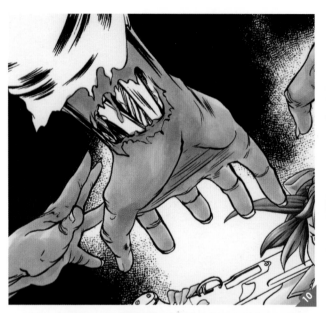

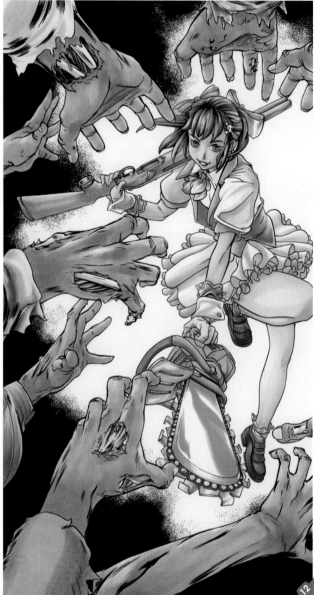

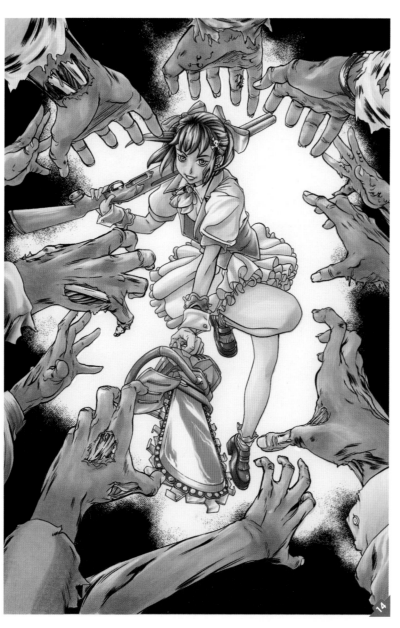

The last small step is to go in with some white ink and add the hard highlights with a brush. To add areas of highlight that you don't want to be as strong, water down your ink slightly (**Fig.13**). Once everything has dried you should have a finished image of Ayaka, the Zombie-Slaying Idol Singer! (**Fig.14**)

To create this illustration I used two sets of different makes of markers to decide on the right color palette. One of the sets of markers was not used at all in the illustration. I used some Faber-Castle color pencils to add fine details over the marker ink. The pencils I used to draw the image were an H 0.5 mechanical pencil for the rough sketch and an HB 0.5 mechanical pencil for the finished sketch. I used a small bottle of Japanese inks for the inking. I use a manga brand of ink because it is water resistant, which is vital when you are working somewhere as humid as Japan.

Coloring a Female Warrior
By Phong Anh

Introduction

Before starting, we need some basic tools that will help us during the coloring process. Remember not to use normal paper. Thin photocopy paper will get wet and become wrinkled when covered with water, unless you utilize some special techniques to strengthen the paper. Usually people draw on paper from 90gsm to 300gsm depending on individual taste. For this image I'm using Daler Rowney 300gsm because it is popular and easy to use. It also has a nice texture to increase the vintage feeling of traditional artwork, which will really help make this image look interesting.

Tools Used

- Watercolor paints
- Watercolor paper
- Clean water
- Watercolor brushes
- Palette

So let's see how to add color to your sketches in a way that gives your manga drawing a digital look.

Coloring

There are many sizes of brush; small brushes are effective when painting details and outlines, whereas big ones are useful for coloring large areas. My drawing is detailed and on small-sized paper (A4) so there won't be many chances to use big brushes. If your image is on A4 you will probably just need three basic brushes: size 0, size 5 and size 10 (**Fig.01 – 02**).

Artist's Tip: Using Watercolors

When using watercolors try to keep your line art faint, as thick strong lines will blur and bleed when mixed with wet paint.

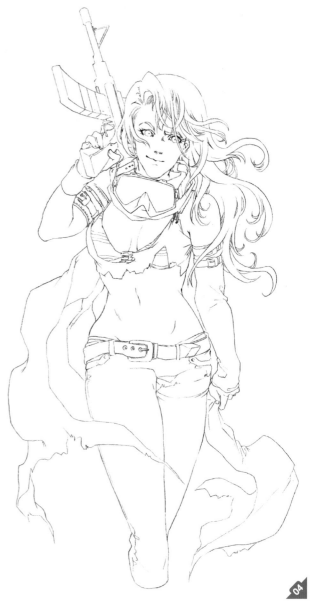

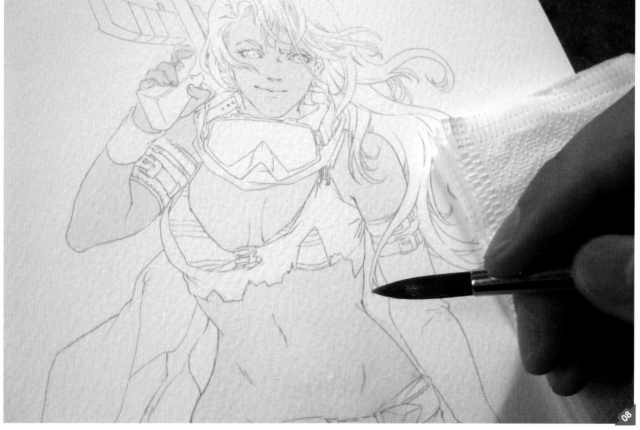

Preparing your Drawing

The first thing you will need to do is transfer your drawing onto a piece of watercolor paper. Watercolor paper isn't great to sketch on as it isn't easy to erase lines on it, so you will need to transfer your finished line drawing onto your new paper. The best way to do this is using a light box, but if you don't have one you can hold your image up to a window and trace it, or put a lamp under a glass table (**Fig.03**).

You can see my sketch ready for painting in **Fig.04** (note that the lines in this image have been adjusted in Photoshop to make them visible).

The Painting Process

Painting a manga image is simpler than a watercolor environment or most things that you could paint. For all parts of the image the same basic steps will be used.

- Paint a faint wash as the foundation using the lightest color (**Fig.05**).

- Paint a second layer that is slightly darker than the first to give it a sense of volume (**Fig.06**).

- Paint a final layer with a slightly darker color to strengthen the outline and increase the sense of volume (**Fig.07**).

Now that we know how the image will be painted it is time to put the technique into practice. Use a size 10 brush to paint the base color for all of the skin. The best way to do this is to dilute a yellow until it is very pale (**Fig.08**).

When using the large brush and the lightest color, you don't need to worry about small mistakes or areas where the paint has covered something it shouldn't. These places can be painted over until you can no longer see them. I often find that a few small mistakes like this make the image look more authentic and interesting (**Fig.09**).

Next you will need to move over to a size five brush to add the shading. Mix some orange with the yellow you used in the first step and paint it in the areas that would be shaded. Remember to demonstrate the volume of the surfaces when you do this. Remember to keep some tissues next to you in case you need to remove paint from an area that looks too dark.

A tissue can be used for many different things. It can be used to remove any extra paint that may drip from the brush. It can be used to help you smudge and smear paint in areas where you want a smooth appearance. It can be used to almost entirely remove color from an area to create a transparent effect or the impression of clouds. Tissue really is helpful when you are painting so keep a clean piece with you at all times (**Fig.10**).

Now that the first two colors have been used you can start to see the shape of the character (**Fig.11**).

Now you can move on to the third color layer. Mix a bit of red or pink into the earthy yellow, and use the smallest brush (size 0). Dip your brush into the mixture and paint the darkest areas of the image, such as the joints and areas covered by hair (**Fig.12**).

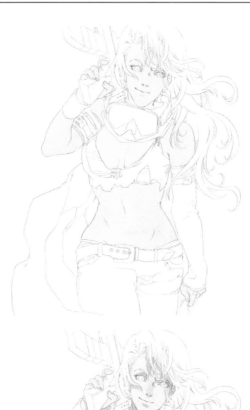

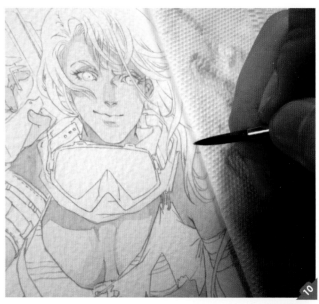

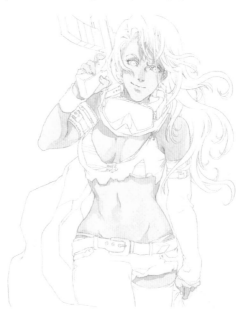

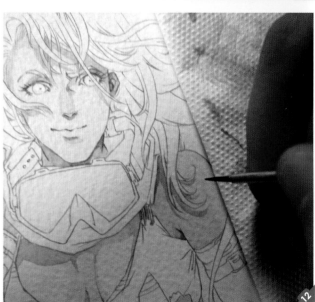

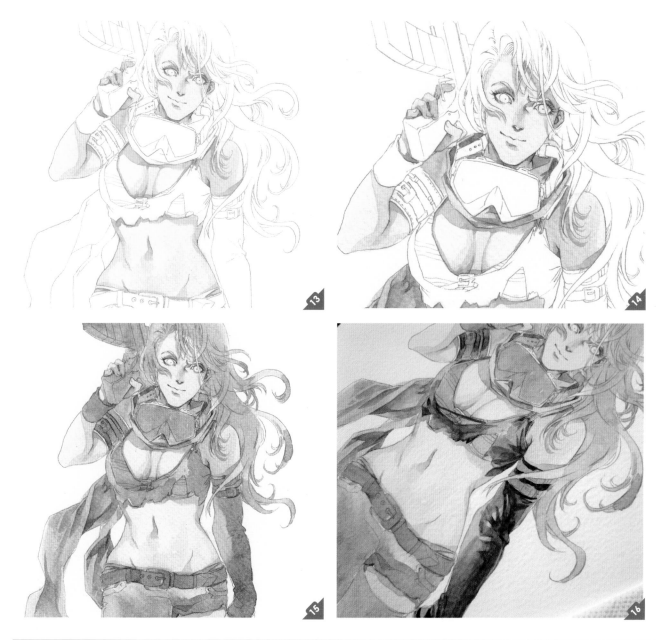

At this point you may want to create a yellow wash again and go over some areas to strengthen the base color of the skin (**Fig.13**).

This same technique can be used to paint the rest of the elements in the image. Paint a base color, paint the volume with a slightly darker color and then finally paint the darkest shadow with the darkest color (**Fig.14 – 15**).

Continue to paint each feature in a layer, but in some areas use a slightly darker base. An example of this is the shirt and gloves which would be quite vivid colors. Make the base of these darker and use colors that are subtly darker for the shadows (**Fig.16**).

The hair is the only part of the image that will be painted slightly differently. The reason for this is that it will require more layers to make it look believable. Use a few different tones to add more layers or use the same color twice to make the color a little stronger in areas (**Fig.17 – 18**).

Artist's Tip: Drawing Hair

Try not to paint individual strands of hair or too much detail. In my experience, the best-looking hair is always painted in sections that have good shape and form.

You should try to be patient when painting details. There is no miracle brush or clever tool that helps you paint them. You just have to be patient and careful, and practice until you can get consistently good results. In **Fig.19** you will see that the hair detail is almost finished. There is still one more thing to do to the hair, but we will do this at the end.

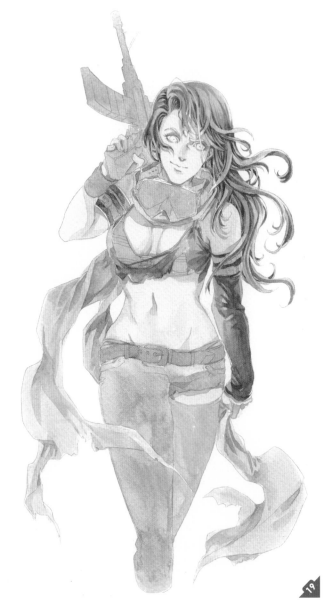

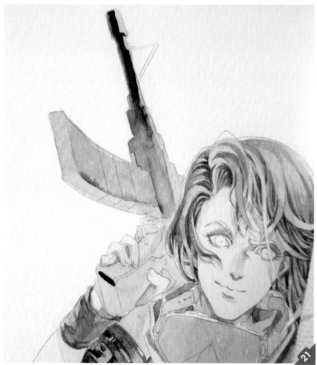

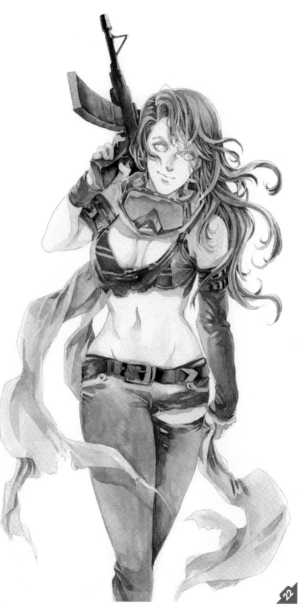

If you want to create some gradients and smooth color transitions, do the following:

- Apply the darkest tone of the color.

- Clean your brush, or get a new brush that is dipped in water, and gently drag the dark color in the direction you want it to spread (**Fig.20**).

Once you have practiced this technique you can use it on your image. You can see how it was used on the gun, leather straps and goggles in **Fig.21 – 22**.

The next thing to paint is the eyes. I've decided to do the eyes green. The first thing to do is use a very pale gray to paint the areas that will be in shadow (**Fig.23**).

Use a bright yellow as the base color and then, over the top of it, apply a green layer. Use a darker green around the pupil to give them a more realistic appearance and make sure that they are also dark where they meet the eyelids, so they stand out well (**Fig.24 – 25**).

When you are painting a female character it is a good idea to include some lipstick and make-up on your image to make them look more feminine (**Fig.26**).

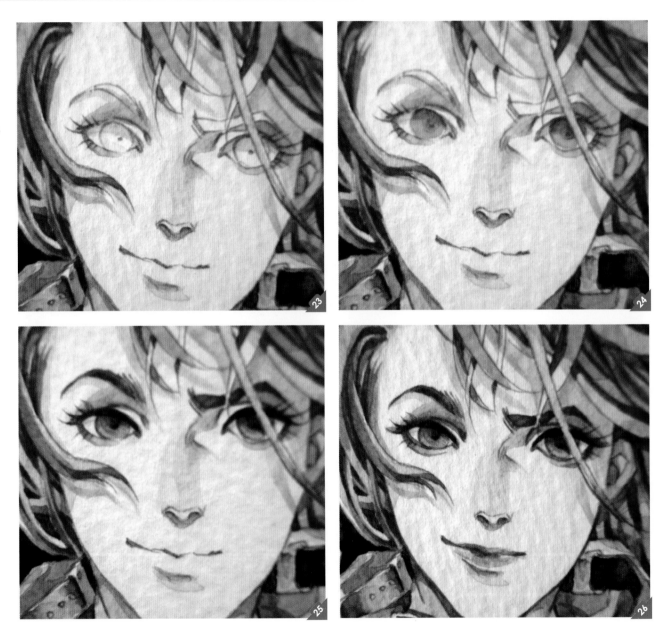

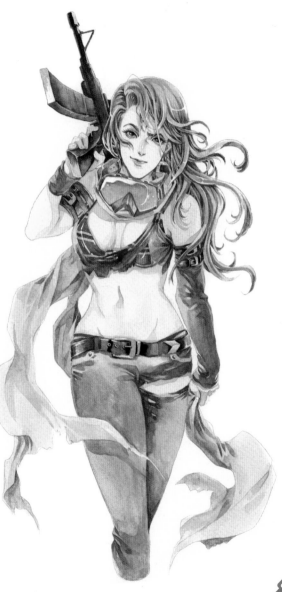

Use a bright cobalt blue paint that is well diluted (you can also add a little purple) and paint in some of the shaded areas to give the impression that there is something around your character, and that light is bouncing off their clothing (**Fig.27**).

Use a white poster paint (alternatively you could use white ink or white acrylic) to paint highlights on the eyes, glasses, locks of hair and metal parts (**Fig.28**).

At this point the painting of the image is done. You can still make adjustments to it though using Photoshop. Scan your image and open it in Photoshop. You can use lots of different tools here to change the overall color of your image or even individual parts of the anatomy that have gone wrong. Use the different tools and make yourself familiar with how you can get the best out of your image. When you have done this you can call your image complete (**Fig.29**).

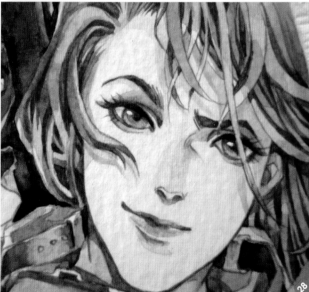

Coloring Kléo the Cat Girl
By Mateja Pogacnik and Marco Paal

Introduction

In this tutorial we will explain how to color the sketch you created earlier, step-by-step. The coloring of this image will be done using a variety of tools, but the main tool will be Copic markers. Copic markers are very popular among designers, comic artists and illustrators. There is a massive catalog of colors to choose from and they have brush-like nibs, which are really handy when adding color to your image. The best thing about Copic markers is that they blend really well to give a smooth effect.

Tools Used

- 0.35mm mechanical pencil
- 0.3mm Copic multiliners in different colors
- Copic markers
- Polychromos
- Chalk pastels
- Cotton pad
- White ink
- Manga drawing pens (G-pen and Maru-pen)

You don't need to use these exact tools to create good results, but these are the ones I use and with them you can create a really smooth finish.

Another medium that I will be using extensively in the creation of this image is Polychromos pencils, which are made by Faber-Castell. They are oil-based pencils, which have an almost creamy texture. They tend to come in bright colors and create a nice, smooth effect.

The Skin

The first thing to work on is the skin. The reason you should start with the skin is that it is one of the most important parts of the image to get right, and the tone of the skin will also help you when it comes to choosing the rest of the colors for your image (**Fig.01**).

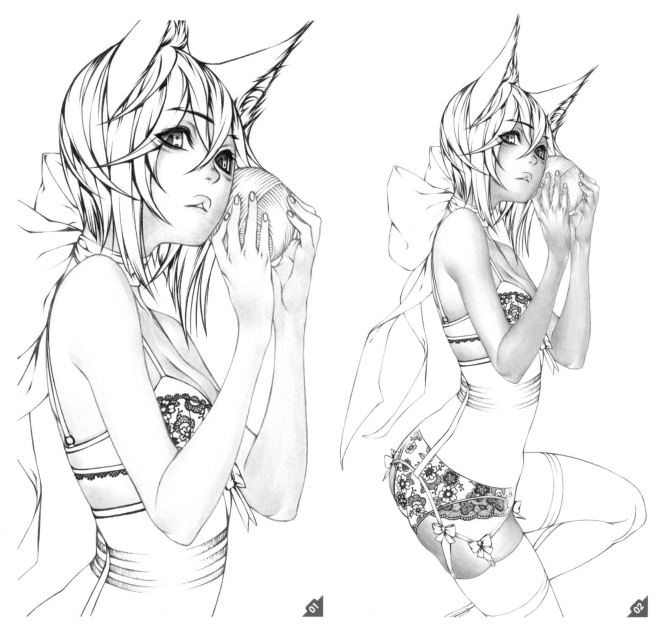

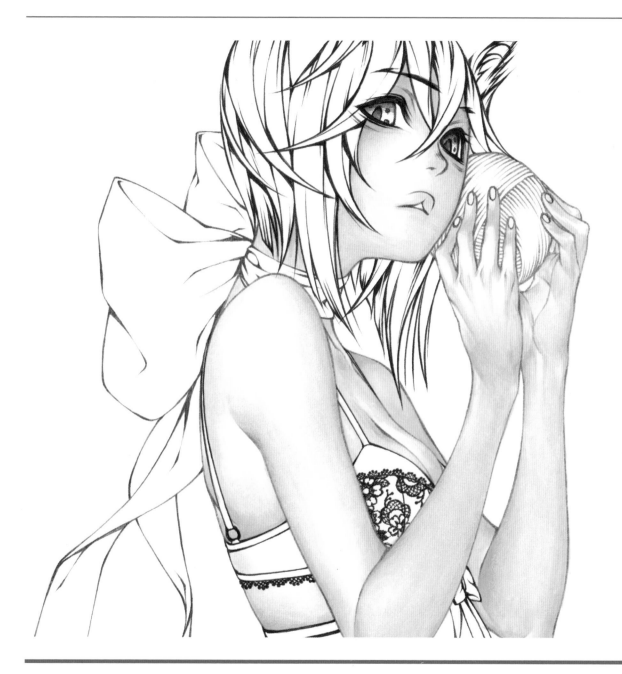

Kléo is a young, healthy character so her skin will be quite light in color. Also her skin should look healthy and stretchy. To portray that in the coloring of the character some parts of the flesh should be left without any color on them to make it look like the skin is reflective. This means that when you start to add your first color there will be some indication of volume and shape.

Once you have added your base colors you will need to move on and apply some stronger tones. The next pen to use is a barley/beige color (E11). You may notice in **Fig.02** that the coloring has gone slightly wrong on her buttocks and there is a bit of an unwanted mark there now. If this happens on your picture don't worry too much as you will be shown how to fix this later.

Artist's Tip: Testing Copic Markers

Copic markers can occasionally create a blotchy effect if you haven't used them for a while and they have dried out. This effect can also come about if the ink in the pen is running out. Always test your markers on a blank piece of paper before using them on your image.

The next step is to use a white Polychromos pencil to make the changes between the colors look smooth. Use the white pencil all over the image, but vary the pressure you apply. If the color looks too strong in an area, apply a little more white pencil to create a smooth transition between the colors. You can also rub over the pencil with a cotton pad to get a nice clean effect (**Fig.03**). You can use this white pencil to fix any areas where errors may have occurred.

Some people might think that it is a little chaotic to use so many different tools on one image. They may not like the idea of letting something get quite dark in color and then lightening it, but you should be willing to use or try different approaches to get the best results. Creating a good image involves development and making changes. These changes can be big or small, but the important thing is that you end up with an effect that you are satisfied with.

The final thing to do when coloring the skin is to use a red pencil and accentuate the outermost part of the skin, near the line art. This is to create an overall sharper contrast. You may also find that the line art starts to look a bit faint when pencil and pen has been used over it. If this is the case, go over it again with the same pen that you used originally.

It isn't common to color the lips in manga art, but on this occasion I've given Kléo some bright red lips to make her look eye-catching. This was done using a red marker and pencil crayon (**Fig.04**).

The Clothes

The same process that was used for the coloring of the skin will be used throughout the image. Apply a base color using Copic markers and then use a secondary Copic marker to add some volume and stronger colors. Once you have done this, use pencils to blend the colors further and fix small issues in the illustration.

If you look closely at the big bow you will notice some violet shadows in the dark red areas. This is because most materials are reflective and have very individual qualities. The best way to demonstrate this in your image is to study real-life examples carefully and consider how you can achieve a similar effect.

The girdle and stocking present a bit of an issue. These materials are transparent and will allow you to see the skin beneath them, but also have their own color and reflective qualities (**Fig.05**). The first

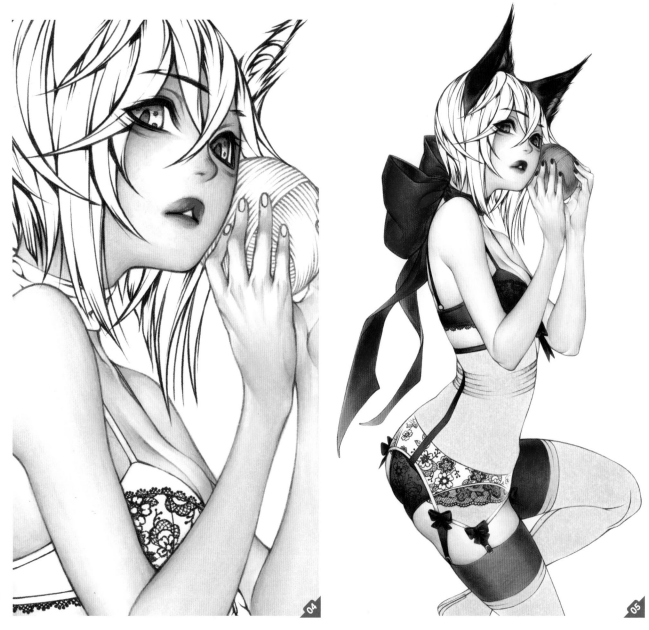

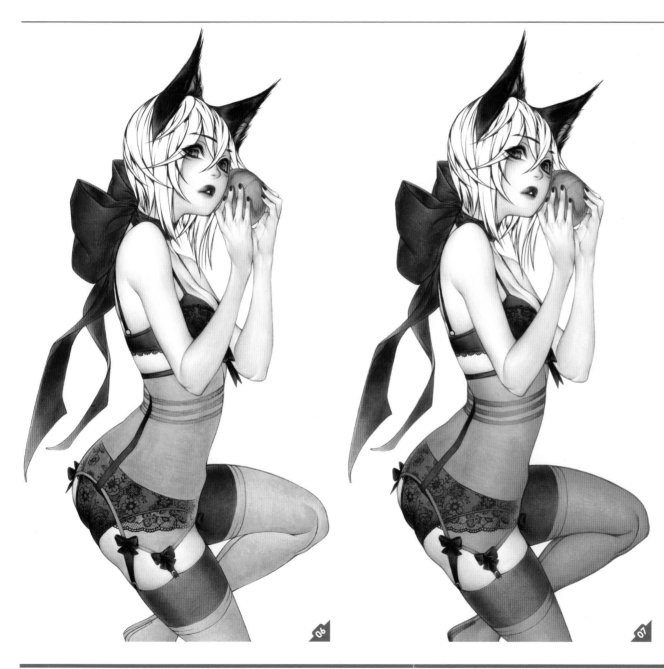

thing to do when tackling this approach is to add a base layer with a skin-colored marker. It is probably best to go for quite a saturated color at this point as you will need it to show through layers of markers and pencil.

Over the base color, use a red Copic marker to add the next layer. Use a color similar to another color in your image to tie everything together. For example, the girdle is similar in color to the bow. Take great care to not completely cover the base layer because if you do the transparent effect will be lost (**Fig.06**).

Use pencils to blend everything together and add small details like the two dimples in the character's back. Details like this help make the image more believable and interesting (**Fig.07**).

As you can see in **Fig.08** the covered part of the panties has been colored with different Copic markers and pencils. They're not just a simply gray like the uncovered part, but a mixture of gray and pink. This effect really helps to make it look like the material is transparent.

At this point shadows can be added to certain parts of the illustration. On the face the shadows should be added with a red pencil. The shadow on the face is being cast by the hair and therefore should follow its shape. The shadow cast on the rest of the character should be done carefully with a mechanical pencil.

Artist's Tip: Adding Shadows

Adding shadows can seem very simple and straightforward, but if it is done well and the shape of the character has been considered carefully it will make the image look more 3D

The Hair

The hair is a tricky part of the illustration to tackle. The hair needs to looks glossy and shiny, which is typical for hair on manga characters. With a black pen, first draw the darkest parts of the hair. These will be located directly next to the shiniest parts (**Fig.09**).

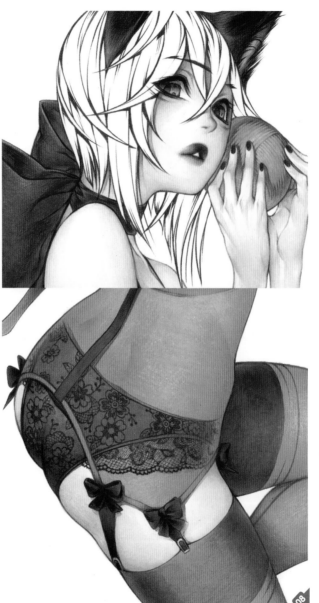

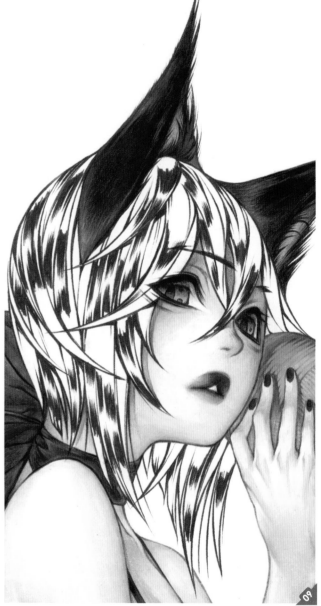

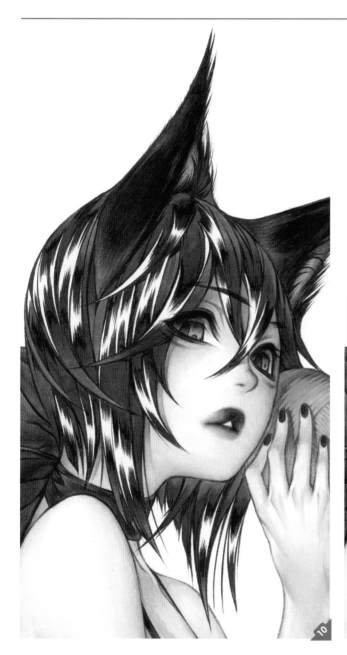

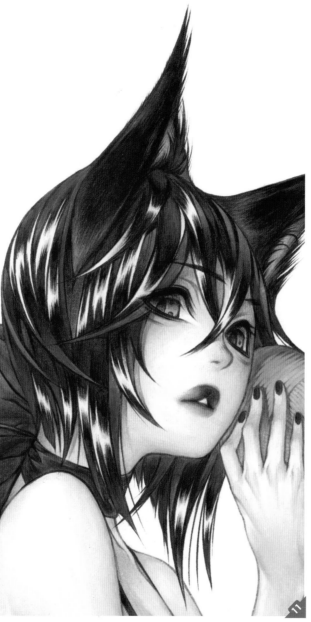

The next step is to color the hair in a blue/gray color. At this point you will color all of the hair apart from the glossy parts. Even if you intend your character's hair to be black, don't use black. Using black will make it hard to show any subtle changes in color and shading, which there are a lot of in hair (**Fig.10**).

The last thing to do with the hair is to use pencils to fix any minor mistakes and to add some more subtle changes in the hair color. This will make the hair look even shinier and more reflective (**Fig.11**).

The Wool

Now the rest of the image is virtually complete it is time to add the thread that is wrapped around the girl's body. To add these you will need to use white ink and pens. The pens that are used to do this are designed specifically for manga and comic artists, and have a variety of nibs that you can use in different circumstances. To draw the thread use a G-Pen, which is designed to specifically draw thick dynamic lines and white ink. Draw the path you want your thread to follow and then when the ink is dry, use an orange marker to add the color. If you need to you can tidy up the thread using a orange pencil (**Fig.12**).

Chalk Pastels

The next step is quite strange and may be different to the way you usually use art tools. Apply some pastel to your finger and dab it on parts of the illustration that you want to give a lighter and shinier look. A red chalk pastel should be used in areas like on her bow, and blue on her hair. It is important that you don't use too much pastel as if you do it will make your image look too light and dull (**Fig.13**).

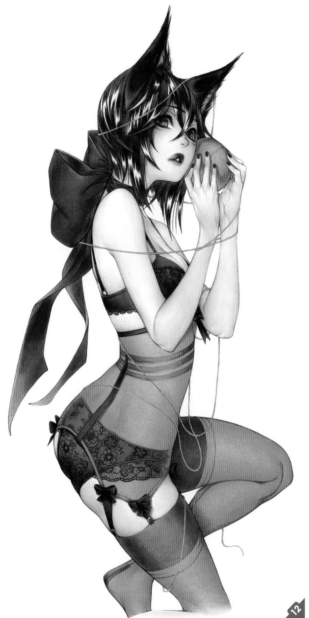

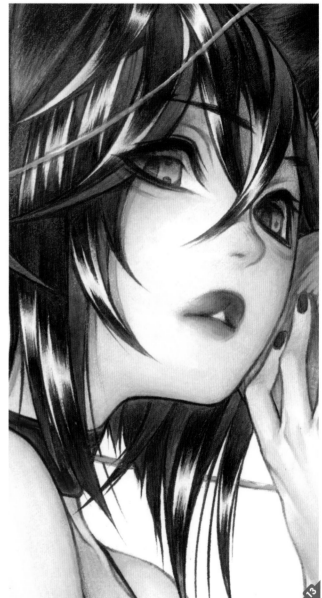

Completing the Image

The coloring process is almost finished at this point. The next and final step is one of my favorite parts of the process. To finish the image you will need to add some highlights and white outlines in the areas that will be hit directly by sunlight. This will make parts of the image stand out and will make the form of the character really clear.

To add the white lines and highlights, use white ink again. The best pen to use when adding these lines is a Maru-pen. This pen is particularly good because it is thin, which makes it easier to draw thin, precise lines. The white pen will be used in quite a few places, but the most obvious place is probably on the characters' face. By adding large highlights to the eyes and lips it makes them look much more glossy (**Fig.14**).

Once this is done, your image will be complete. I hope you found this tutorial useful (**Fig.15**).

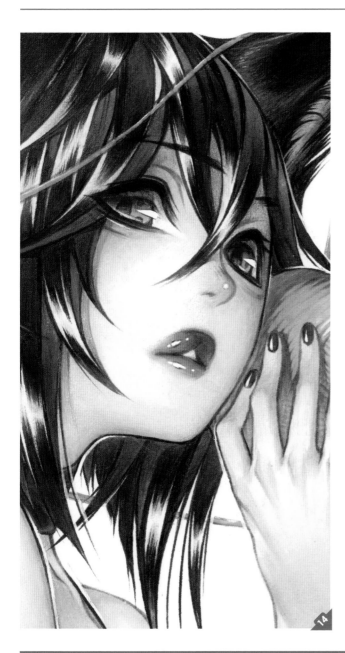

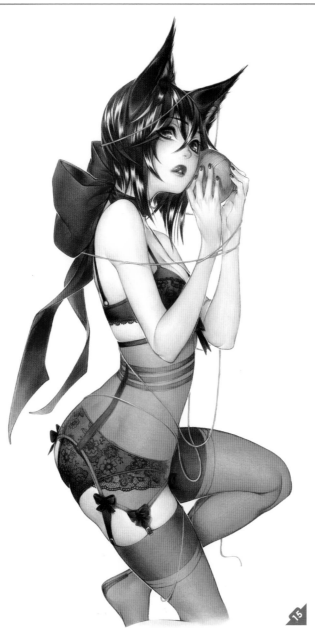

Coloring the School Girl
By Giovana Leandro da Silva Basílio (Eudetenis)

Introduction

In this tutorial I will explain how to add color to your line art using Copic markers. Copic markers are ideal for adding colors to your image as they dry quite quickly and blend well. If you are like me, you will want your image to be finished quickly so they are great if you are impatient. They can be used on plain office paper and can create really strong, vivid effects, as well as soft tones for areas like skin, etc.

Tools Used

- Copic markers
- Faber Castell Pitt watercolors set of 24
 (color sketch and final touches)
- Copic Opaque White
- Deleter brush (small)

I originally started working with these markers because they seemed to have become particularly popular with the mangaka (manga artists) that I particularly admire, like Takeshi Obata and Tenjo Tengen. Don't feel daunted about using them; they are fairly easy to use, particularly if you are used to working with paints and colored pencils.

Getting Started

Before you start adding color to your image you need to think about the environment your character is in. Is it night or day? What lighting and weather conditions are affecting the scene? I decided to have my scene set at night so it is dark. You may find it helpful to do a very quick mock-up of your image in color to see if your proposed plan for the image works (**Fig.01**).

When doing a study like this it is best to try to use the dominant colors in your mock-up. For mine I used mainly blues, but also showed the areas where I wanted to use warmer colors like the reds and browns.

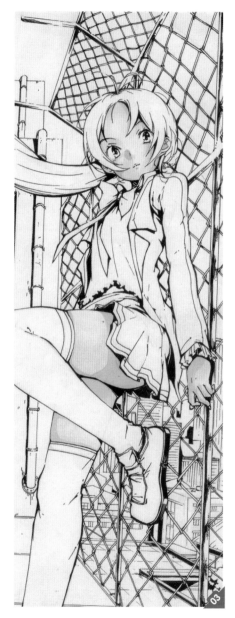

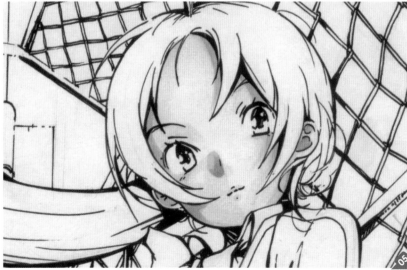

Coloring your Character

There are many ways to use Copic markers and when you have used them a few times you will settle on the method that you would like to use. I will explain the colors and the approach that I used and hopefully it will be helpful to you.

Start by using a fairly strong skin color (YR00), which will be the darkest skin color that you will use. Use this color to add color in the areas of the skin that would be in the shade or under clothing (**Fig.02**).

Using some slightly lighter flesh colors, (YR000 and YR0000) color the skin's middle and lighter tones. When you do this, drag your pen strokes from the darker areas through to the lighter sections. This will help the colors blend together. The lightest areas can be left totally white for now (**Fig.03**).

When I was creating the mock-up I decided that the shadow on the girl would be blue. To create this effect, use a blue (B41) to add shadows to the appropriate parts of the skin. The same blue color can be used on the face, and for areas such as around the eyes and where the hair covers the face (**Fig.04 – 05**).

The next part of the image to move on to is the eyes. It is important to use more than one color for the eyes to make them look believable and authentic. Use an orange color (E39) to lay down the base color for the eyes and then a red (R39) for the outline of the eyes (**Fig.06**).

Once you are happy with the skin and eyes you can move on to the hair. Use the same technique for the hair as you used on the skin. Choose your darkest tones (E79) and lay them down first. Then once that is done use your middle (E47) and lighter (E04) tones, and color from the dark to lighter areas to help blend the colors (**Fig.07 – 08**).

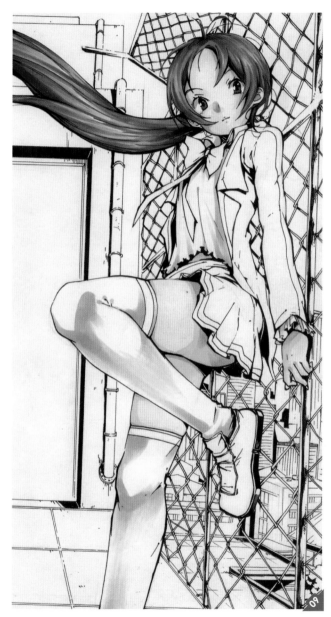

Early in the process a blue color was used for the shadow on the skin. The shadow on the clothing needs to be done in a similar way. For the areas of the clothing where the shadow will be darkest, use a fairly strong blue color (B21). Then using the same technique of using your marker over the dark areas and then dragging them to the lightest areas, use a lighter blue (E40) to color the weaker shadows. Remember to leave the lightest parts white again (**Fig.09 – 10**).

Using a dark blue (B99) marker color some of the details on her clothing. This same color can be used to do some shading in areas where it would be particularly dark, like on areas of her skirt and socks. Finish the skirt by using another blue (BV04) to fill in the bulk of the skirt's color (**Fig.11**). As always, remember to leave the brightest areas white.

Continue to use the same technique of using the darkest colors first by filling in the darkest areas of the jacket with a strong brown color (E47). Then using a lighter color,(E35), add the mid-tones, remembering to leave the lightest areas white. Using the light blue color (B45) that was used earlier, add some shading in the same way as you did on parts of the clothing and the character's skin (**Fig.12 – 13**).

For the shoes, use a brown (E79) to add the color. Once again, use a blue color (B45) to add some small areas of shadow to the shoes (**Fig.14**).

Artist's Tip: Shiny and Polished Surfaces
To demonstrate a surface is polished or shiny in appearance, leave bold areas totally white.

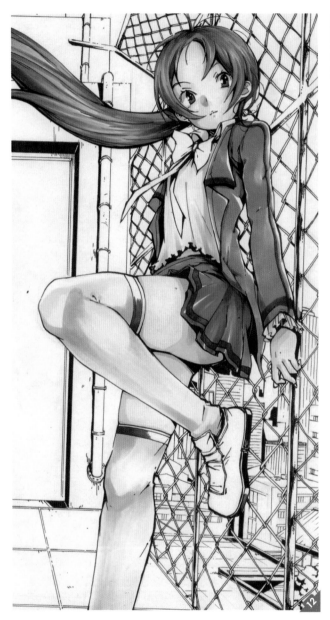

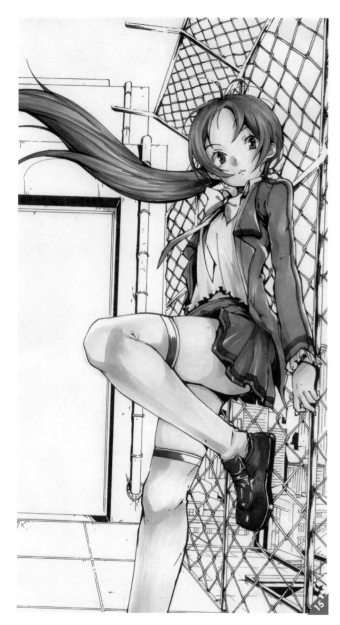

Copic markers are very versatile and can be used in many ways. This can be demonstrated by how we will color her tie. Start by using a blue marker (B45) to color the shadowed areas. Leave lighter areas totally white. Take a red color (E07) and go over the entire area of the tie and you will see that the blue which was added previously provides the shadow effect through the red (**Fig.15 – 16**).

Once the character is completed it is time to move on to the environment. The first thing to color are the red, metallic parts of the image like the fence and the metal towers in the background. To do this, use the same techniques as has been described for other parts of the image using a mid-colored (R39) and dark colored (E07) red. Remember to leave some parts white to demonstrate the reflective nature of metal (**Fig.17**).

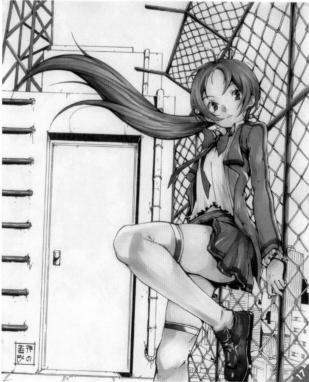

Using the same light blue color (B45) as you will have used a few times now, color a shadowed area on parts of your image that would be in the shade, like the area at the top of the door in the background (**Fig.18**). Over this blue color, use a brown (E47) to show that the door is wooden. When you color areas such as a wooden door don't make the color look too smooth; keep your pen work quite rough to give the impression that this area is textured wood (**Fig.19**).

With a gray (N5) marker add some shadows to the white parts of the background, such as along the wall, floor and the pipes on the wall. Use one of the colors you used on the character to add color to some of the features in the scene (**Fig.20**).

Artist's Tip: Linking Character and Environment
By using a color on the character and on details in the environment it demonstrates that they are linked and adds story to the scene by showing that the character belongs in that environment.

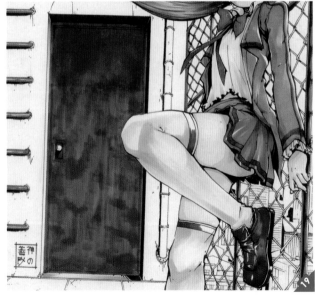

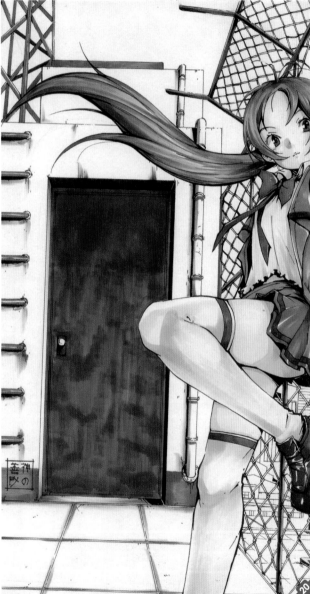

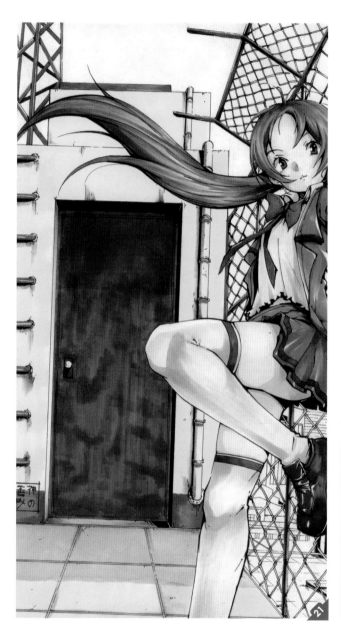

To be consistent and continue to show this is a night scene, use a blue (B000) to color the wall in the background. Also show the shadow of the building on the floor with another blue (BV31) color (**Fig.21**).

The buildings in the background will need to look as if they are in the distance. To do this you will need to make them darker. Use a dark blue (BV23) to do this. Continue to use dark blues (BV31) to paint some of the other sides of the buildings in the backgrounds. The roofs of the buildings will catch the lights from the moon and therefore will be lighter than the sides of the building. To color them use a lighter blue (B000). This same color can be used for the sides of glass-fronted buildings (**Fig.22**).

Using a cold green (G85), color the trees in the foreground and the sides of the buildings that are far in the distance (**Fig.23**).

With a light blue (BV31), draw the shape of some clouds in the sky. Don't fill them with color as this will be done shortly. Fill the sky (apart from the clouds) with color using a dark blue (B99). Rather than leaving the clouds totally white, add some shadow to them using a light blue (B21). This gives the impression that the clouds have some volume (**Fig.24**).

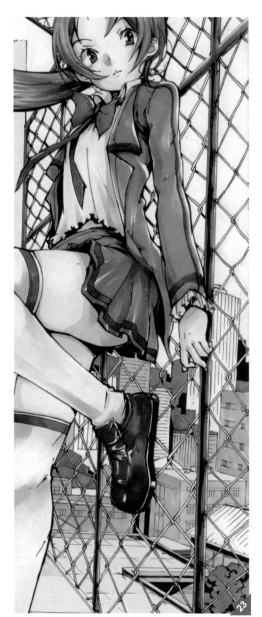

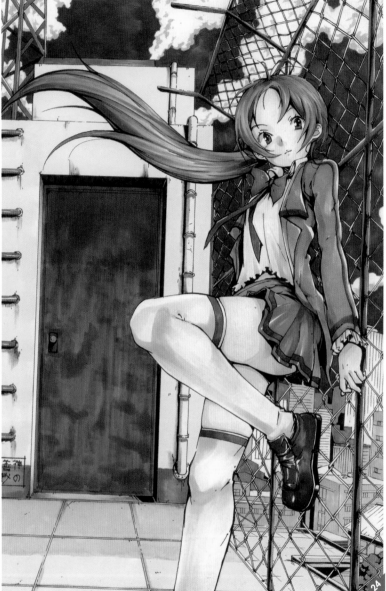

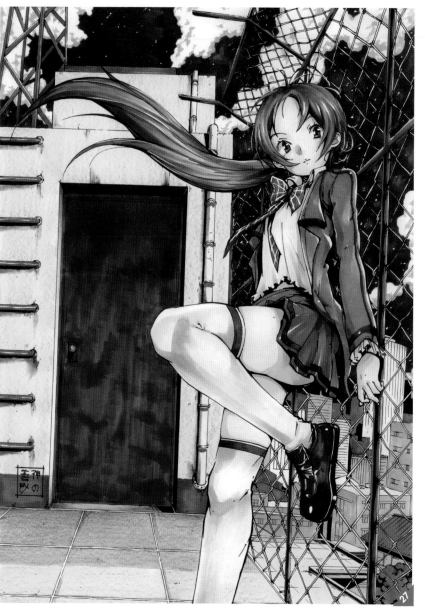

With the use of colored pencils apply textures to parts of the foreground that look a bit flat and as if they could do with some texture on them (**Fig.25**). To complete the image use Copic Opaque White to add the stars and white lights (**Fig.26**). This should be done with a very fine brush and a steady hand.

I hope you found this useful and that soon you will be creating manga images of your own (**Fig.27**).

Coloring a Manga Duo
By Supittha Bunyapen

Introduction
There are so many different methods you could use to color your completed sketch, and every one of them has their benefits. In this tutorial the image will be completed using an affordable tool that most artists will be familiar with or would have used before: watercolor paints.

Tools Used
- Watercolor paints
- Masking fluid

When you hear watercolors you instantly think of traditional art and landscapes, however over the following pages we will see how to use them to color our manga images.

Preparing your Image
Before you start adding any paint to your image, use some masking fluid (Liquid Frisket) to mask the area just inside the sketch of your characters. Masking fluid is like liquid latex that you can apply and remove from your paintings to protect specific sections from paint. Use an old or inexpensive brush to apply the fluid to the paper and wait until it is totally dry before painting around it.

Painting with Watercolors
Wet the surface of the paper around the sketch. Mix indigo and phthalo blue paints with water and use a ¾ inch flat brush to apply the paint to background. Try to make the color darker around the bottom of the picture.

When the first layer of paint has dried, paint a wash of cobalt blue over it using a ¾ inch flat brush. Paint this color into the corners of the image and dilute it to make the color weaker as it gets nearer the center of the image (**Fig.01**).

Artist's Tip: Spotted Texture

To give the paint a spotted texture, sprinkle some rubbing alcohol onto the wet paint. The rubbing alcohol pushes away the color and creates a unique texture.

Create a thin wash made up of indigo and burnt sienna. This color should be used to give the impression of there being some features in the mid-ground. This should not include any details or depth of color, but should simply be like a silhouette. Above this wash of color you can paint the foreground details using similar colors with some van dyke brown mixed in. As this is nearer the foreground the colors should be stronger and the shapes more detailed and refined, however don't detail them too much as that would be distracting the viewer from the main focal point of the image (**Fig.02**).

Once the background is complete you can use an eraser to gently remove the masking fluid from the paper.

The Skin

Brush some clean water over the areas where you will paint the skin of the characters. Paint a cadmium red (or rose madder) on their cheeks and the tip of their noses with a small round brush. While the paper is still wet, mix rose madder and a small amount of cadmium yellow together and apply it to the skin areas. Try to spread the color quickly to make it look smooth. Once the base paint is dry, use the same mixture to paint over it and add the shadows (**Fig.03**).

The Hair

Paint a wash of cadmium yellow and cadmium red on the hair of the foreground character. Try to make the hair more yellow on the left side, where it is closer to the light source. Let the first wash dry completely and lay another layer on selective areas to create shadows. To build up darker shades of red, create a mixture of cadmium red and van dyke brown. Use this mixture to pick up darker shadows and strands of hair with a small round brush.

For the character in the background, paint a wash of cadmium yellow over his hair so it looks like a light yellow. As you did before, try to keep the wash lighter on the left side to make it look like it is catching the sun. Wait until the first wash is dry and mix cadmium yellow and burnt sienna to create a darker shade for the hair's shadows. Use the mixture to paint shadows and individual strands with a thin brush (**Fig.04**).

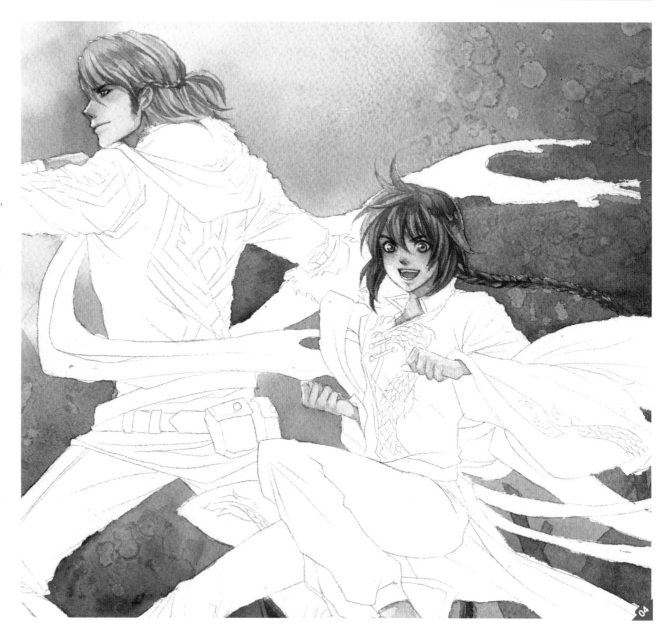

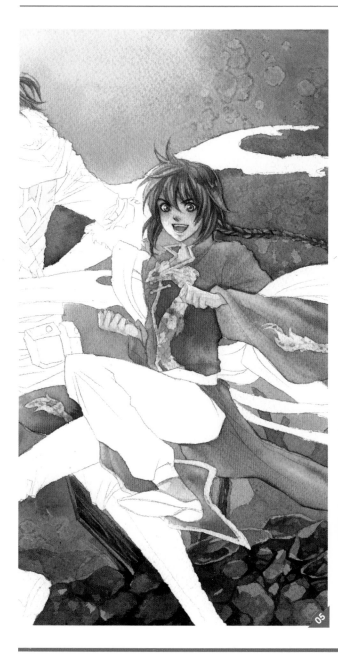

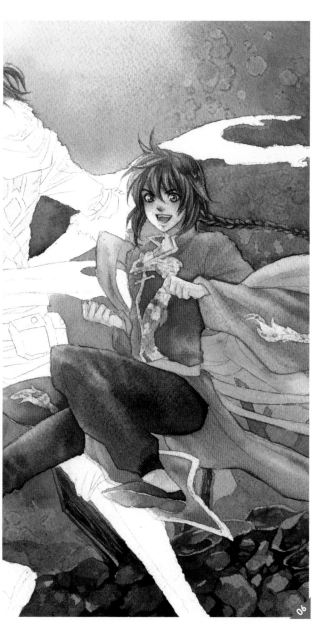

Painting the Clothing

To make the color process of painting the clothing easier, apply masking fluid to the small details, such as the dragon designs, trims, and the patterns. When the masking fluid is dry, brush some clean water on the front character's top. While the paper is still wet, lay a wash of cadmium yellow over this area with a round brush. When the wash is still wet, spread a concentrated wash of crimson lake over it and let the paints gradually blend with each other (**Fig.05**).

Use the same process again and brush some clean water on the front character's pants. While the paper is still wet, lay a wash of cadmium yellow over them with a brush. Quickly lay a mixture of payne's gray and indigo over the wash. Let the colors blend with each other, but try to keep a yellow tint on the left side, again because of the sun. Use the same mixture and technique for his shoes. Paint a flat wash of cadmium yellow and cadmium red on his waistband (**Fig.06**).

For the extra cloth, dilute cadmium yellow with clear water and paint it over the cloth. Use a wash of lilac to overpaint this quickly so the colors blend with each other. Try to maintain the yellow wash on the left side again to demonstrate the light from the sun.

Using a variety of different blue washes, such as cerulean blue, cobalt blue, phthalo blue and indigo, paint the shadow all over the characters' clothing. Remember that the shadows should show the wrinkles in the clothing. If you need to, paint the shadows in multiple washes (**Fig.07**).

Artist's Tip: Shadow Colors

The color of the shadows should match some of the colors from the environment to make the characters look like they are part of the scene.

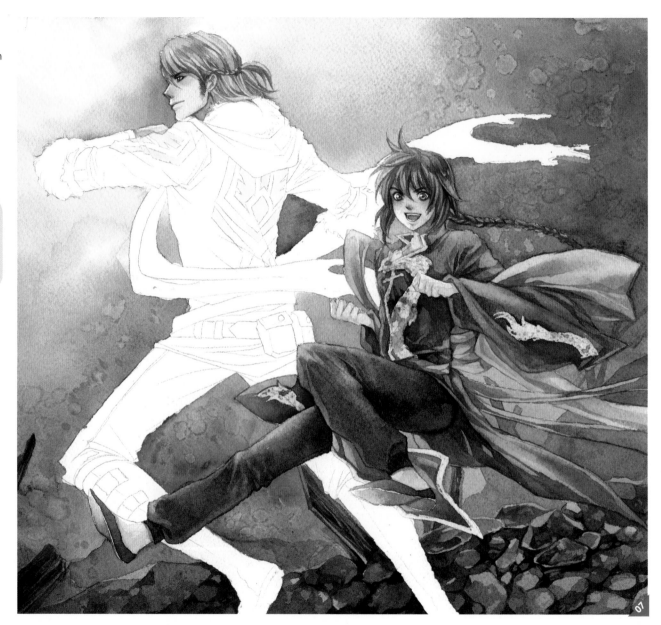

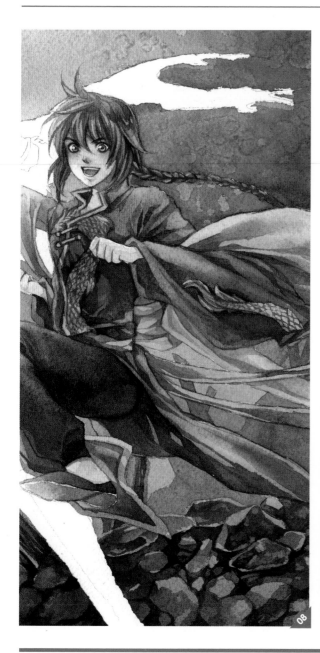

Remove the masking fluid from the trims and the dragon design. Mix cadmium yellow and add a tint of burnt sienna and paint the previously masked areas. When the base wash is dry, paint a diluted wash of cerulean blue to add the shadows. Paint a second and maybe even a third wash in areas where you want the shadow to be darker. To refine the design, use a small brush with concentrated burnt sienna on it to add the details like the dragon's scales (**Fig.08**).

Now it's time to work on the background character. To begin with, spread some clean water on his top. While the paper is still wet, lay a wash of cadmium yellow over it. Quickly lay another concentrated wash of van dyke brown over the initial wash. Use the brush to make the colors blend with each other, keeping the left side of the character lighter with a yellow tint. Mix burnt sienna and a tint of crimson lake, and add clear water until the mixture is light. Paint the mixture on the fur areas. Mix van dyke brown and payne's gray together, and use that on the leather straps on the arms. Simply paint the buckles with cadmium yellow (**Fig.09**).

Use the same routine as you have done on all of the other parts of the image and start the pants by brushing some clear water over them. Paint a cadmium yellow wash over the area. While the wash is still wet, spread a concentrated mix of van dyke brown and payne's gray over it. This mixture will create a darker shade of brown. Simply paint a flat wash of burnt sienna on his boots, but leave the bottom of the boots lighter than the rest. Use a round brush to paint a flat wash of van dyke brown on the boot's straps, and cadmium yellow on the buckles (**Fig.10**).

Remove the masking from the patterns and paint a flat wash of cadmium red on the patterns. Next, spread some clear water on the scarf and quickly paint a diluted wash of cadmium yellow over it. Use a wash of cadmium red over the yellow, remembering to keep the left side yellow. Let these base colors dry and create a mix of cadmium red and van dyke brown. Use a small brush and paint the end the scarf. Use a concentrated wash of van dyke brown and burnt sienna to paint the belts and the bags. Use a diluted cadmium yellow wash for the buckles and buttons (**Fig.11**).

When the background character is dry, work on the shadows by painting washes of cerulean blue, cobalt blue, phthalo blue and indigo in shaded areas. Cerulean blue and cobalt blue are great when painting shadows on lighter areas such as the scarf and fur, while phthalo blue and indigo are better for darker areas such as his top, pants, and boots (**Fig.12**).

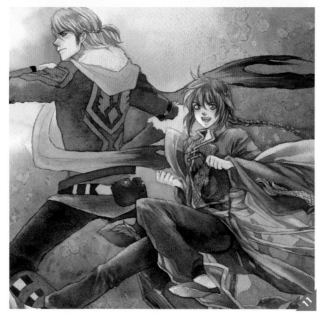

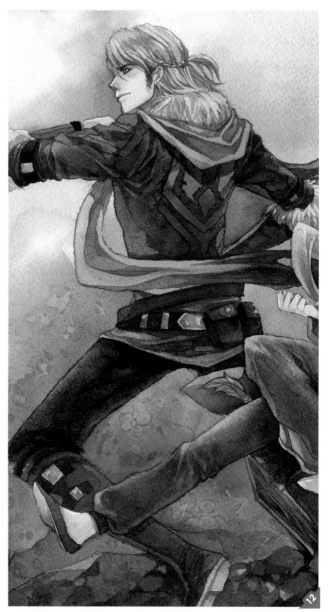

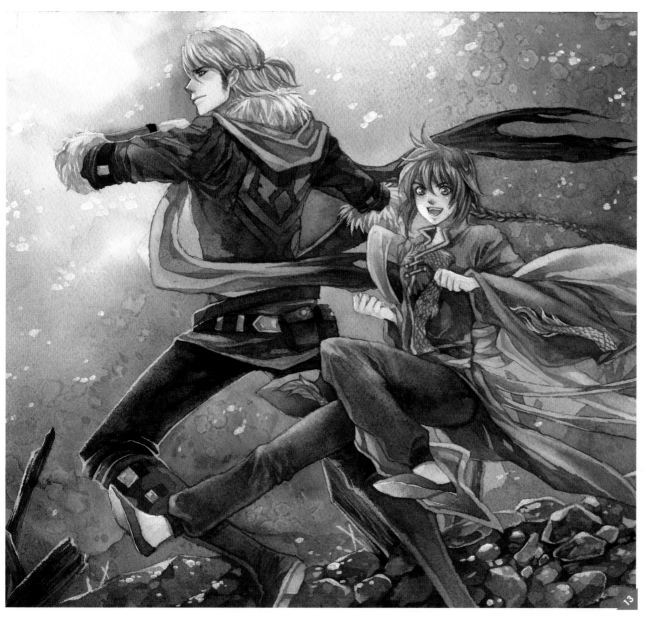

The Highlights

The final step is to use a small brush and white paint (or a white gel pen) to add highlights to reflective surfaces and areas that would catch the light. Add dots of white around to make the background more interesting. I hope you found the tutorial useful and feel well equipped to start your own manga painting (**Fig.13**).

Coloring the Angel

By Sandra Chlewińska

Introduction

Once you have a complete sketch you have a decision to make. Should you add color to it? If you do, what tools should you use? The beauty of this book is that a host of techniques and tools are used to complete the image, providing you with a useful catalog of approaches for you to adopt into your own workflow.

Tools Used

- Pencil crayons
- Black pen
- White paint

The tools used in this tutorial are some of the most widely available and affordable art tools on the market, so let's see how to use them to color our image.

Coloring the Image Using Pencil Crayons

When coloring your image I strongly recommend working from the background forwards, as you will find it much easier to color the skin accurately when you have an entire background palette to match it to. However on this occasion we are going to begin by adding some color to the character first. When using pencil crayons start by adding the darkest color first. Softly shade the skin using your darkest skin tone in the areas that would be least exposed to light (**Fig.01**).

Artist's Tip: Coloring an Image

Try to color your image with pencil strokes that match the form of your character as over time, you will build up color and it will give your character more volume.

Before you finish shading the skin, color the darkest shadows on the hair. Use simple strokes from the end of the hair to where it meets the head and vice versa to make the hair look as natural as possible. Change the amount of pressure you apply. By only applying a light amount of pressure in certain areas you will be giving yourself the opportunity to mix more colors in that area later. You should mix colors all over the image to make it look more believable. For example, use reds under the eyes, yellows on the forehead, blues under hair and on the jaw, and pinks on the cheeks. Always use more than three pencils to color each part of the picture (**Fig.02**).

Artist's Tip: Multiple Colors

It is important that you use a mixture of colors and don't use large parts of one color in an area. By using multiple colors to color the individual elements you will make your image more believable.

Now it is time to use some brighter colors. You can start to press a little harder with your pencils. Start by finding a light yellow color and applying more pressure as you color the areas where there would be light hitting the character. Remember to also use other colors to make sure the image continues to look believable (**Fig.03**).

Continue to color the hair using multiple colors. For the hair on my image I used over five different colors. Even when you are using more diverse colors in the hair, remember to color along the strands of hair to make it look more like hair. Some parts of the hair can be left completely white to show that they are reflecting surrounding light.

Start to color your background. Use multiple colors again and don't let one area be filled with too much of the same color. Never use black at this point as it is too strong and will not look realistic or believable. Use dark reds, violets and browns as these will blend together cleanly. Use a variety of strokes at this point to give your image a textured effect (**Fig.04**).

I strongly suggest coloring with a gradient in the background. Make transitions from one color to the next that either move from hot to cold or from dark to light. In the background of my image I have left some streaks to make it look like stars are falling.

The wings need to reflect some of the colors from the background, so start to color them using violets and blues. The darker and stronger colors should be in the areas that are covered by feathers (**Fig.05**).

As your image progresses continue to move around it, adding more color to each of the different areas. By doing this you will make the whole image feel consistent and will give your image a greater sense of depth. As you work across the image remember to leave white the areas that are hit with light. Continue to use blue colors in the shadows to tie the image together (**Fig.06**).

Artist's Tip: Focal Points

By making less important parts of the image darker it will draw more attention to the important parts. For example, by leaving the face of my character lighter than the body, it will make people look there.

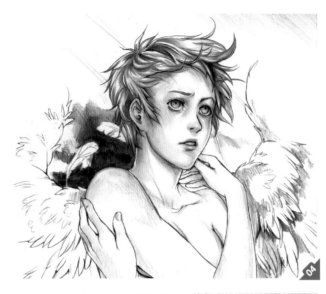

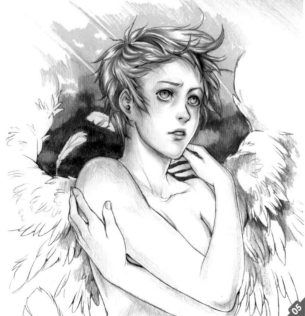

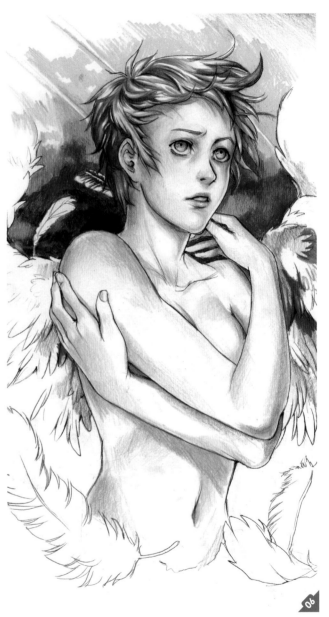

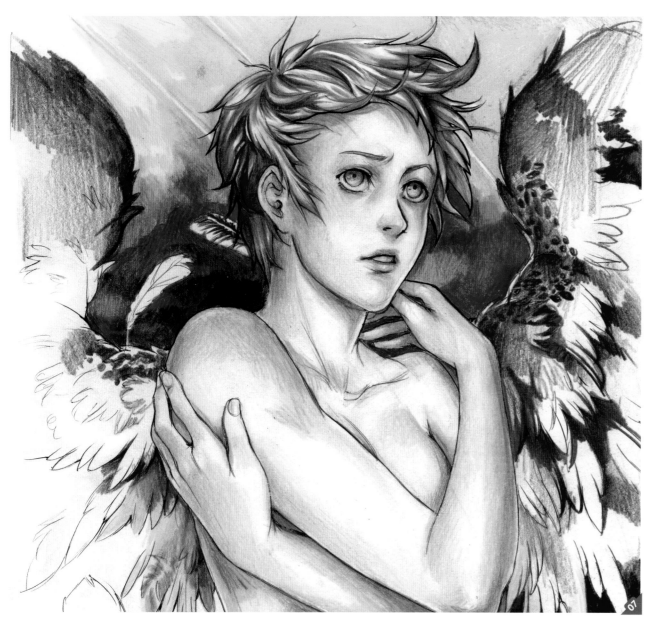

In my image I decided that I would make the top of the wings blue so that they would contrast nicely with the warm background. Add some specs and dots to parts of your image, like I did to the wings, to make it look more textured and natural.

If a character is lit from behind it would usually leave some sort of rim light effect on them. If you can apply this to your image it will make the main focal point stand out more and feel separate from the background (**Fig.07**).

The wings need to appear layered so use a variety of colors to fully demonstrate the separation of certain sections. If you feel that some of the colors you have used don't match, don't use an eraser; when you have finished the coloring, scan it into a computer and adjust sections using software like Photoshop (**Fig.08 – 09**).

Artist's Tip: Avoid the Eraser

Try not to use an eraser when using pencil crayons as it often leaves dark smudges is lighter areas.

Try to consider the image as a whole, rather than a collection of different elements. Don't color the skin, then move on to the hair, then the wings, etc., as this will make your image feel disjointed as if all the elements weren't in the same scene (**Fig.10**).

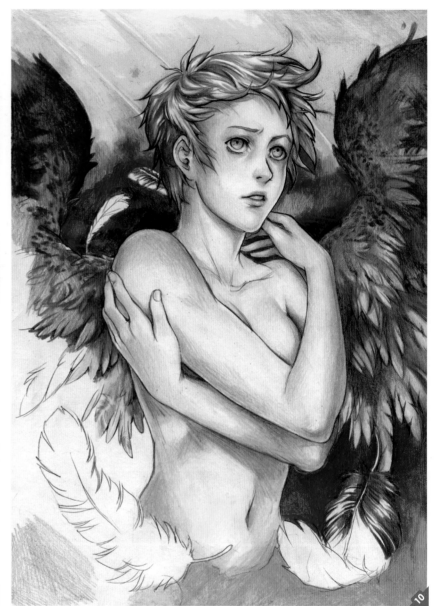

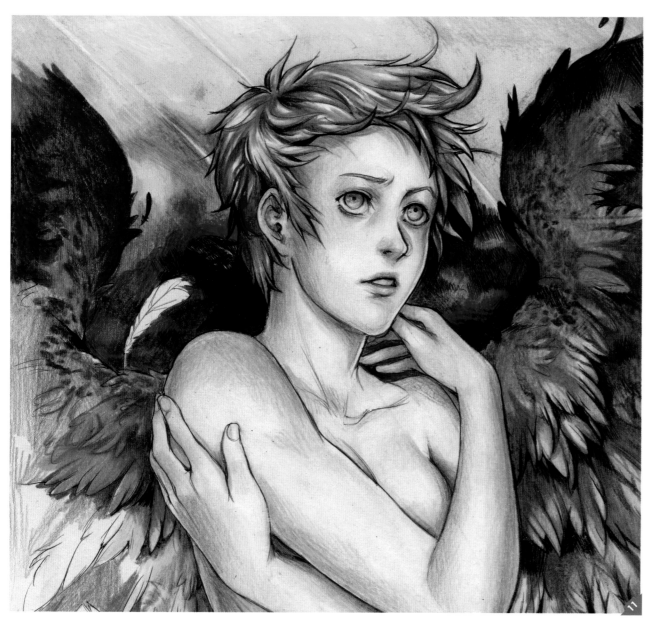

At some point, you might, as I did, feel that there isn't enough contrast in the image. I wanted the character and wings to look more separated from the background. I always avoid using a black pencil crayon because it can leave dirty marks, so to darken the image use a 0.5 black pen and add some cross hatching to the background and on the wings (**Fig.11**).

Using the same pen add some details to the feathers on the wings by drawing lines that flow in the direction of the hairs on the feathers. Due to the darker colors that have now been added you will need to make sure you use plenty of lighter colors to balance the image.

The next step is to add some highlights and specks of white to show areas hit by light and to give a sense of atmosphere to the environment. To do this you will need to use something like white paint. I used a white Sakura marker as it is opaque and fade resistant. This type of pen can be applied in layers to make it a stronger white. If you have one of these pens and want a really strong white color, shake the pen a lot before you use it (**Fig.12 – 13**).

Making Adjustments

The coloring of this image is now complete. You may decide, however, that you would like to edit it further. To do this you will need to scan your image. Once you have done this, open it in Photoshop to edit it. The first thing to adjust is the contrast. To do this click on Image > Adjustments > Levels. Adjust the black and gray sliders to make the drawing appear more vivid.

When you adjust the levels you may find that a few dark spots appear in your image. These are simply spots or specs that would have been picked up when you scanned the image. These appear dark because you tweaked the contrast. To get rid of them, use the Spot Healing tool, which is the tool that looks like a plaster. Set your brush size to be slightly larger than the dark patch on your image and use it gently in the marked areas. This should get rid of any specs.

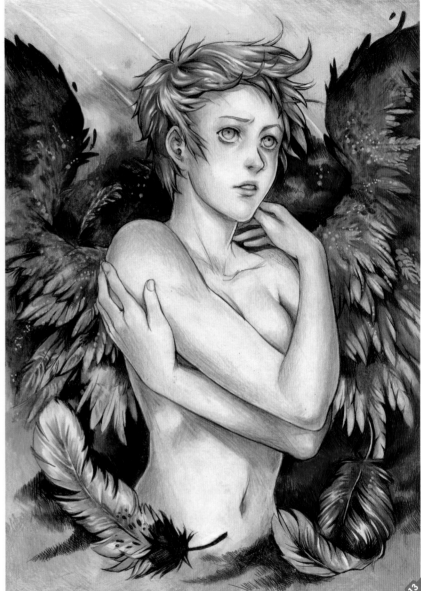

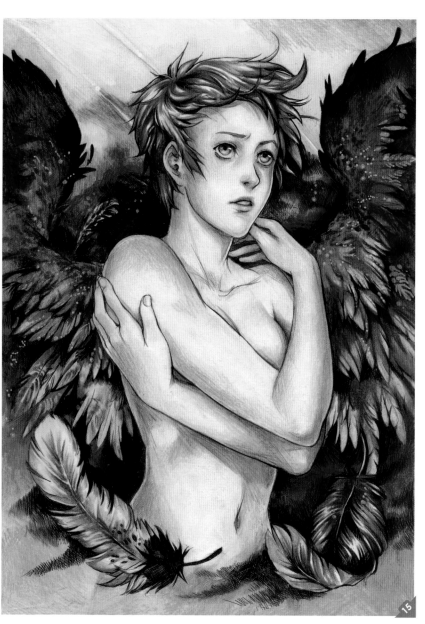

If you have made a big mistake and you accidentally drew a line across the face of your character with your pen, use the Patch tool. To find this tool, click on the Spot Healing tool icon and hold down the left mouse button. A small list of tools should appear; click on the one called the Patch tool. Once you have selected this tool circle the area that contains the fault and left-click on it. Hold down the mouse button and drag it across to a clean part of the image. Don't make the selection too big though as it may mean you end up with a smudged area.

I didn't feel satisfied with the yellow background so I decided to fix that. To adjust a specific color in your image go to Image > Adjustments > Selective Color and choose the color you want to change. Move the sliders until you are happy with the changes made to your image. In my image I desaturated the yellow without affecting any of the other colors (**Fig.14**).

To make the final adjustment to the colors, create a new layer on top of your image. Change the blending mode to Color and choose the Airbrush tool. Choose your colors carefully and adjust each of the different areas until you are happy with the image, then you can call it done (**Fig.15**).

Coloring a Forest Spirit

By Valentina Remenar

Introduction

You may be tempted to finish your illustration as a sketch, which is fine. Every now and then though, you will decide that an image really needs color to look complete. In this tutorial we will look at an approach you can use to color your image.

Tools Used

- Tria markers (Letraset)
- Pencil crayons
- Pastels

Color Schemes

The first step is to settle on the color palette you want to use. You could copy your sketch and scribble some colors on the copy to get a good idea of what works or you could do it digitally. If you do it digitally you will need to scan your image, open it in Photoshop and paint under it using a graphic tablet. This option may not be open to everyone, but it is a very versatile way of testing the colors.

Marker colors can be quite expensive so you may not have a huge variety of colors available to you. If this is the case, choose your colors carefully and consider how you can use them creatively. Sometimes you can create the best results when you are forced into using tools and colors in an unconventional way.

At this early stage you should try to consider the light's direction and color carefully. This will have a huge effect on the colors you use and the overall brightness of the image. Also if your light source is quite yellow, this should be reflected in the image. In contrast to this, a night scene will consist of dark blues and grays. For my image I have chosen a strong white light as my light source, but with a dark touch to it.

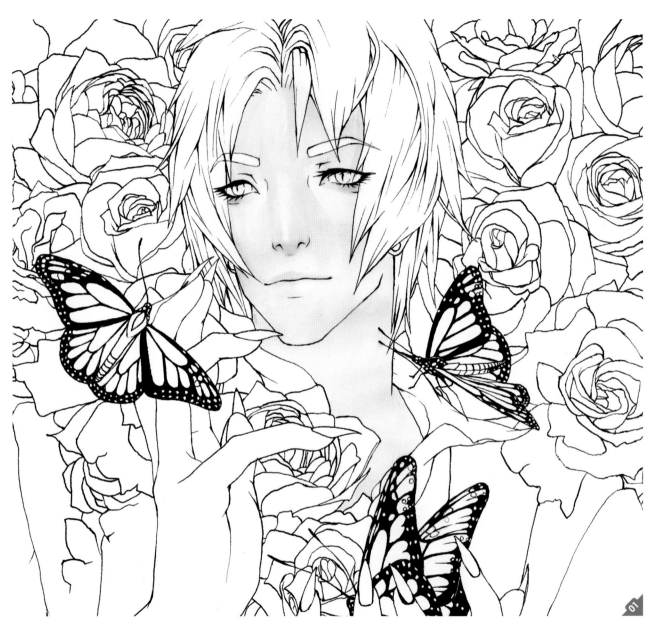

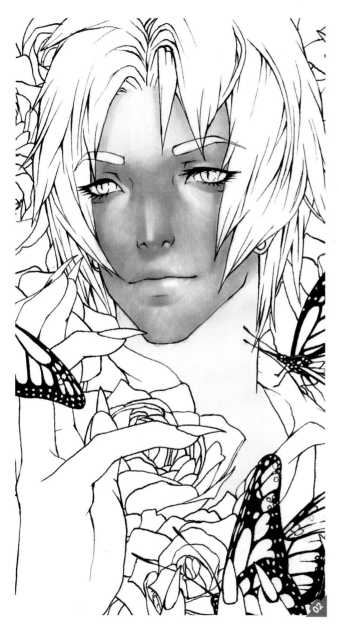

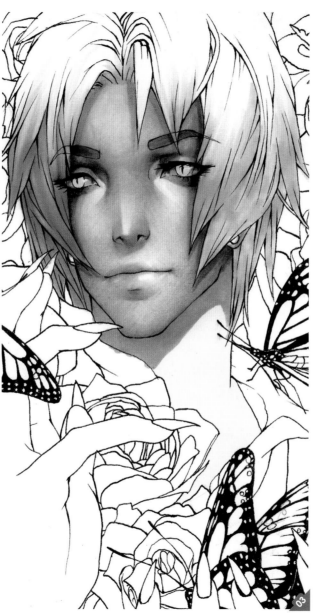

Coloring the Image

Now that you know what type of colors you would like to use you can start by coloring the character's skin. I started by coloring the character's face with a light yellow color (Y119). Try to leave the areas that would catch the light white, particularly if, like me, you have chosen a strong white light as your main light source. To demonstrate the volume of the face use a slightly darker yellow (Y129) in shadowed areas (**Fig.01**).

I decided I wanted my character to have very pale, gray skin. To reflect this I used a light cyan (C719) and a light gray (NG07) over the yellow, while still being careful to leave the areas catching sunlight untouched. I wanted to make some areas of his face look fleshy and pink later, so I was careful to not make those areas too strongly colored at this point. To blend these colors together you can use a white marker (**Fig.02**).

The next step is to move on to using the pastels I mentioned earlier. Using pastels accentuates the highlights on your character's face. The most obvious places to do this are on his nose, chin, mouth and under his eyes. By using these softly and smoothly you will give a clean appearance to your image. Doing this also gives you an opportunity to correct any errors that may have occurred when you were using markers (**Fig.03**).

To add the shadowed areas like under his eyes, use a darker gray (NG02) and a green color that looks quite gray (G917). When deciding on my color scheme I decided I wanted to have his eyes orange, so I colored this color using a light orange for the base (O528) and a darker gray (NG02) for the shadowed areas. To create the highlight on the eye, simply don't add any color to the highlighted area.

To add the fleshy effect that makes him look living, use colored pencil crayons and add a pink/red color to his mouth, nose and cheeks.

Like all the areas of this image, his hair was first colored using a base color. On this occasion it was a light gray (NG07). I wanted the hair to look white and gray so, again, I left the highlight areas white. Once you have colored your base color you can move on to work on the shadowed areas. To do this I used a light cyan (C719) and the yellow (Y119) I used earlier. To do the dark shadows, use darker grays and maybe even a black if you have very shaded areas (**Fig.04**).

Artist's Tip: Tria Markers

Tria markers have three tip sizes; two on one end and one on the other. You will find the medium-sized tip helpful when doing the hair, as it has a brush-like tip that helps you follow the flow of the hair nicely.

Once the head is done you can move on to the body. This area should be different in tone to the character's face to make it look different. Because of this, I used darker tones to create a dark gray base for the roses (NG02) and waistcoat (CG01).

Try to tie features in the image together by using similar colors across the image. An example of this is when I used a similar orange (O949) for the butterflies as I used on the character's eyes.

Once these colors are in place it may highlight areas you want to adjust on the character's face. I added a few blue tones using pastels, which I smudged using a cotton pad to get an even finish. The orange tones in his eyes were also lifted with some stronger colors to link their color to the butterflies (**Fig.05**).

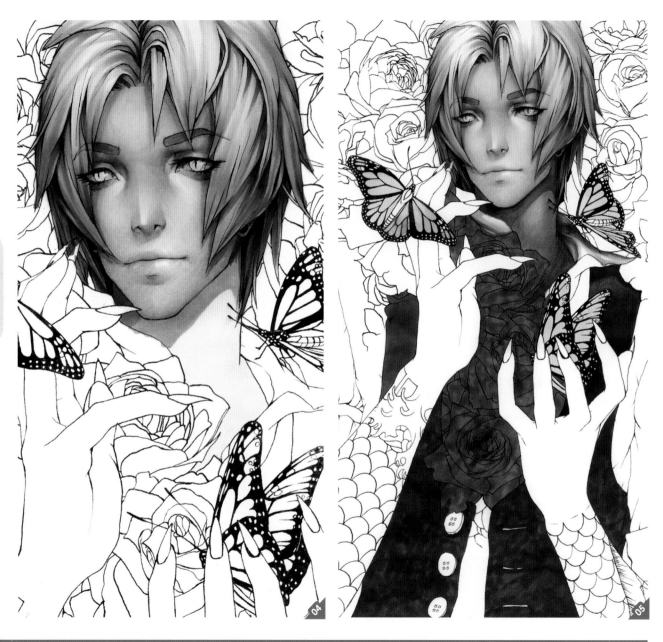

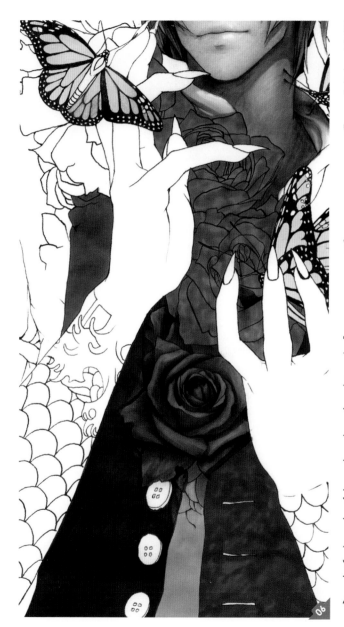

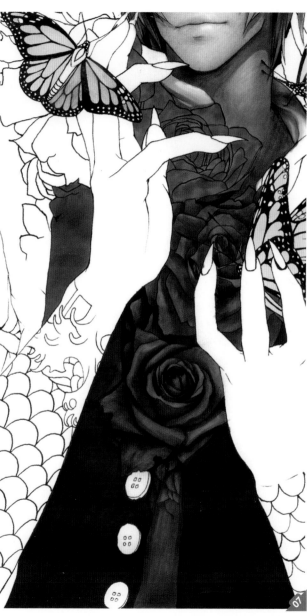

Always view your image as one big project and be willing to make changes to areas you have already worked on, as this will make your image look more consistent than if you work on it bit by bit.

The roses coming out from his jacket should be almost black. This means that a lot of darker grays will be used. Before moving on to darker colors though, use the same color as you used for the base again and go over your base. This will darken the base color in these areas and start to demonstrate areas of shade and volume.

Use a dark cyan gray (CG01) to do the darker areas of the shadow. Once you have these colors in place, you can use a lighter marker over everything to blend the colors together. You could even use the black in the really dark and shadowed areas (**Fig.06 – 07**).

Artist's Tip: Blender Pen

I never use a blender pen to blend dark colors as it doesn't work as well as using a lighter version of the main color to unify and blend the different tones.

The roses in the background can be colored differently. You won't need to use the dark grays that you used earlier. Instead, use a lighter gray. This is so that it doesn't distract the viewer from the focal point and also because the flowers by his chest would be more shaded due to their location between his arms.

You can use a limited amount of markers to do areas such as this. For example, most of the roses were colored using the same single marker used in layers. The same applies to his shirt and waistcoat.

To create some variations in the tones in areas such as this, use the pastels again. For example, I used a dark blue pastel in the shadows and added some highlights to them using a pink pastel. Again, these can be smoothed using cotton wool (**Fig.08 – 09**).

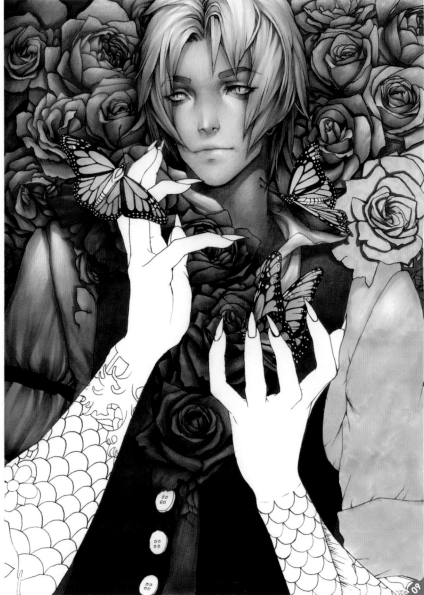

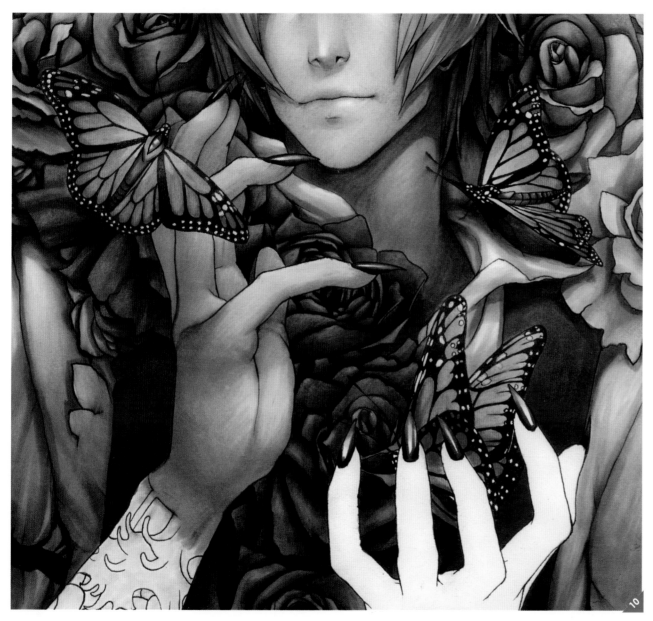

Once these large elements are done, you can turn your attention to some of the smaller features of the image. The next element to work on is the butterflies. These can be colored with a strong orange and even some red tones (O929, O739, O628 and R666). These colors can then be added to again with the use of a yellow pastel (**Fig.10**).

The arms are the next area that needs to be worked on. These should be similar in color to the face, which you worked on at the beginning. Because of this you can use the same pens and the same method. The one difference on the arms is that there will be a tattoo on them shortly. To help you when adding the tattoo, use the base color on the arms and demonstrate some volume using layers of the same color, but don't use the darker grays for shading yet, as the tattoos will need to be added over this color (**Fig.11 – 12**).

Because you used the base color to paint his arm earlier, any colors added over the top will look more natural and like a tattoo when they are added. Use a red (R666) to add the color of the tattoo. A layer of red over your base color almost acts like a transparent layer that adopts some of the volume you colored when adding the base color.

This effect can then be added to with the use of some of the darker grays. Using a dark cyan gray (CG01) you can add some diversity to the tattoo. You can see these changes in **Fig.13 – 14**.

The other arm can be done using a similar technique. Again, the red marker can be used, but the difference this time is that you should mix it with a different orange/pink color. This is to make the tattoos look different from each other and therefore make the image more interesting.

Once you have finished with the markers, use the pastels again to add to the shadows and different colors to the highlights.

At this point you can look back at your image and pick out areas that you are not happy with. I decided that I wanted to make the roses a little darker, so I used some of the grays I had used earlier, and some pencil crayons, to smooth out the highlights and shadows.

If there are any highlights that have lost their vibrancy they can be painted using white paint or pen. It is particularly important that these are obvious on reflective surfaces (**Fig.15**).

As you can tell, the same process is repeated throughout the coloring process. Begin with base colors and add depth by using them again over your base. Add more depth with darker tones and then smooth everything out with pencil crayons and pastels. Once you have practiced this a few times you will master it and come up with some great results.

Coloring a Japanese Warrior Boy

By Georgina Chacón

Introduction

Some of you may not be familiar with digital painting and the results you can create using Photoshop. However, in this tutorial you will be led through a technique that could be used by any artist, beginner or intermediate, to create a stunningly clean manga illustration using Photoshop.

Tools Used

• Photoshop

So, are you intrigued to see what you can achieve in Photoshop? Well, without hesitating any longer, let's look at how to start our digital image.

Choosing Colors

Before you start working on the colors, try to have a think about what color you would like the character to be. If you don't have any good ideas, look on sites like deviantART and Behance, or if you're looking for color palettes, try Kuler or Colour Lovers.

Open your sketch in Photoshop, create a new layer and set your sketch to Multiply. Paint over it freely without worrying about the line art boundaries and details. This will give you a fairly good idea of how the colors will look in the final image, without having to change it multiple times because you didn't like the scheme (**Fig.01**).

Artist's Tip: Choosing a Color Scheme

If you still can't decide on a color scheme after creating a few sample versions, show your images to friends or family who will be able to help you choose the one you want to use. You could even put the options up on your social network pages.

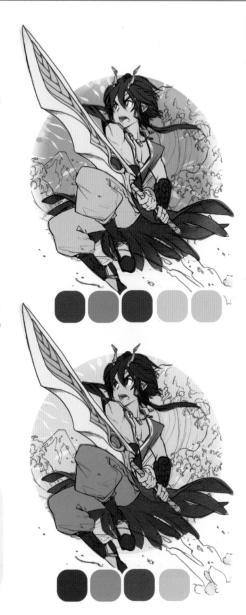

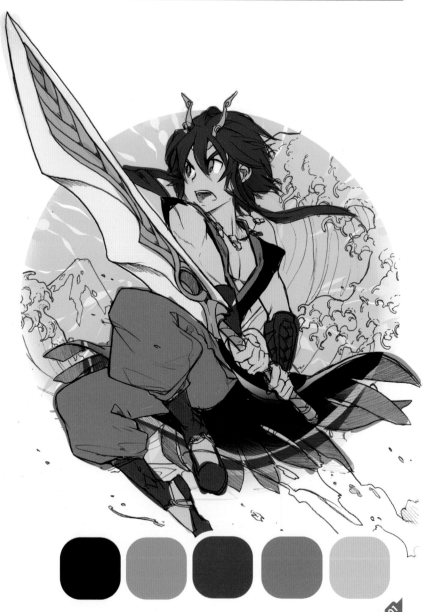

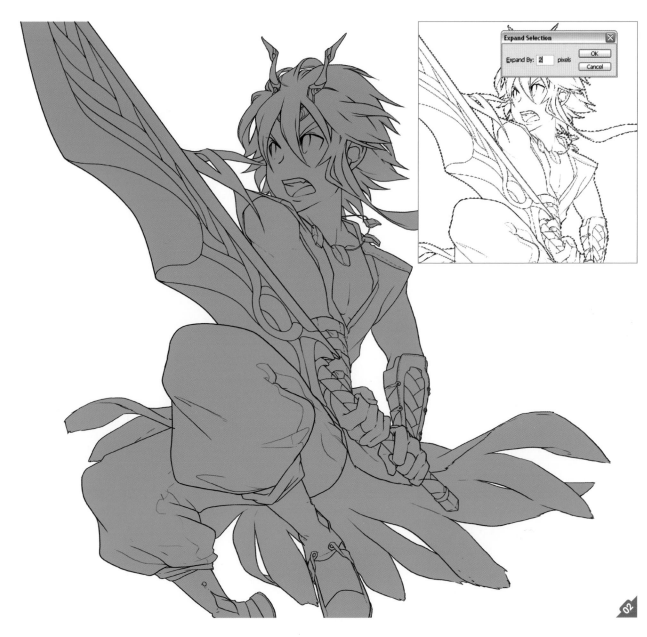

Expand Selection

Expand By: 2 pixels

OK

Cancel

Selecting the Character

Open your line art again in a new canvas. Choose the Magic Wand tool and before selecting anything, take a look at the options that appear in the upper toolbar. There's an Anti-alias checkbox; make sure it's unchecked.

Select all the background, never inside the line art. If you have an open edge on your line art it will make the selection go inside it. If this happens, de-select the selection and paint over all the open gaps you find. Once you have done this, take the Magic Wand tool again and repeat the process until the selection is all around the character.

Expand the selection by 1 or 2 pixels (Select > Modify > Expand). Invert the selection (Select > Inverse), take the Paint Bucket tool and fill it in a new layer below the line art (**Fig.02**). Make sure that the Anti-alias is unchecked.

Painting the Base

Now you have a clear silhouette that you can select at will, it's time to paint the flat, base colors. First, lock the transparency of a new layer in the Layers tab, then select the Pencil tool (it will show up if you select the Brush tool, and keep pressing it until a little menu pops out) and paint all the sections of the character. You can also use the Bucket Fill tool to do this, but you may find you spend a lot of time filling in gaps in the line art. The base colors should all be done in one layer (**Fig.03**).

Artist's Tip: Establishing Base Colors

This may take some time to do, but if you do it carefully you will be able to use these flat colors to make selections later.

Painting the Shadows

Before you start adding the shadows you will need to know where to place them. Take a minute to think about where the light source is (**Fig.04**). If you have trouble deciding where to put the shadows, create a new Multiply layer above the flat base colors and rough in some quick shadows. It doesn't matter what color you choose to do this as it is only a guideline (**Fig.05**).

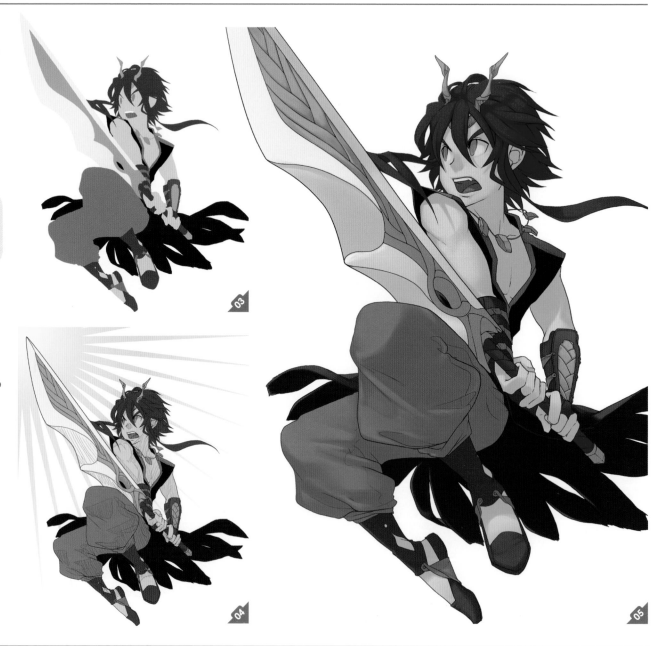

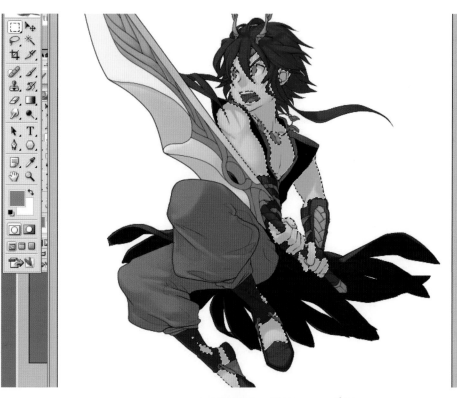

Duplicate your flat color layer (Layer > Duplicate layer); this layer will be the main canvas. This can be scary at first because all of the coloring will be done in a single layer, but this is why you have a flat layer. If you make any mistakes you can go back to your flat layer, select a section and adjust or re-paint it as you wish (**Fig.06**).

For the brushes, use a combination of the Hard Round airbrush and the Soft Round airbrush. These brushes are available as standard in Photoshop (**Fig.07**).

The way I select the colors for the shadows is quite simple. As you will see in **Fig.08**, I rotate through an imaginary curve and choose two shadow colors. The first one is more saturated and the second has the same level of saturation as the base color, but in a much darker shade. These two shadows act together to give the painting a more natural feeling.

Use the two shadow colors to show the form of the materials and his body. When using the second shadow color, make sure that you don't completely cover the first shadow color (**Fig.09**).

I also added stripes to the lower part of the clothing. Since these areas are covered in shadow, pick the second shadow color of every tone to keep everything looking consistent.

Add some highlights in specific parts, such as the hair and golden accessories (**Fig.10 – 11**).

Remember the circle in the background of the previews? It's time to add it in a new layer below everything. To do this you simply create a new layer and place it below your existing layers. Create a circular shape and fill it with your chosen color.

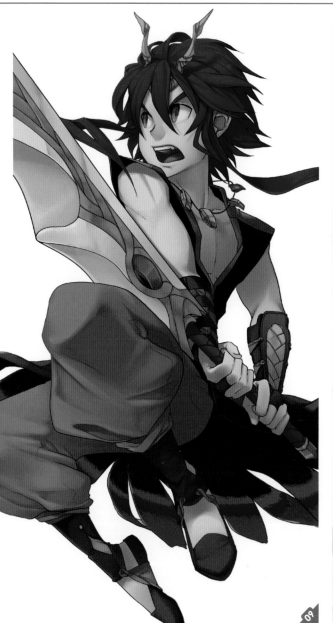

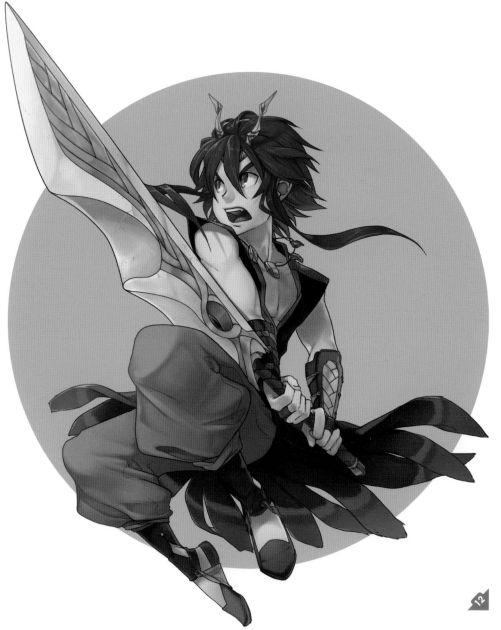

The colors now look a little bit strange and all the shadows look separate in hue to the background color. This is because there is a secondary light source in the background now that isn't reflected in the image.

Select the background color and create a new layer set to Normal above the color layer. Turn it into a clipping mask (Layer > Create clipping mask). You will notice in the Layers tab that the layer will have a little arrow in it that will point down to the color layer. This means that if you color outside the boundaries of the color layer it won't be seen.

Paint some hints of the background color over the shadows at a low opacity. This will link the image with the background nicely.

To give your image a warmer feeling, create a new layer at the top of your layer stack and turn it into a clipping mask. Set the layer type to Overlay mode. With a soft airbrush, paint some light yellow accents in areas that would be hit by the sun's glow. In the areas you paint you will notice the colors will begin to look more vibrant. You can also do this for the shadows if you like (**Fig.12**).

Now it's time to prepare the image that will appear in the
background circle. Since this is a Japanese-themed illustration,
I'll add a Japanese sea. Repeat the same steps as you did in the
sketching section, but this time ink the line art traditionally using a
liner, giving it a more traditional feel (**Fig.13**).

To prepare the drawing to be used in Photoshop, repeat the steps
that were described in my sketch tutorial to get rid of the blue pencil
lines.

Duplicate the layer and go to the Channels tab; below it are four
little buttons. The first one should appear as a circle, created by
a dotted line (**Fig.14**). Click on it and it will select all the white
sections. Press the Delete button and it will go away, leaving
the line art a bit lighter. This can be adjusted now by locking the
transparency of that layer and painting over it in brown. Now you
have a clean line art layer (**Fig.15**).

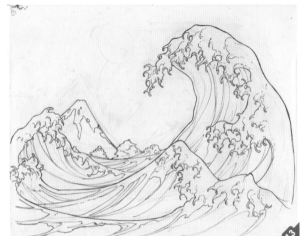

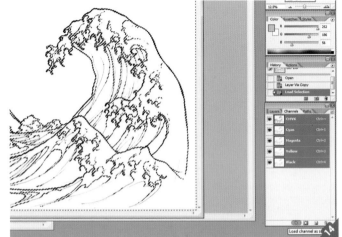

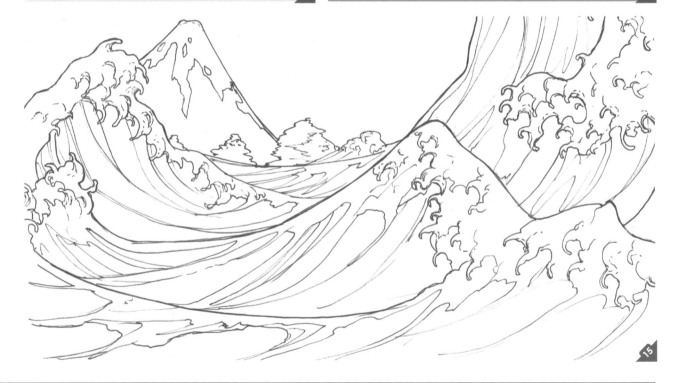

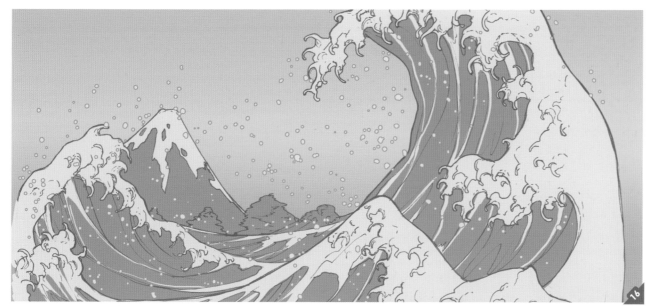

You should now be able to color this layer using light tones that look similar to the background color. Adding tones that are too light or dark in color will draw people's attention away from the main illustration (**Fig.16 – 17**).

Now that you have finished the background image, merge all the layers (Layer > Flatten image). All finished! All you need to do now is add your signature and save your file (**Fig.18**).

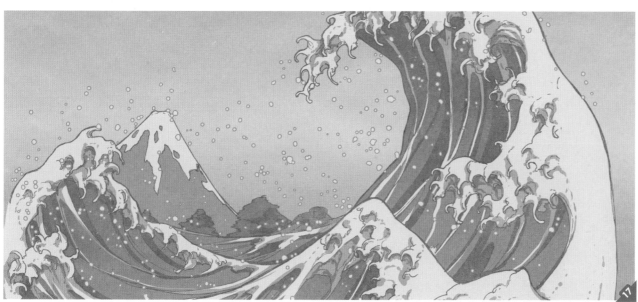

Coloring a Lychee-Obsessed Girl

By Sandra Chlewińska

Introduction

Photoshop is an amazing tool that provides any artist with a plethora of options. In this tutorial, Photoshop will be used to add color to the previously created sketch called *Lychee*.

Tools Used

- Photoshop

Adding color to an image brings it to life and makes it really eye-catching. Let's see how to do that in Photoshop to create a bright and exciting image.

Image Orientation

With your sketch already created you can now start to paint it. Once you have your file open in Photoshop you can start to edit it in all sorts of ways. The first thing I do is to see how the image looks flipped. To do this go to Image > Rotate Canvas > Flip Canvas Horizontally. This is a great way to spot any inconsistencies or problems. When I did this I decided that I actually liked my image better this way round so I kept it this way round for the rest of the process.

Gradient Fills

When working on the colored version of your image you can remove any unnecessary layers that you might have, like the original sketch, etc. All you want at this point is your finished, tidy line art.

Create a layer underneath your line art and fill it with a nice gradient. To do this, select your color and the layer you want to fill with the gradient. Left-click on the Bucket icon in your toolbar, hold down the mouse button and select the Gradient Fill option. With this selected, click on your layer and drag in the direction you want your gradient to go (**Fig.01**).

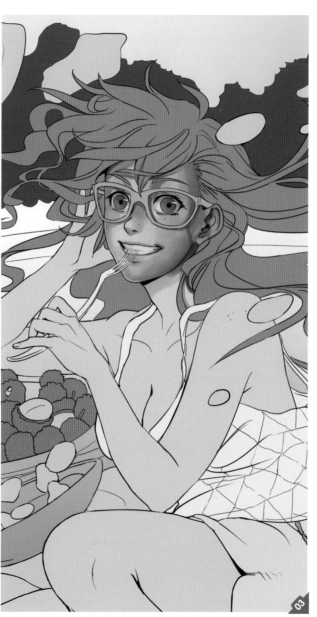

Base Colors

Now it's time to start to fill in the color using the Bucket Fill tool in its normal mode, rather than Gradient Fill mode. Once you have selected the tool make sure the All Layers button in the top toolbar is clicked and in an individual layer, use the Bucket Fill tool to fill each part of your line art with appropriate colors (**Fig.02**).

Artist's Tip: Bucket Fill Tool

If the Bucket Fill tool colors too much of your image it is because there is a gap in your line art. To correct this, fill the gaps in the line art and use the Bucket Fill tool again.

Shading the Base Colors

Now that the flat colors are finished it is time to start to shade the picture. I recommend doing this in one layer. It may not be the best approach, but I start with the face as if that goes well it will motivate me to use the same quality of finish throughout the image (**Fig.03**).

Try not to use one color for the shading and one color for the highlights. This will make your image look a bit flat. Try to vary the colors for both the shading and the highlights by considering the influence that environmental elements will have on the color. Use real-world references to help you do this, if you like.

When looking at the type of person you are painting you will realize that there are some color traits you should try to include. For example, there is more yellow in areas like the forehead than the cheeks, which look quite pink in comparison. Also try not to use pure white or pure black as these colors don't really exist in the natural world. This means that even the whites of the eyes should be slightly yellow. The same applies to the teeth. Don't forget to paint a shadow on the eyeballs to make them look as if they are behind the eyelids.

The Hair

The next thing to do is work on the hair. To start the hair, use the Gradient Fill tool again and fill the area with a color you've sampled from the background (**Fig.04**).

Once you have done this try to use long, smooth strokes on the hair (like you did when you drew it originally) to show that sections of the hair overlap each other. As I said earlier, do not use white in your image to add highlights. However there are few colors that will really stand out against bright orange, so use a very warm yellow over the hair to add the highlight.

Line Art Adjustments

You may decide that you don't want to, but you can change the color of your line art in areas if you like. An example of this can be seen around the girl's leg, hair and top (**Fig.05**). To lighten areas of the line art, select its layer and click the Lock Transparent Pixels button in the Layers tab, which will have Lock written next to it. Once you have done this you will be able to paint directly onto your line art without marking the rest of the painting.

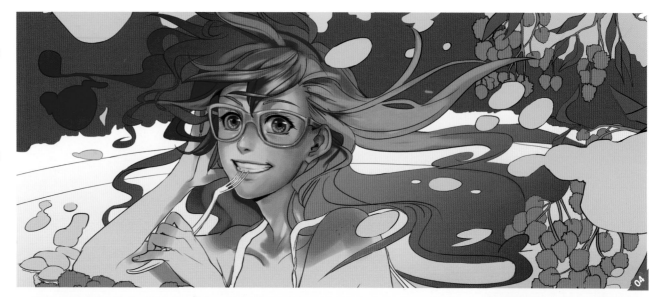

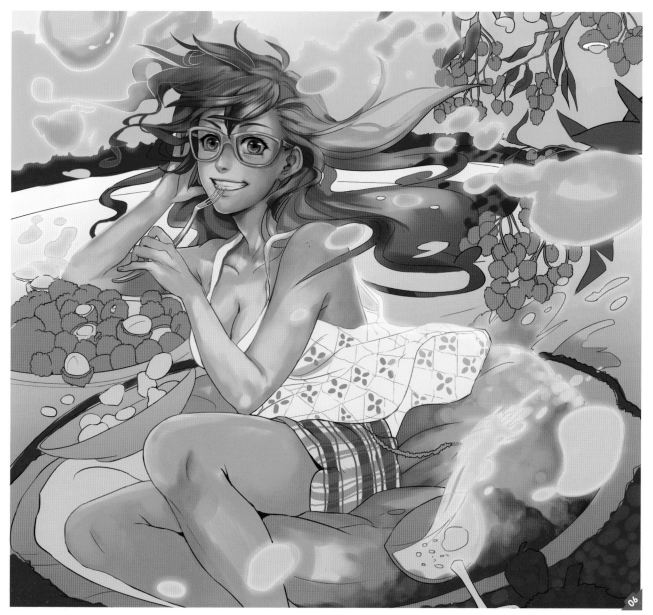

Glows

Sometimes it is good to make areas look as if they are being hit by strong sunlight. When you do this you want selected areas to glow. It is good to make parts of your line art glow to make it look like there is a strong rim light in areas. To achieve this, duplicate your line art layer by clicking on Layer > Duplicate Layer. Right-click on the new layer in the Layers tab and choose Blending Options. Tick the Outer Glow option on the left and set the blending mode to Screen or Linear Dodge. Adjust the Spread and Size sliders until you are happy with the effect (**Fig.06**).

Lychees

The fruit that is scattered around the image now needs to be colored. To start with fill the fruit with a gradient and then start to shade them, remembering not to use black or white. When shading these use the Airbrush Pen tool (**Fig.07 – 08**).

Artist's Tip: Selecting Colors with Alt

When you are painting, keep one finger over the Alt key. If you press the Alt key and click on a color, you will select that color. It is a great way of selecting colors quickly and making your image look consistent.

Making Changes

Continue to move around the painting, coloring each of the individual elements in your scene. At this point you can still adjust anything that you don't like by selecting a set area and coloring it a new color. An example of this in my image is the green of the leaves in the top right, which I made darker in color. Also the sky in the background was tweaked (**Fig.09**).

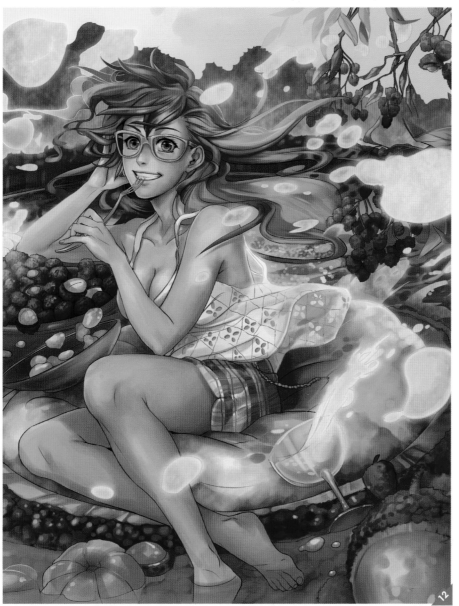

Foreground and Background Separation

It is important that the foreground character stands out from the background. To make it appear this way, use darker colors in the background. This will draw the viewers' eye to the focal point of your image. Sometimes using unexpected colors in areas will make elements look separated (**Fig.10**).

Final Adjustments

When you have finished painting the image you can still make some changes. Create a new layer over your image and fill it with any color you choose. Set the blending mode to Saturation and adjust the opacity to around 27%. This will tie all of the colors together and make the image look more vivid.

The final thing to do is apply some texture to the background. To do this I used a photo texture (**Fig.11**). Insert the texture above the background, but behind the character. Click on the layer while holding the Alt key to create a clipping mask. Set the blending mode of the photo reference to Soft Light and leave its opacity as it is. This will give a nice textured feel to the background.

Once this is done you can make more adjustments using adjustment layers, but at this point I was happy to call my image done (**Fig.12**).

Coloring a Fantasy Elf

By Christopher Peters

Introduction

Once you have used Photoshop to paint an image digitally you may find that you become more confident when using it. In this tutorial we will look at a slightly more advanced approach to painting a character digitally and will see the amazing results you can achieve using Photoshop.

Tools Used

• Photoshop

Values

To start the coloring of an image you need to begin by thinking about the overall color scheme. It is often daunting to start adding color to an image without having an idea of how you want it to look when it is complete. Painting a certain color scheme carefully then deciding that you don't like it does happen and is very frustrating.

Start the coloring process by scanning your image in and opening it in Photoshop. Set your image's blending mode to Multiply and create a new layer beneath it. Use a fairly large brush to quickly rough-in the overall color of the different elements in the scene. Don't spend time on details, but simply try to find a color palette you think works for your character (**Fig.01**).

I started my final colored version using only gray and by painting over the sketch on a separate layer. The main benefits of using gray at the beginning of the process is that it is easier to concentrate on the values of the image, without having to concern yourself with the color choices. Seeing your image in shades of gray also helps you to make sure that the contrast in your image is good enough, to avoid it looking bland.

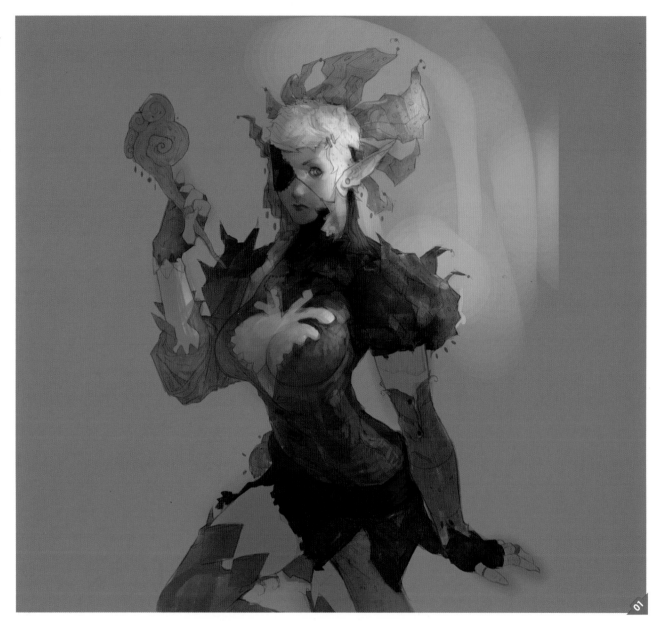

01

Start your painting by using grays to paint the base values while making sure there is enough contrast in your image. Try to paint the skin a consistent shade of gray across your character and then paint the clothing and other elements with grays that vary in darkness. You can also paint some volume in your character at this point by using lighter and darker grays to start to demonstrate shape.

Choosing Colors

Every artist has their own process for choosing color. Some simply choose the colors that they think look nice and others are influenced by the mood they are in at the time. Other artists make a selection of studies or test images.

You may decide to go with a certain color scheme, but then change your mind at a later date. For example, I decided to go with a burgundy color scheme using whites and yellows with the burgundy base color (**Fig.02 – 03**). You will see as we go through the process of developing the image that the color scheme will change. You can test color schemes by adding a layer above your sketch and adjusting the layer modes and opacity, but I will come back to that in more detail shortly.

The Hair

While I was still working with the burgundy color scheme, I decided that the hair wasn't looking good in its current state and that it would be good to make the hair a focal point of the image. This is supposed to be a bit of a cross between a fairy and elf so she should have magical hair. If you decide on a focal point it is a good idea to refine it early on in the process so that you can decide on the color scheme, etc., with one of the main elements in place.

To create the magical hair effect, first choose some saturated colors like bright blues, reds, greens and yellows (**Fig.04**). Select a soft brush that will give a smooth effect without any harsh lines. Create a new layer over your image and set your layer to Dodge blending mode. Then using your soft brush, carefully paint over the hair in your image. You can choose any colors you want to do this and can use textured brushes to get different and interesting effects. The important thing to remember is to use saturated colors otherwise the effect won't work (**Fig.05**).

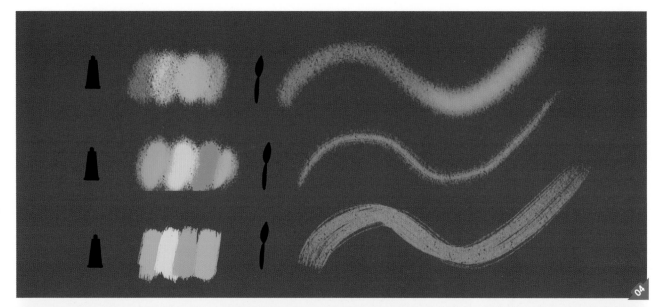

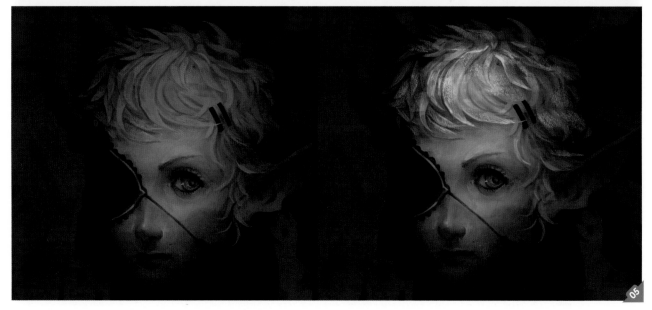

Changing Colors

At this point in the painting you really need to decide on the final color scheme to develop the painting any further. I started with the burgundy color over my grayscale painting, but decided I didn't like it. You may be happy with your choice, but if you aren't and you want to make it darker you can change it quite easily by adding a new layer over your grayscale painting and setting it to Multiply mode. You can then tweak the opacity and color of this until you are happy. In my case, however, the image needed to be much lighter and more mystical-looking.

To make your image lighter while changing the overall colors, use a new layer that you put above your grayscale painting and hair color, and set it to Overlay mode. You can see how an Overlay layer has changed the color scheme in **Fig.06 – 07**.

As you can see, with your image in grayscale at the bottom of the layers you can make quite large changes quickly. You can even add multiple Overlay layers in different colors to make your image look full of color and interesting. You can see how I did that to create my final color scheme in **Fig.08**.

Artist's Tip: Avoiding Saturated Colors

Don't use colors that are too saturated in Overlay mode as they will not react in the same way, and will make your image look too light and almost as if it is glowing.

Painting

At this point you will have a strong base to work on to continue your illustration. You will have settled on the colors and will have most of the things you need to continue to develop the painting. There is no easy way to describe how to paint the rest of the character. You will need to decide on the final effect you would like and this will influence the type of brushes you use. However, one thing you can do at this point that is really helpful is to sample colors from you painting to add the volume and detail. Choosing colors randomly would be very difficult, but by using the Eyedropper tool you can choose colors from your image and paint them wherever you need them, which means that your color choices will remain consistent (**Fig.09**).

If you want to paint shadows or darker areas, they can be done on a separate layer in Multiply mode. I suggest using a softer brush to do this and using an eraser to remove paint in areas that need to look like they are catching light.

Artist's Tip: Real References

The best way to make sure that the different elements in your image are painted correctly is to look for examples of them in books or online, and to paint what you see. Pay attention to the way things look in the real world and it will help you when it comes to painting them, even if you are painting them in a manga image.

More Magical Effects

The lighting effect that was used on the hair is a great way to demonstrate the mystical nature of this character. For that reason we will now apply it over the body. When this approach was used on the hair we used a soft brush. Now we are moving on to the body, it almost needs to look like specks or shiny freckles. For this reason you will need to choose a brush which has harder, clearer edges and a textured appearance. Once you have chosen a brush create a new layer and set it to Dodge mode. Paint in the areas you want this effect to appear. Try not to overdo this as too much of it will ruin the image. If you feel the effect is too strong or overdone you can reduce the opacity or delete areas (**Fig.10**).

The magical effect can be applied wherever you think it works best. The next area I worked on was the conch-like wand. In **Fig.11** you will see how the paint on the hand was developed, as well as the magical effect on the wand. Again, use the brushes in a layer set to Dodge blending mode. This time you could add an area of intense light, like the yellow glow coming from the center of the wand. Do this by using a hard brush to create the area of light and then a softer one to add the glow. You can also use the soft brush to make it look as if the magical effect is reflecting onto surrounding elements, like the hand.

Patterns

Painting patterns on clothing by hand is a long, drawn-out process that might not even look that good when you have finished. By using Photoshop to color your image you will present yourself with a variety of options that will make this much easier. To add fabric patterns to your character's clothing, take a photo of some fabric you like or find a photo you like online. Place it over your image in a new layer and set the blending mode to Overlay. Once your texture is there you can tweak the opacity until you are happy with the effect (**Fig.12 – 14**).

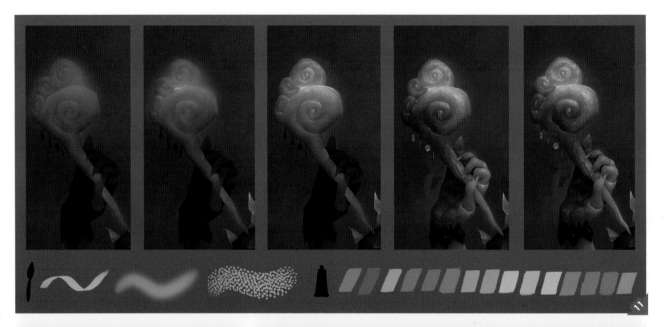

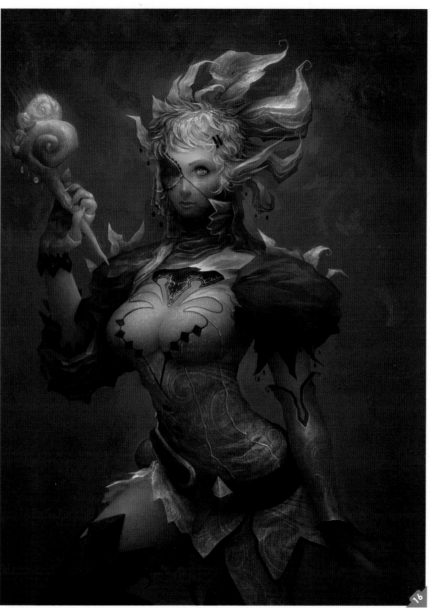

Final Touches

To finish your image and focus the viewers' attention, you can use a vignette effect. You can make your own vignette layer using soft brushes or find one to use online. Simply add it to the top of your image and play with the layer modes and opacities until you are happy with its appearance (**Fig.15**).

The process of creating an image like this can be quite long and tricky. The key to everything is patience and observation. Don't worry if you get it wrong the first time. Mastering digital tools takes a lot of time and practice, but once you have then the results can be really impressive (**Fig.16**).

The Manga Gallery

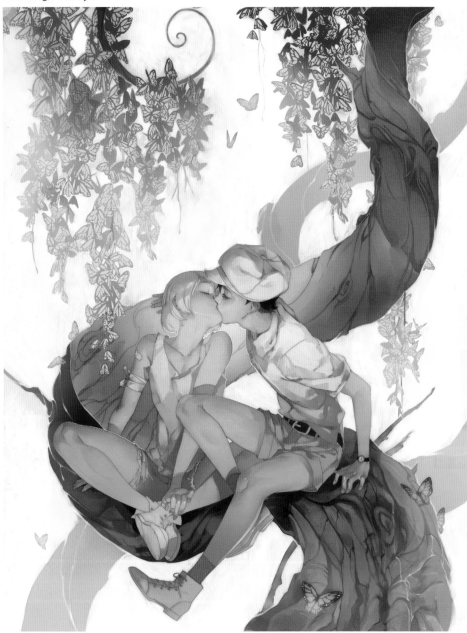

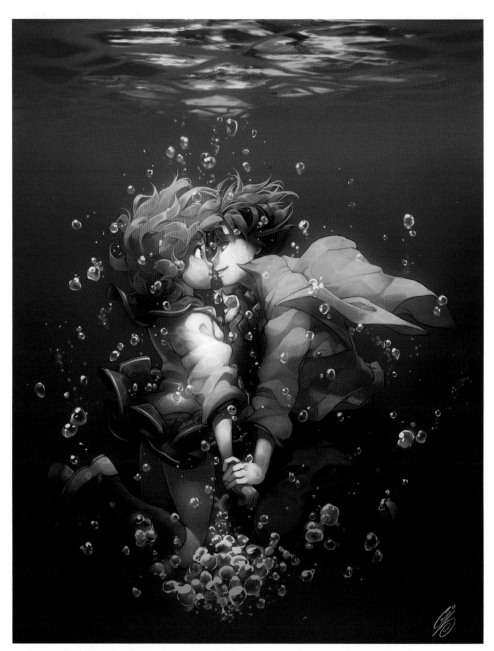

A Kiss by Ein Lee // © Ein Lee

Underwater Love by Gina Chacón // © Gina Chacón

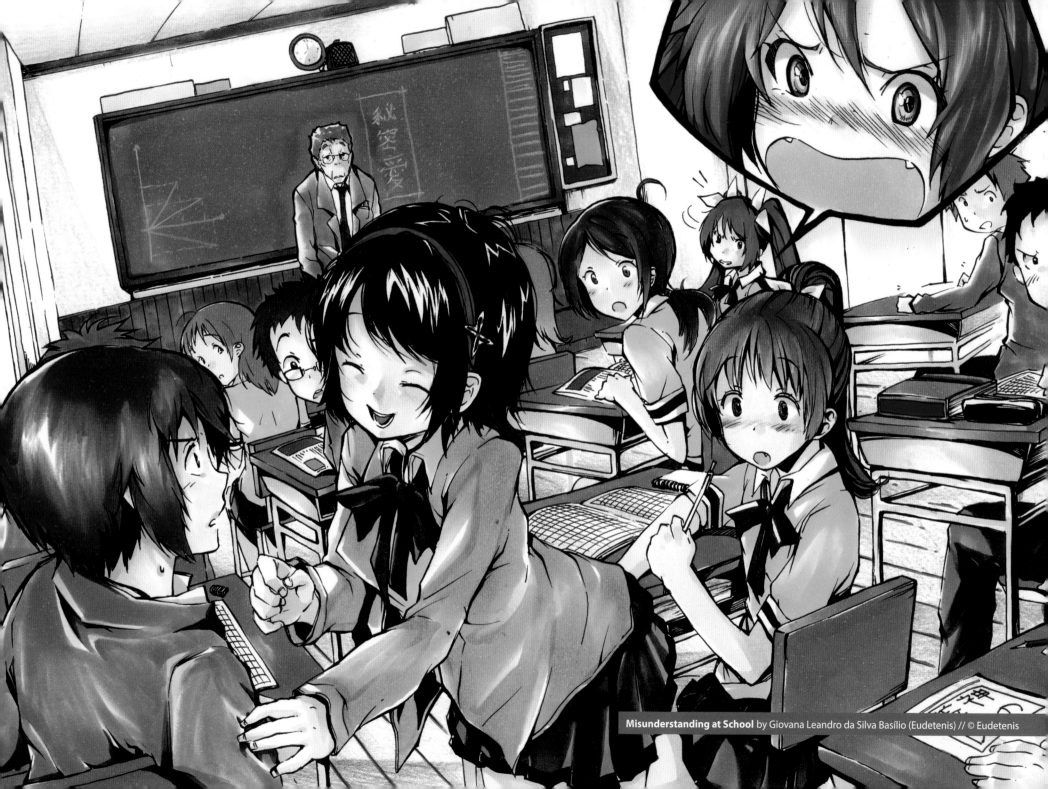

Misunderstanding at School by Giovana Leandro da Silva Basílio (Eudetenis) // © Eudetenis

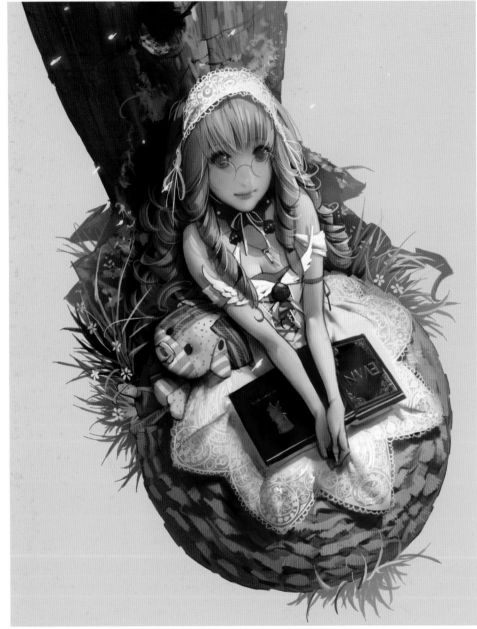

Gladius Regalis by Evan Lee // © Evan Lee/Chinese Gamer

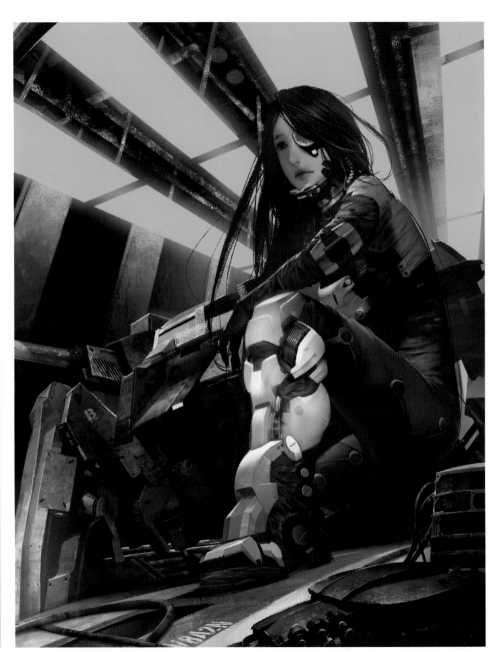

Galaxy Saga by Evan Lee // © Evan Lee/Chinese Gamer

A Walk in Asian Winter by Gina Chacón // © Gina Chacón

Lovey Dovey by Sandra Chlewińska // © Sandra Chlewińska

Gladius Regalis by Evan Lee // © Evan Lee/Chinese Gamer

Art Studio by Ein Lee // © Ein Lee

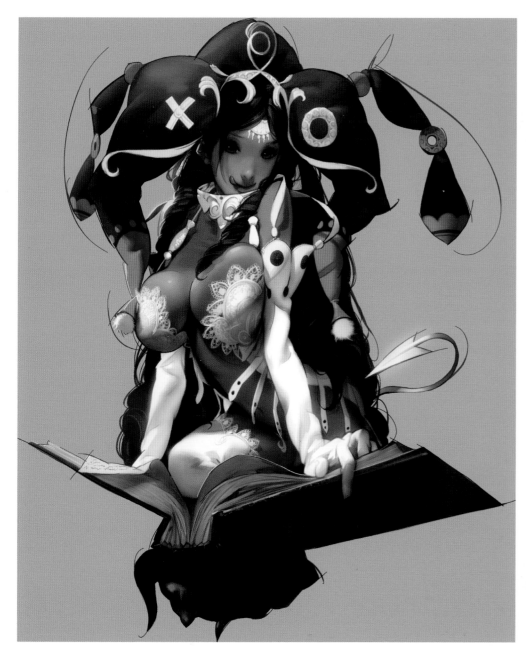

Gladius Regalis by Evan Lee // © Evan Lee/Chinese Gamer

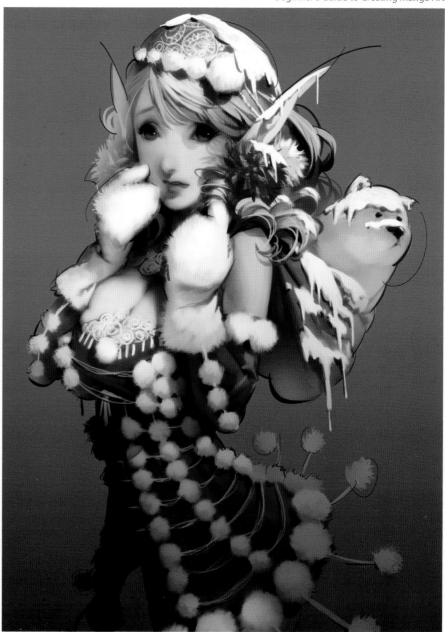

Gladius Regalis by Evan Lee // © Evan Lee/Chinese Gamer

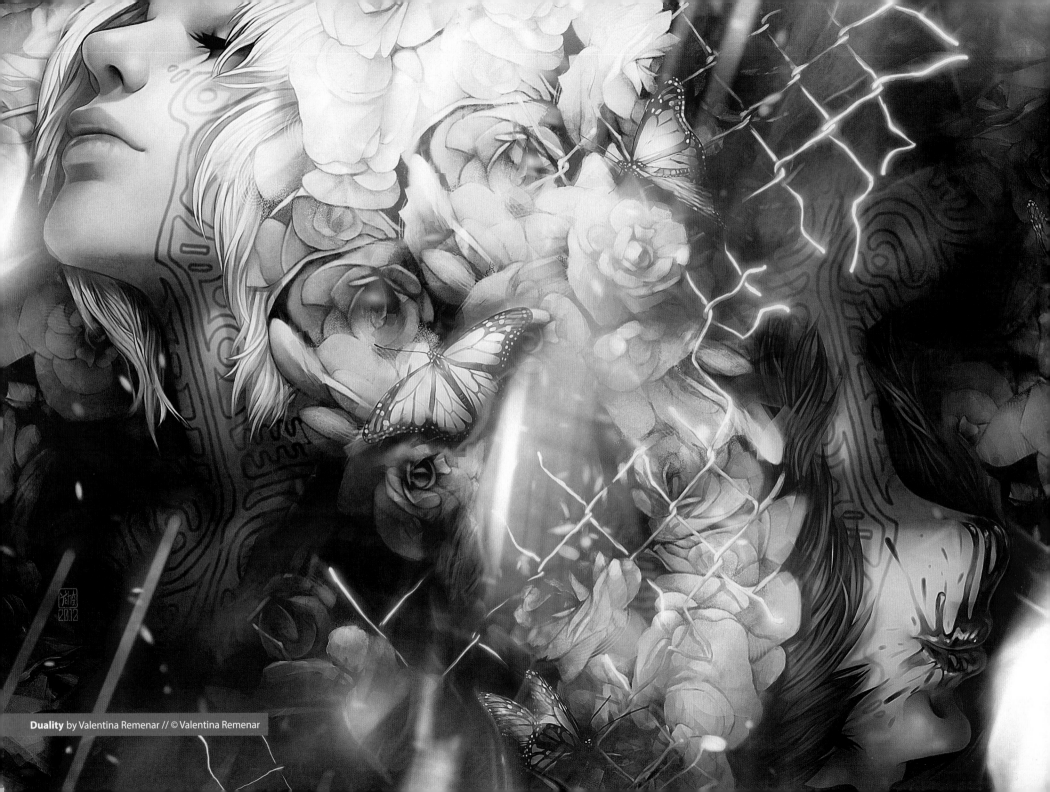

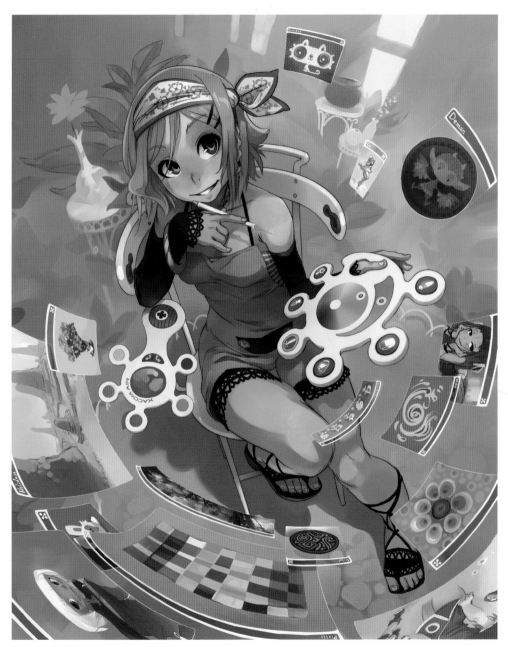

Xa by Xavier Houssin // © Xavier Houssin

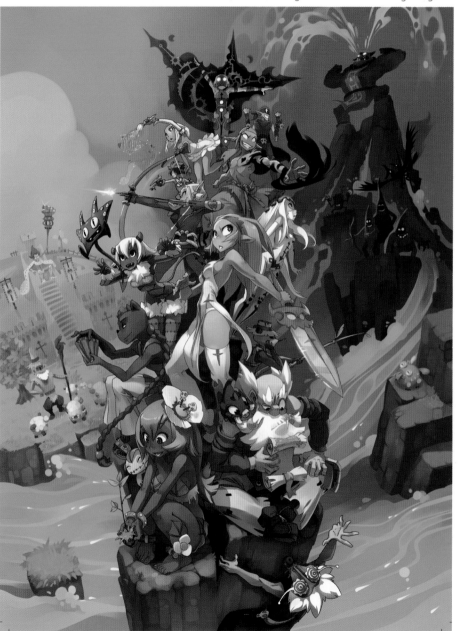

Wakfu by Xavier Houssin // © Ankama

Fantasy Girl by Xavier Houssin // © Xavier Houssin

Elf by Xavier Houssin // © Xavier Houssin

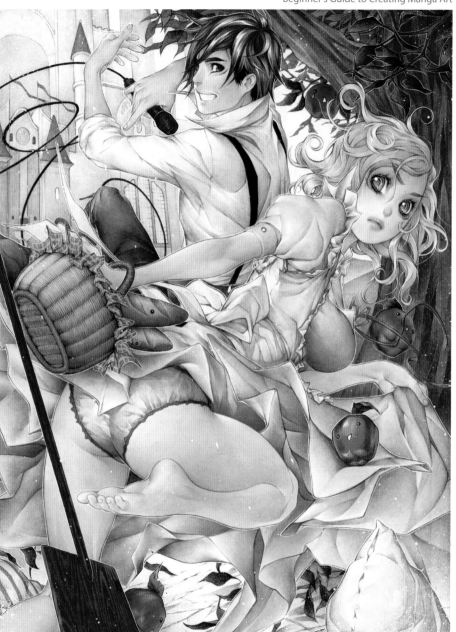

Lopette by Xavier Houssin // © Ankama

Power Walk to the Palace by Mateja Pogacnik // © Mateja Pogacnik and Marco Paal

DIGITAL PAINTING
techniques

Book Specifications
21.7 x 27.9 cm | 288 pages
ISBN: 978-0-9568171-2-9

"Once again, *Digital Painting Techniques: Volume 4* secures its place as one of the top books in the world when it comes to painting tutorials. The artists taking part in this volume are seriously amazing and I couldn't be more excited."

Marc Brunet | http://bluefley.deviantart.com
Character Artist at Blizzard Entertainment

Digital Painting Techniques: Volume 4 continues the tradition established by its predecessors by exploring a variety of painting subjects and styles with some of the most talented artists in the industry. These include veterans like Ian McQue, who looks at vehicle design from concept through to completion; Serge Birault, who shares the secrets behind his amazing pin-up style and Simon Dominic Brewer, who covers the art of fairy tale illustration. So whether you're looking to learn more about these subjects, want to know how to create new worlds and design customs brushes or simply wish to experiment with painting tribal warriors and comic art, *Digital Painting Techniques: Volume 4* will serve as an invaluable tool in your artistic arsenal. This book is a priceless resource for:

- Matte painters and concept artists for the TV, film and game industries
- Lecturers and students teaching/studying digital art courses
- Hobbyists who want to learn useful tips and tricks from the best artists in the industry

3DTOTAL.COM
Visit 3dtotalpublishing.com to learn more about our book range

THE ART OF DAARKEN
ELYSIUM

Book Specifications
22 x 28 cm | 200 pages
ISBN: 978-0-9568171-3-6

"Daarken's art is always awesome and his style has always stood out to me as totally his own; I could spot it anywhere. Not only that, but you can say the name Daarken and any artist will know exactly who you're talking about. That's very powerful in this industry and I've always admired that."

Dave Rapoza | http://daverapoza.blogspot.co.uk
Illustrator

Take a trip through Daarken's mind as you travel from epic fantasy to contemporary beauty in *Elysium – The Art of Daarken*, the culmination of the past four years of this freelance artist's work in the gaming industry.

This exciting journey begins with a tour through a selection of Daarken's personal illustrations and private commissions, ranging from CD covers to charity art, accompanied by his thoughts regarding the illustration and concept art industry. This is

followed by an exclusive look at previously unseen pieces for world-famous franchises such as *Magic: The Gathering* (Wizards of the Coast) and *World of Warcraft* (Blizzard), before culminating in an in-depth tutorial covering how Daarken created the cover illustration in Photoshop.

If you are a fan of fantasy and sci-fi art, then *Elysium – The Art of Daarken* will suit your every need and leave you longing to see more work by this talented artist.

3DTOTAL.COM
Visit 3dtotalpublishing.com to learn more about our book range